Leonardo da Vin
and *The Virgin*
of the Rocks

Dear Lizzy,

Enjoy,

best wishes & good luck,

⟨ Katy x

Leonardo da Vinci and *The Virgin of the Rocks*:

One Painter, Two Virgins, Twenty-Five Years

By

Katy Blatt

Cambridge
Scholars
Publishing

Leonardo da Vinci and *The Virgin of the Rocks*:
One Painter, Two Virgins, Twenty-Five Years

By Katy Blatt

This book first published 2017. The present binding first published 2018.

Cambridge Scholars Publishing

Lady Stephenson Library, Newcastle upon Tyne, NE6 2PA, UK

British Library Cataloguing in Publication Data
A catalogue record for this book is available from the British Library

ISBN (10): 1-5275-0644-4
ISBN (13): 978-1-5275-0644-2

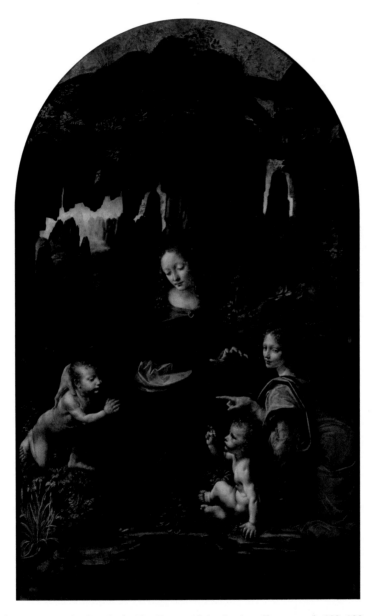

Fig. 1: Leonardo da Vinci, *The Virgin of the Rocks*, oil on panel, 199x122 cm, c.1483-4, Musée du Louvre, Paris © Musée du Louvre, Paris, Dist. RMN-Grand Palais / Angèle Dequier.

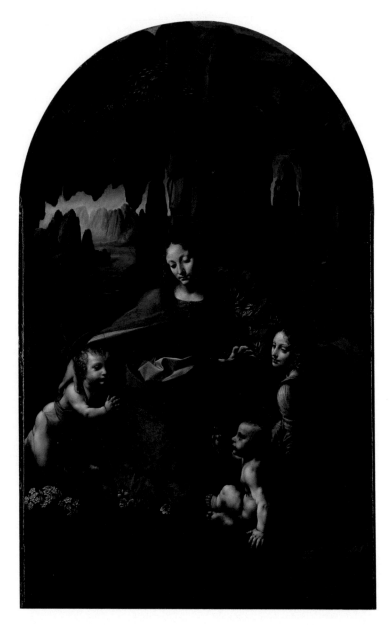

Fig. 2: Leonardo da Vinci, *The Virgin of the Rocks*, oil on poplar, 189.5x120 cm, c.1495-9 and 1506-8, National Gallery, London © The National Gallery, London.

For Granny,
who held my hand in front of *The Virgin of the Rocks* at the National
Gallery when I was five.

CONTENTS

LIST OF ILLUSTRATIONS

Fig. 1. Leonardo da Vinci, *The Virgin of the Rocks*, oil on panel, 199x122 cm, c.1483, Musée du Louvre, Paris © Musée du Louvre, Paris, Dist. RMN-Grand Palais / Angèle Dequier.

Fig. 2. Leonardo da Vinci, *The Virgin of the Rocks*, oil on poplar, 189.5x120 cm, c.1491-9 and 1506-8, National Gallery, London © The National Gallery, London.

Other works not illustrated in this book:

For direct links to the art works listed below, as well as location photographs relating to Leonardo's life, please visit **www.virginoftherocks.com**.

The images listed below are given in order of mention in this book. The figure numbers relate to links found at the website above.

Fig. 3. Ambrogio de Predis, *An Angel in Red with a Lute*, c.1495-9, oil on poplar, 118.8 x 61 cm, National Gallery, London.

Fig. 4. Andrea del Verrocchio (and workshop), *The Baptism of Christ*, c.1472-5, oil and tempera on panel, 152 x 180 cm, Uffizi Gallery, Florence.

Fig. 5. Leonardo da Vinci, *The drapery of a kneeling figure* c.1491-4, brush and black ink with white heightening on pale blue prepared paper, 21.3 x 15.9 cm, Royal Collection, Windsor.

Fig. 6. Leonardo da Vinci, *Head of the infant St John the Baptist* (section from the cartoon for *The Virgin of the Rocks*), c. 1482-83, 13.4 x 11.9 cm, metalpoint with traces of pen and ink and wash heightened with white on prepared paper, pricked for transfer, Musée du Louvre, Paris.

Fig. 7. Leonardo da Vinci, "The Burlington House Cartoon" or *The Virgin and Child with Saint Anne and the Infant Saint John the Baptist*, c.1499-1500, charcoal (and wash?) heightened with white chalk on paper, mounted on canvas, 141.5 x 104.6 cm, National Gallery, London.

Fig. 8. Andrea del Verrocchio, *Bust of Lorenzo de' Medici*, c.1478, polychrome terracotta, 65.8 × 59.1 x 32.7 cm, National Gallery of Art, Washington D. C.

Fig. 9. Donatello, *David*, c.1430, bronze, 158 cm, Museo Nazionale de Bargello, Florence.

Fig. 10. Cimabue, *Maestà di Santa Trinita,* c.1280, tempera on panel, 385 x 223 cm, Uffizi Gallery, Florence.

Fig. 11. Masaccio, *The Holy Trinity,* c.1427, fresco, 667 x 317 cm, Santa Maria Novella, Florence.

Fig. 12. Giotto di Bondone, *Madonna Enthroned /Ognissanti Madonna*, c.1306-10, 325 x 204 cm, Uffizi Gallery, Florence.

FOREWORD AND ACKNOWLEDGEMENTS

To choose to write about one of the most famous figures in the history of western art is ambitious and perhaps even a little foolhardy. This book cannot but reformulate information from over two centuries of study on Leonardo, and for this reason I am indebted to countless authors, many of whom I warmly credit in the bibliography. Even before Leonardo's notebooks started to be published over a century ago, his life and work were a topic of fascination both in scholarly circles and in the public domain. As Richard Turner[1] has pointed out, Leonardo has been systematically re-imagined since his death, with each successive author reinterpreting the evidence in ways culturally relevant to themselves. The myth or aura surrounding Leonardo has itself become part of our cultural inheritance. In this book I hope to show how Leonardo and his work are relevant today. As much as at any other point in history *The Virgin of the Rocks* is an important part of our cultural heritage, and learning about it should be accessible to all who wish to enjoy it.

At a time when art and its histories–indeed many forms of visual, physical, tactile and sensual learning–are increasingly threatened by the shallower high-speed processing encouraged by today's technology and by the government's often limiting education strategies, it seems more important than ever to facilitate a process of "slow looking": a deep and meaningful contemplation of our world. This is central to the discipline of Art History, and by focusing on a single painting commission I have tried to model this approach. By spending time with Leonardo's painting of the *Virgin of the Rocks* in the National Gallery, looking at it for a period of an hour or more, coming back to it repeatedly, and by learning about the philosophy and politics surrounding this painting at the time it was created, it begins to breath with a life of its own.

I started writing this book with several questions in mind: why did Leonardo make two versions of *The Virgin of the Rocks* and, since the second is a copy, why do they look so different? By comparing the two paintings and exploring Leonardo's experiences during the intervening years between his completion of the first and second version, I hope to have gone some way towards answering these questions. In accordance

with most recent scholarship I have taken the London, National Gallery, version to be the later and more mature of the two.[2]

Part 1 of this book is intended as an introduction to the commission of the *Virgin of the Rocks* and focuses on the first version, now in the Louvre, Paris, but painted in Milan in c.1483. Chapter 1 describes the painting in terms of Leonardo's revolutionary style and technique. Chapter 2 goes back in time, to Leonardo's training in Renaissance Florence. By exploring the socio-political and artistic context in that city, the roots of Leonardo's astonishing technical skill are established. It also explains the frustration that led to his departure from Florence to seek his fortune in Milan. Chapter 3 sets the scene in Milan under the rule of the warlord Ludovico Sforza, a stark contrast to republican Florence. It introduces the patrons of *The Virgin of the Rocks*, the Confraternity of the Immaculate Conception, and explains the dominant Christian iconography of the painting. The section ends with the mysterious disappearance of the first *Virgin of the Rocks*.

Part 2 introduces the second National Gallery painting, picking out the differences from the first version in terms of composition and style (Chapter 4). Having set up the two paintings as contrasting, I then return to the events of the intervening years thematically in order to assess the reasons for the changes. These include Leonardo's personal development as the master of his own workshop in Milan (Chapter 5), his scientific and anatomical research (Chapter 6), and his philosophical and intellectual developments during this period (Chapter 7).

Part 3 continues the story, focusing on the growing political unrest in Milan, which forced Leonardo to flee in 1499, leaving the second painting unfinished (Chapter 8). I consider Leonardo's vastly elevated social status, evident during his next few years of travel through Venice, Florence and the Papal states as a military engineer. Finally, the chapter looks at the patronage of the French, now governing Milan, which attracted Leonardo back to that city, resulting in the long-awaited completion of the second *Virgin of the Rocks* (Chapter 9). In the two-part post-script I consider how *The Virgin of the Rocks* facilitated Leonardo's vast increase in status during his lifetime, as well as his reception after his death and in the twenty-first century.

The thematic approach of this book allows new links to be made between the two paintings and their contexts and offers subtle insights into their specific cultural meaning. This single commission becomes a focal

point from which to explore diverse subjects: from politics, philosophy and science, to religious and theological concerns, psychology and personal relationships, workshop environments and artistic practices. This process of exploration is intended to highlight the multi-layered complexity of Leonardo's work, his identity, and the rich iconology[3] embedded in the *Virgin of the Rocks*.

The notion of studying an art object from a range of inter-disciplinary perspectives is central to Art History–we need only remember Ernst Gombrich's interest in the psychology of perception to make this tradition clear[4]–and for students, this link-making between subjects and forms of experience promotes an unusual intellectual versatility. A thematic approach is at the heart of the new Edexcel A-level Art History syllabus, as well as the International Baccalaureate (IB) and the Cambridge Pre-U. Indeed, this book is organised so as to deal directly with core themes within these courses, such as historical context, patronage, form and style, and materials and techniques, so it may be used as a textbook (see 'Note to Teachers').

It is often possible to engage with art works on an emotional level, but those new to Art History may lack the language to describe, and therefore to critically analyse, what they see. This is no wonder since, despite living in an image-saturated world, visual literacy is rarely a core part of a child's learning at school; indeed in 2017 we narrowly avoided losing the A-level in Art History all together. This book celebrates the revival and continuance of Art History education in schools and Chapters 1 and 4, in particular, are intended to guide the reader through a thorough process of visual analysis by modelling the use of a "tool kit" or checklist of formal components, such as composition, light, tone, space, colour and form. This is an approach first published comprehensively in Penny Huntsman's *Thinking about Art* (London: Wiley, 2015).[5] With these elements in mind it should be possible for readers to go on to examine other art works irrespective of historical context or style, and ultimately to engage more critically with the messages embedded in visual culture day-to-day.

For introducing me to this approach I am indebted to Caroline Osborne, Head of History of Art at Godolphin and Latymer School in London. Her deep and far-reaching knowledge of Art History has been invaluable to me. My sincere thanks go to Elaine Miles, Annie Liggins, Eddy Myres, Edith Poor, Thelma Robinson, Dr. Noah Charney, Julian Bell, Dr. Jenny Stevens, Prof. Jean Michel Massing, Dr. Diana Presciutti and Prof. Martin Kemp for their expert advice as well as their kind words of encouragement. I would also like to thank my wonderful and ever-supportive family.

NOTE TO TEACHERS AND STUDENTS

This book was written with students and teachers in mind, and I very much hope that it may be useful. The book is structured like a tapestry and draws on the threads of key themes repeatedly, so, although it can be "dipped into", it is advisable to read the entire text to get a full overview of any given strand. Below I have outlined how the book is relevant for different courses currently being taught in Art History.

CAMBRIDGE PRE-U

Paper 2, Historical Topic 4: "**Man, the measure of all things: the Italian Renaissance, c. 1400 to c. 1600**", Topic 4.5, "**The High Renaissance in Rome, Florence and Milan**" . This topic directs teachers and student to research Leonardo's work in Florence and Milan, specifically naming his *Virgin of the Rocks* (both the Louvre and the London versions) as well as other works mentioned in this book: *Adoration of the Magi*; *Portrait of a Lady with an Ermine*; *Mona Lisa*; *The Last Supper*; and the preparatory drawings for *The Battle of Anghiari*. This book deals with key themes that must be considered by students, including: technical and stylistic developments, historical, political, and intellectual contexts, patronage and artistic status.

EDEXCEL–A Level

Paper 1: "Nature in art and architecture". Within the new Edexcel syllabus, the *Virgin of the Rocks* can be used as a case study work for this thematic paper as an example of the religious symbolism of landscape and plants in renaissance Italy, the symbolism of the elements, as well as illustrating the contemporary view of wo/man as a microcosm of the natural world, thus relating directly to the scope of works for this exam.

Paper 1: "Identities in art and architecture". *The Virgin of the Rocks* can also be used as a case study work for this thematic paper, since it reflects not only Leonardo's artistic and psychological development, but also issues of regional and national identity. Seen at the time as a product of the high culture of the Florentine Renaissance, then the Milanese, the two paintings, now at the Louvre in Paris and the National Gallery in

London, are today seen as part of French and British cultural identity.

INTERNATIONAL BACCALAUREATE (IB)–Diploma

Paper 2: "Art of the Renaissance". The *Virgin of the Rocks* is also an excellent case study that may be used in the longer essay responses for Paper 2, and this book deals with all five thematic areas questioned in this exam, including: A. Style and formal qualities; B. Iconography and meaning; C. Historical context and function; D. Artistic production and patronage; E. Techniques and materials.

Guided Coursework Project. If the "Art of the Renaissance" is not part of the taught course, this book may be used as a key text for the Guided Coursework Project as it deals with the requisite cross-cultural influences on art, including the adoption of Classical influences by Italian Renaissance artists and the adoption of Florentine culture in Milan.

INTRODUCTION

It is midnight. The date is 1508. You are kneeling in the Chapel of the Immaculate Conception in the Church of San Francesco Grande in Milan. A single candle throws a foggy disk of light into the air. As your eyes accustom to the gloaming something extraordinary unfolds.

Shadows ripple across stone. Light spots dart. And the far wall of the chapel seems to shift, opening out into what looks like an antechamber, a room within a room, a cavernous space. From an inky bed, boulders–gnarled, lichen-covered–jut out and up, to right and left, monolithic, primordial. In the distance a dazzling aquamarine river winds between toothy mountains. And, in the centre of this eerie subterrane a human figure slides into focus: first a face, then a hand stretches out towards you.

A beautiful creature kneels before you. She is heavenly. Her skin is porcelain-white, spotless, pure. Her delicate shoulders are draped with soft silk, blue and gold, like the sea and the sun. The folds of her dress cling to her hips and crisply encircle her waist. She is so close that you can almost see her chest rise and fall, and her curls flutter in the breeze. Two infants perch beneath her cloak, and an angel, with the wings of a swan, leans in.

This might sound fantastical. But in 1508, when Leonardo da Vinci put the finishing touches to his second painting of *The Virgin of the Rocks*, (Fig. 2) those who looked upon it must have felt they were experiencing a vision. It is hard to understand nowadays the sheer amazement, the intensity of experience, that this painting would have evoked when it was first seen in that chapel in the Church of San Francesco Grande in Milan. Using a uniquely experimental oil technique, as well as scientific observation of the human body, Leonardo had succeeded in creating the illusion of striking three-dimensionality and a psychologically convincing world in paint.

In terms of subject matter too, Leonardo's work was unprecedented. When he set out to paint his *Virgin of the Rocks*, the Catholic theology of the Immaculate Conception of Mary had never before been visualized; the Virgin had rarely appeared in a cave setting. In many ways this was a

record-breaking, world-changing work. It profoundly influenced Raphael and Michelangelo, and it was central to the advent of the High Renaissance style in Italy. There are fewer than twenty surviving paintings by Leonardo. This is one of his largest at around two metres in height, and one of the most famous in the world.

To this day intrigue surrounds the commission of *The Virgin of the Rocks*. In c.1482 the young Leonardo emigrated from Florence to Milan and agreed to paint the original version (Fig. 1), now in the Louvre in Paris, within a year of his arrival. It was commissioned by a brotherhood of wealthy Milanese attached to the Church of San Francesco Grande, known as the Confraternity of the Immaculate Conception. The painting propelled him to fame in the humanist court of the warlord, Ludovico Sforza. But unlucky circumstance and financial disputes between the artist and patrons meant that, sometime around 1490, the painting was mysteriously lost, and the Confraternity were left without their promised altarpiece. Leonardo continued to live and work in Milan, yet another eighteen years passed before he would honour his commitment to the Confraternity by completing a second version of the lost work.

When Leonardo finally completed the second *Virgin of the Rocks* in 1508, now at the National Gallery in London, twenty-five years had passed since he had first signed the commission papers, one of the longest-standing agreements of its kind in history. During these crucial decades, Leonardo underwent the most startling artistic, intellectual and scientific development of his life. At first glance the two paintings seem very alike, yet on careful comparison the differences start to come into focus. These differences hold the key to an understanding of the life and times of one of the most famous artists and thinkers that has ever lived.

This is the story of Leonardo and his two paintings of *The Virgin of the Rocks*: one painter, two Virgins, and a twenty-five-year period of revolutionary discovery.

PART 1

THE FIRST *VIRGIN OF THE ROCKS* C.1483-4 (LOUVRE, PARIS)

CHAPTER ONE

EXPLODING THE LIMITS OF PAINTING

Technical and Stylistic Analysis

Those who saw Leonardo's *Virgin of the Rocks* when it was first completed in the mid 1480s would have been stunned. A parallel might be drawn with the immersive experience of 3D film today. Like James Cameron in his 2009 film *Avatar*, Leonardo had pushed visual effects to the limit.

In the battle scenes of *Avatar* arrows seem to fly into the audience and the surround sound recreates the "zing" of metal whizzing past our ears. In the forest scenes the holographic projections trick us into thinking that a web of branches meets over our heads; the sense that the drama is unfolding in our own space is confirmed by the sound of rustling leaves above and behind us. During this experience our disbelief is suspended. We tense our shoulders and hold our breath when we see objects hurtling towards us; even our heart rate increases.

This is not unlike the impact that Leonardo's *Virgin of the Rocks* must have had in its original setting. It was intended as part of a total-work-of-art: a physical, spatial, aural and tactile encounter, not just a visual one.[1] It was displayed in a side chapel of San Francesco Grande: an enclosed and darkened room, lit by candles, with cold stone walls and reverberant acoustics. The painting was a devotional aid. Members of the Confraternity of the Immaculate Conception would have come here to pray in silence, contemplating the perfection of the Mother of God and her sacrifice. Kneeling in that gloomy chamber they hoped to be transported, to experience religious clarity, to truly empathise with Mary. In this context Leonardo's painted cave would have seemed like an annexe of the real room in which they knelt. They would have felt the cold stone walls and the roughness of the wooden pews under their fingertips as an extension of Leonardo's rocky landscape. The red silk draped over the angel's shoulders might have matched the cloth of the real altar below the painting. Muffled footfalls and the drone of plainsong would have been the

eerie soundtrack. Leonardo was intentionally blurring the boundaries between the real and imaginary. Like our experience of 3D film today, the fifteenth-century audience would have been momentarily taken in by Leonardo's painted world.[2]

Leonardo aimed to suspend the disbelief of his audience through his "special effects", which, like Cameron's more recently, were revolutionary. On a two-dimensional surface he could create the illusion of three-dimensional space, and he could paint human figures that seemed to think and feel. In comparison, the work of contemporary Milanese artists must have looked artificial. The side panels for Leonardo's altarpiece, *An Angel in Red with a Lute* of c.1495-9 (Fig. 3) and another angel in green, are now at the National Gallery in London and were painted by Leonardo's associate, Ambrogio de Predis. Ambrogio may even have made a copy of Leonardo's Virgin to use as a template for his first angel: he borrowed the incline of the head, the sloping shoulders, the centrally-parted hair and pouting lips. But despite these similarities, his attempt at depicting the human form simply highlights Leonardo's unique naturalism. Compared to de Predis' rigid and angular figures, Leonardo's were compelling. To contemporary viewers Christ must have seemed like a real infant twisting in movement, with rolls of fat around his waist, the hollows and dimples of his arms hinting at muscle beneath the skin, each silken curl picked out by a fleck of gold, each fingernail present. Mary's hand, gently indenting the flesh of St John's shoulder, describes the softness of a real, warm body.

With smoky tonal modelling–*sfumato*–Leonardo created a shift from highlight to shadow so gradual that the boundaries between solid and void became invisible to the naked eye. Unlike Ambrogio's angel, which is contained by a hard outline, the limits of Leonardo's figures are deliberately elusive. This effect requires the mind to make a "top-down" analysis of meaning: the brain has to complete parts of the image that the human eye simply cannot see.[3] As a result Leonardo's figures seem literally to vibrate with life, as if they are breathing. It was because of this effect that Vasari later reported seeing the "pulse beating" in the throat of Leonardo's *Mona Lisa*,[4] and that her eyes appear to follow you. Rather like the effect of a 3D film, where our eyes and brain trick us into believing that the characters are leaping out of the screen, Leonardo's *sfumato* forces the mind of the viewer to become more actively involved in decoding the forms within the *Virgin of the Rocks*, and therefore more invested in the scene.

Not only did Leonardo's figures seem to breathe, they also appeared to think. The hands–the tactile, sensual parts of the body–act like sign language. The outstretched hand of Mary, the pointing finger of the angel, the hands of the little boys in prayer and blessing, highlighted by soft light, seem to dance between their bodies. Not touching, but almost, they tell of a charged, meaningful communication between the figures. Their gazes are also interactive: Mary glances down at John, who focuses on Christ, who looks back at his cousin. We trace with our own eyes the circle of faces; the direction of our gaze replicates theirs in real time. Looking outward, the angel appears to welcome us into the silent conversation. Leonardo had choreographed audience participation in a way that is still psychologically gripping today.

Leonardo's ability to render subtle differences in texture was also wonderfully convincing compared to the stylized, flattened folds of fabric covering Ambrogio's angel. Mary's blue velvet cloak, finished with a necklace of golden threads, is pulled taut by a broach at her breast. The sling of golden silk at her waist appears crumpled in stiff, three-dimensional folds. The angel's arm can be glimpsed through the transparent fabric of her sleeve, its delicacy contrasting with the heavy red roll of silk that folds down her back. The depiction of this weighty cloth is so believable that we can almost hear it tumble with a "plomp" from the ledge. A clear sheath of gauze encircles John's stomach, fragile as a cobweb. The apparent contrast between the warm, soft flesh, the dry crisp herbage, the silk, velvet and gauze, and the cold stone, emulates the raw sensuality of life.

Beyond the human forms the observed detail in Leonardo's landscape was unparalleled. The flora is rigorously accurate. A careful observer would have been able to identify the plant species by the shape and colouring of the leaves: there is a columbine to the right of the Virgin's head; a species of galium above her right hand; a cyclamen with heart-shaped leaves below the foot of Christ; and a basal rosette of primrose by his knee.[5] Just above St John's back we see the soft fan of a fern frond, each delicate blade painted individually, caught by a sliver of light.

Finally, Leonardo's figures seem to inhabit a physical space. This is partly due to his development of *chiaroscuro*, the stark contrast between dark and light tones. The shadow appears to recede, creating the illusion of depth in the cave, while the highlighted areas seem to project towards us. Thus the illuminated faces and hands of the figures seem to burst out of the painting into our world. He also observed that, in the distance, colour

density decreases. This "atmospheric perspective", seen in the lighter blue of the mountain peaks in the background, also helps to create a sense of depth. Leonardo went further in his attempt to create the illusion of three-dimensional space within the painting by arranging the figures in a novel pyramidal composition. Mary's head is the apex, her knees, and those of St John and Jesus, form corners of the base. But, truly revolutionary, was Leonardo's implication that the viewer was seated at the fourth corner of the base of this pyramid, *beyond* the picture plane. In doing so Leonardo makes us feel included in this formation of holy figures. If recreated as a filmic projection the rock ledge would shoot out and up under our feet and Mary's hand would reach out towards us. For Leonardo's intended audience, kneeling in that darkened chapel, this illusionism would have contributed to an experience of total physical and spiritual immersion.

·········

Interviewed just before the release of *Avatar*, the director, James Cameron, said:

> "The irony with *Avatar* is that people think of it as a 3D film and that's what the discussion is. But I think that, when they see it, the whole 3D discussion is going to go away ... That's how it should work. All of the technology should wave its own wand and make itself disappear."[6]

Cameron had invented new stereoscopic cameras that mimicked the way human eyes view the world in three dimensions. Each lens had a filter that removed a different part of the image as it entered the eye, giving the brain the illusion of seeing two different angles simultaneously, in turn creating the 3D effect.[7] Cameron was successful. The result was so naturalistic that viewers reported forgetting that they were watching a film; instead they were swept up in the action. His technology was, indeed, so good that it had "made itself disappear".

Leonardo's revolutionary naturalism was also the result of new "technology". His artistic process was at the cutting edge of Renaissance practice. Craftsmen of the Middle Ages had often traced or copied images from stock collections in block-books.[8] This can still be seen in paintings from the workshop of Leonardo's teacher, Andrea del Verrocchio (c.1435-1488). The palm tree on the right of his *Baptism of Christ* of c.1472 (Fig. 4) is a typical block-book creation. The artist, probably one of Verrocchio's apprentices, had clearly never seen such a species with his own eyes: the tree appears rigid and stylized, almost cartoon-like, with

strange frond formations. In addition, as was usual, there are several hands at work in this painting; different apprentices or associates were given separate sections to complete, and the result is a disjointed composition. Leonardo sought to rectify both these problems.

His solution was to make a series of preliminary compositional studies. These allowed him to imagine and then rework the arrangement of figures in space as a unified group. A sheet of drawings with *Designs for an Adoration of the Christ Child* (1482-3)[9] in the Royal Collection at Windsor dates from the same years as *The Virgin of the Rocks*. With pen and ink over metalpoint Leonardo drew Mary kneeling over her child within a semi-circular frame. He repeats the scene from four slightly different angles on the same sheet of paper. Similar to the way Cameron might experiment with camera angles, Leonardo was assessing which "shot" would best convey his story.

Once he had decided on the viewpoint and composition Leonardo started to make meticulous drawings from life. Leonardo's study entitled *The drapery of a kneeling figure* from c.1491-4 (Fig. 5)[10] depicts a figure in a very similar pose to the angel in *The Virgin of the Rocks*. Leonardo probably used a maquette for this study, wetting a rag, dipping it in plaster and then letting the folds harden over a supporting framework or armature.[11] The drawing illustrates the precision with which he recorded the play of light on the fabric, the shape and quality of the shadows cast by a fold, and the way a lip catches the light and appears brighter. Using the blue tinted paper as a mid-tone, directional hatching in black ink for the shadows, and building up to highlights in white chalk, his drawing took on a sense of sculptural mass. The obvious pleasure he took in working up such studies, almost as if they were finished masterpieces in their own right, suggests that Leonardo was interested in the effects of monochrome as much, if not more, than *colore*. His working method, focusing heavily on drawing and design, was later called *disegno* by the Renaissance Art Historian Giorgio Vasari (1511-1574). Gone was the reliance on the block-book. Here was a new confidence in human vision as a source of knowledge. In believing his own eyes Leonardo had begun to transform the role of the artist from a craftsman—a reproducer of stock images—to a scientific observer of nature; a thinker. The unsurpassed naturalism of his painting stemmed from this novel approach; his acute attention to observed detail.[12]

Leonardo's detailed studies were then combined and reworked to create a *cartone*, or cartoon. A section of the cartoon for *The Virgin of the*

Rocks, depicting the *Head of the infant St John the Baptist* of c.1482-3 (Fig. 6), is held at the Louvre in Paris. It is just a small part of what would have been a full-size monochrome mock up of the painting on paper. At the National Gallery in London there is an example of a completely intact cartoon by Leonardo. *The Burlington House Cartoon* of c.1499-1500 (Fig. 7),[13] as it is known, depicts the Virgin and Child with St Anne and John the Baptist.[14] Leonardo would then have transferred this design to a primed wooden panel via a tracing process called *spolvero*. Using a needle he pricked small holes along the primary lines of the drawing. Then, reversing the paper so that the drawn lines were underneath, he used a powder puff made of sacking to brush charcoal particles through the holes and onto the panel below. When he gently removed the cartoon the dots of charcoal left on the panel could be joined up using a wetted brush. These lines would form the basis for the underdrawing on the panel, which laid out the composition for the painting.[15] Unique to Leonardo was the delicacy with which he then worked up this underdrawing with the finest charcoal modelling. This allowed him to create an effect of three-dimensionality and mass in his figures in *The Virgin of the Rocks*, even before he started to use paint.[16]

Leonardo's painting technique was also radical: he was one of the first Tuscan artists to paint entirely in oil colour. First perfected in the Netherlands by Jan van Eyck (1390-1441) and his contemporaries in the early 1400s, oil paint technique had been brought to Italy in the mid 1400s by artists such as the Sicilian Antonello da Messina (1430-1479) and Ferrarese painter Cosmè Tura (c.1430-1495), when the majority of painters in Italy were still working in the traditional egg tempera.[17] Even Leonardo's teacher, Andrea del Verrocchio, who experimented with oil, only used it for the final touches to his tempera work.[18] Consisting of ground pigment bound in egg yolk and water, egg tempera had serious limitations: it was opaque and so dried with a rather flat, matt finish; its water base meant that it was absorbed quickly into the gesso ground and was hard to blend; and any tonal modelling had to be achieved with hatching and crosshatching. This meant that brush strokes remained visible, drawing attention to the painter's hand rather than the subject depicted.[19]

In *The Virgin of the Rocks*, however, Leonardo mixed his pigment with linseed oil binder to create a translucent, slow-drying medium. The light shone through the oil, reflecting off the suspended pigment particles, creating a new vibrancy and luminosity of colour, seen in the rich red of the angel's cloak. His innovative *sfumato* effect was created by gradually

building up glazes of oil, with each layer being so thin that pigment concentration and intensity of colour increased by tiny increments. By building up many such layers a new and dramatic *chiaroscuro* could be created, in turn adding to the convincing sense of depth and mass in his figures. The natural lip of the oil binder meant that brush strokes were invisible, allowing the viewer to forget about the painting process and instead become absorbed in the story unfolding before them. Because the oil binder sat proud of the surface of the panel rather than being absorbed, it was also possible for Leonardo to create the minute detail in the painting, like the wisps of hair and the fern fronds.[20]

Like Cameron too, Leonardo was fascinated by the science of vision. He consciously sought to imitate the natural mechanisms of light, for example, as a means of creating a believable scene. Because his oil glazes were transparent, colour from the lower layers showed through the upper layers, allowing for subtle blending of colour by the eyes. Using coloured glass to explain his theory, he wrote later:

"If you wish to see readily the variety of all compound colours, take some coloured pieces of glass and look through them at all the colours of the countryside that can be seen behind them, and thus you will be able to see that all the colours of the things behind the glass appear to be mixed with the colour of that particular glass …"[21]

In *The Virgin of the Rocks*, blue glazes show through the red of the angel's cloak, creating purple tones in the shadow.

Leonardo's development of what he called "aerial perspective", seen in the mountainous background, was also the result of a scientist's observation of nature. He wrote:

"The blueness we see in the atmosphere is not intrinsic colour, but is caused by warm vapour evaporating in minute … atoms on which the solar rays fall rendering themselves luminous…"[22]

Noticing that the higher one climbed, the lighter the sky-tone became, he deduced that this must have been because the atmosphere had become gradually thinner.

"It is clearly seen that the air which borders most closely on the plain of the earth is more dense than the other air, and to the extent that it is higher it is thinner and more transparent. Things which are tall and large, whose bases are distant from you will be little seen, because the visual axis passes through the denser air surrounding them."[23]

 Leonardo translated this in a literal sense to his painting, so that pigment particles corresponded to atmospheric "atoms". To depict the stratospheres, for example, where he believed there to be a lower concentration of these "atoms", he mixed fewer blue pigment particles in with the oil binder, resulting in a lighter tone. Thus, the peaks of the mountains in *The Virgin of the Rocks* are a lighter shade of blue. Centuries before Cameron, Leonardo had attempted to recreate nature in art. He too had waved his "wand" and made his technology "disappear".[24]

CHAPTER TWO

LEONARDO'S FLORENCE

To the fifteenth-century Milanese, Leonardo's *Virgin of the Rocks* must have seemed like illusory magic. However its innovative naturalism was in part the product of the unique cultural and historical context in which Leonardo grew up: *quattrocento* Florence.

In a letter to Paul of Middelburg in 1492, the well-known Florentine philosopher Marsilio Ficino (1433-1499) proclaimed:

> "If we are to call any age golden, it is beyond doubt that age which brings forth golden talents ... That such is true of this our age [no one] will ... doubt. For this century, like a golden age, has restored to light the liberal arts, which were almost extinct: grammar, poetry, rhetoric, painting, sculpture, architecture, music ... and all this in Florence."[1]

This was the Florence of Leonardo's youth, a place of self-conscious innovation and creative energy. It was a city of "gold"–of great economic wealth–where a proto-democratic constitution allowed a new merchant class to become prosperous. As a result Florence saw an unsurpassed artistic flourishing. The city became the nucleus of the Early Renaissance in Italy, where the great "golden age" of Classical culture was reborn.

A "Golden Age" in Florence

When Leonardo arrived in Florence as a teenager in c.1469 to start his training as an artist, he would have been confronted by a throng of activity and noise. Florence was a busy mercantile centre of over 80,000 inhabitants. Its huge economic wealth was based on the banking and textile industries. Each artisan and trader belonged to a guild, a professional body, which oversaw training and pay and set quality standards. Wool was imported from East Anglia in England and processed by the *Lana* or wool guild; cloth from Flanders and silk from the Far East were dyed by the *Calimala* and *Seta*, the cloth and silk traders' guilds respectively, and sold on for huge profit. Meanwhile, minting their own coin, the *Florin*, since 1252, the members of the *Cambio*, the bankers'

guild, were international financiers responsible for the monetary matters of the largest courts in the world, including that of the King of England.[2] It was a Florentine banker, Amatino Manucci (active 1299-1300), who is credited with inventing double-entry bookkeeping, still used by accountants today, and another Tuscan mathematician, Luca Pacioli (c.1447-1517), who first published a detailed description of the process.[3] Mathematical precision and knowledge was key to Florentine success in what was essentially an early capitalist economy.

The constitution of Florence favoured enterprise and responsibility. The restrictive hierarchy of feudalism no longer existed. An independent city-state and a proto-democratic republic, it was governed by elected officials rather than princes or dukes. Since 1293 it had been run by a *Signoria*, a town council of nine members known as *priori,* elected from within the guilds.[4] Presided over by a temporary custodian or *Gonfaloniere*, the *Signoria* met in the *Palazzo Vecchio* (1299), an imposing medieval crenelated palace in the centre of the city. Each adult male citizen over the age of thirty had the right to vote and to elect a member of his guild to the government.[5] The guilds were also charged with major civic responsibilities, allowing the city to run smoothly. The *Seta*, for example, was responsible for the care of the city's orphans.[6] This was essentially an early form of welfare state. The new merchant classes became not only prosperous but also politically active and socially responsible. There was a competitive pride and sense of agency among the citizens of Florence.

Ficino's words in 1492–"all this in Florence"–ring with patriotic pride. Yet a strong sense of collective identity was already well established when Leonardo first came to Florence thirty years before. As early as 1403 Leonardo Bruni, chancellor of Florence between 1410 and 1411, had written *Laudatio Florentinae Urbis* or *Panegyric to the City of Florence*, comparing the Florentine State to that of Classical Rome. With rhetorical zeal Bruni proclaimed:

> "Recognise, men of Florence … that you are, of all races, the most renowned … [because] your founder is the Roman people–the lord and conqueror of the entire world."[7]

Bruni continues to make links between the Florentines and the Classical Romans, citing their superior system of government as a prime example of this lineage:

"... fired by the desire for freedom, the Florentines adopted [the Romans']
... zeal for the republican side ... [Like Classical Rome, Florence] ... has
outstanding civil institutions and laws. Now nowhere else do you find such
internal order, such neatness, and such harmonious cooperation ... faith,
integrity, steadfastness, and ... concern for fellow citizens ..."[8]

Bruni's language reflects his own intense pride in Florence, its social order
and balanced republican government. To him it was a new empire state,
ripe for expansion. But Bruni's comparative approach also signalled the
birth of a new concept, that of modern history as we know it today. This
was the moment when a medieval, mystical understanding of existence was
overtaken by the notion of a linear, progressive and secular development of
civilisation through time. He expanded on this idea in his book,
Historiarum Florentini populi libri XII (*History of the Florentine People
in Twelve Books*),[9] using textual evidence to formulate a three-part model
for history: Antiquity, the Middle Ages, and the Modern. Like Bruni,
quattrocento Florentines saw themselves as men of the modern age, not in
isolation, but in *relation* to others who came before, in "perspective" as it
were. With this came a new sense of confidence. Man's place within the
cosmos was shifting. No longer was he at the mercy of an omnipotent and
punishing God.[10] As the Greek philosopher Protagoras (c.490-c.420 BCE)
had written, this humanist world-view meant that man had become "the
measure of all things".[11]

Despite Florence's republican constitution and strong collective sense
of order a small handful of banking families started to dominate the
political scene during the *quattrocento*. By the time Leonardo arrived in
Florence one family, the Medici, had gained supremacy.[12] Cosimo de'
Medici, known as *Il Vecchio* (1389-1464), was the banker to the Pope and
inherited the family wealth of 180,000 *florins* in 1429.[13] In 1427, 62% of
Medici income came from Rome, with approximately 100,000 *florins* on
deposit from Papal Curia[14] and by 1429 Cosimo had become the richest
man in Florence. He took a 10% cut of Papal taxes, levied on every
clergyman in Europe, and collected high interest from loans to royalty, the
Pope and other merchants, a practice known as usury. Jealousy between
banking families was rife, and in September 1433 Cosimo had been exiled
by the powerful Albizzi faction of the *Signoria*.[15] Leaving for Padua and
then Venice, he took his bank accounts with him. Florence swiftly went
bankrupt. In 1434 Cosimo returned triumphant, and for the next thirty
years he acted as *de facto* head of state,[16] monopolising the *Signoria* by
arranging for the election of his supporters, offering loans to secure
loyalty, and using intimidation and thuggery to threaten rival families and

to control security and taxation.

Hand-in-hand with Cosimo's rise to power, a renewed interest in ancient art and literature flourished in Florence. Cosimo's public display of humanist knowledge was intended to affirm Medici lineage back to the great Roman emperors of the past, thus legitimising his otherwise spurious claims to power. In 1439 Cosimo used his contacts in the Papacy to persuade the General Council of the Greek Orthodox and Roman Catholic Churches to meet in Florence. Pope Eugenius IV and the Eastern Emperor John Paleologus VIII brought with them ancient texts, offering Cosimo unprecedented access to Classical literature.[17] When, in 1453, the Turks captured Constantinople and the Greek and Roman population fled, taking with them original manuscripts, many came back to Florence where they had pre-established links. Cosimo acquired texts by Plato and Aristotle, amongst others, adding to his humanist library at San Marco and in 1462 he founded an Academy for Platonic Studies, overseen by his court philosopher Marsilio Ficino.[18] On Leonardo's arrival in Florence, Cosimo's grandson, Lorenzo de' Medici, "The Magnificent" (1449-1492), had already succeeded as head of the family in 1469 and was amassing a famous collection of ancient sculptures in the Medici gardens.[19] (A fittingly elegant bust of Lorenzo can be found at the National Gallery of Art in Washington (Fig. 8)). It was at this time that humanist learning in Florence began to trickle into wider artistic circles.

As well as collecting antiques the Medici poured huge sums of money into artistic projects that were inspired by Classical works, providing visual proof of their Roman heritage and defining the Renaissance style. The Medici Palace (1444-1484), designed by the architect Michelozzo Michelozzi (1396-1472) soon after Cosimo's return from exile, was one such enterprise. On an immense scale, with a huge *all'antica* cornice, window mullions in the form of Classical Corinthian colonnettes and Roman-style rustication, it occupied one of the most conspicuous streets in Florence near the Duomo, Via dei Martelli. Leonardo would have passed the Medici Palace regularly; its looming presence would have been impossible to miss in its final stages of completion. Through the entrance loggia he might have glimpsed the internal courtyard and Donatello's (c.1386-1466) bronze sculpture of the nude *David* of c.1430 (Fig. 9) with his Classically-inspired *contrapposto* pose. Framed by the Renaissance arcade, the political message of this sculpture would have been clear: like David of the Old Testament, in his triumph over the Philistine giant Goliath, the Medici had God–and superior heritage–on their side. They would prevail.[20]

The fashion for commissioning art in the Renaissance style spread amongst other wealthy citizens as well as through the guilds. Florence began to reinvent itself as a cultural centre. The centrepiece of the city, the dome for Florence Cathedral (1419-1438), was designed by Filippo Brunelleschi (1377-1446). Supported by generous donations from the *Lana* guild, he had used techniques observed in the Roman forum to complete what was–and is to this day–the largest brick and mortar dome in the world.[21] Later the architect and intellectual Leon Battista Alberti (1404-1472) designed a palace for the banker and Medici supporter, Giovanni Rucellai (1403-1481). Taking inspiration from the Roman Emperor Vespasian's Colosseum (CE 79), Alberti designed the palace façade according to Classical architectural rules, with the first correctly superimposed Orders since antiquity. Harmony and modularity in the visual culture of Florence was explicitly seen as a reflection of the harmony and rationality of their social order.[22]

Parallel to the rebirth of Classical literature and the changing architectural landscape of the city, a new stylistic naturalism developed in the painting of Early Renaissance Florence. This too was inspired by antiquity and was facilitated by the Medici's humanist circles. Few paintings had survived from Classical times, but sculpture acted as inspiration. In c.1430 the Hellenistic *Torso Belvedere* was unearthed in Rome and offered a prototype for anatomical naturalism and movement.[23] Newly discovered texts on art also emphasised the importance of naturalism and copying from life, or *mimesis*. *Naturalis Historia* (*Natural History*, c.77 ACE) by the Roman author Pliny the Elder (CE 23-AD 79) was sought after by Cosimo for his library at San Marco.[24] Pliny's description of the Greek painter Zeuxis was particularly interesting: apparently his depiction of grapes was so naturalistic that real birds were fooled into pecking at the paint.[25]

The unique socio-economic climate undoubtedly contributed to the advent of this naturalism in the work of the Florentine artists, including of course Leonardo. In 1418 the Florentine architect Brunelleschi had famously "discovered" single-point linear perspective: a rigorous mathematical system that allowed the artist to recreate the illusion of three-dimensional space on a two-dimensional picture plane.[26] This was later codified by Alberti in his book, *On Painting* (1435), where he described a complex system of orthogonal lines intercepting at the vanishing point and horizon line.[27] Arguably this system could only have been conceived in the mind of a Florentine. The ability to map the visible world onto a flat surface reflects a mind-set of order and control. It was a manifestation of a culture

where mathematical knowledge was central. It parallels the sense of agency promoted by a capitalist economy, the sense of power and ownership invested in the citizens by the republican state, but also the intellectual "perspective" created by Bruni's concept of modern history.[28]

A comparison between Renaissance and medieval Florentine painting gives an indication of just how far this naturalism had already come by the 1400s. Painted sometime between 1280 and 1285, Cimabue's *Maestà di Santa Trinita* (Fig. 10) was a late medieval altarpiece still heavily influenced by the Byzantine icon tradition.[29] Sitting rather awkwardly on a throne, the Virgin and Child appear within a flattened space. The gilded striations of their drapery, the hierarchy of scale, Mary's stylized and elongated hands and neck, the strange proportions of Jesus' form (his small head and long body make him look like a miniature adult rather than a baby), and the lack of interaction between mother and child, all point towards a reliance on tradition rather than an observation of real models. The religious figures are awe-inspiring, separate from our world.

Yet in the generations before Leonardo's birth, steps had already been made towards a new observational naturalism in Florence. On the west wall of the church of Santa Maria Novella is Masaccio's famous fresco of *The Holy Trinity* of c.1427 (Fig. 11). Using his friend Brunelleschi's single-point linear perspective [30] and Classical architectural features, Masaccio had created the illusion of a three-dimensional barrel-vaulted space recessing into the wall of the church. Within this space he depicted Christ crucified, flanked by the life-sized merchant donors Lenzi and his wife.[31] A reference to Roman cultural heritage is clear in the painted Ionic architectural Orders. Meanwhile, the high status attributed to the mortals, equal to Christ in scale, the mathematically accurate mapping of illusionistic space, the interest in anatomical naturalism seen in Christ's lean torso and visible rib cage, all reflect the humanist world view that pervaded Florence. In essence, if not in subject matter, Masaccio's work was the precursor to Leonardo's naturalism in *The Virgin of the Rocks*.

Psychological naturalism in painting was also developing during the Early Renaissance. Since Cimabue's *Maestà,* Giotto, in his *Madonna Enthroned* or *Ognissanti Madonna* of c.1306-10 (Fig. 12), and then Masaccio, in his *Virgin and Child* of c.1426 (Fig. 13),[32] had both looked more closely at the physical proportions of infants. Masaccio had also introduced gestures, such as the sucking of the fingers that reflected the behaviour of a young child more convincingly. By the 1470s Leonardo's teacher Verrocchio was making images of the Madonna and Child as if

they were portraits of contemporary mothers with their babies. In his *Madonna with Seated Child* of c.1470 (Fig. 14), now held at the Gemäldegalerie der Staatlichen in Berlin, Verrocchio had removed the traditional throne and thus the formality of the scene. Instead the baby wriggles playfully on his mother's knee. Christ's small, chubby form, the dynamism of his arms, stretching out towards his mother, his open mouth, and the engaged gaze between parent and infant, all reflect a new emotional connection. The figures in this painting were clearly intended to inspire empathy rather than awe, and they speak of the changing relationship between man and God at this time. Arguably it could only have been in *quattrocento* Florence that Christ and the Virgin Mary would be imagined in such a homely way; a city where, armed with Bruni's humanist reading of history, citizens were able to conceive of themselves as the last link in a chain traceable back via the Romans to biblical times. The depiction of such a natural relationship between Christ and his mother created a new empathy between the viewer and the holy family that was an essential antecedent to Leonardo's sensitive depiction of the figures in *The Virgin of the Rocks*.

A Craftsman's Training

Very little is known about Leonardo's childhood and early training.[33] He was born on 15th April 1452 in a small hillside town called Vinci on the outskirts of Florence, the illegitimate son of Ser Piero da Vinci, who would become a respected notary or lawyer, and Caterina di Meo Lippi, a peasant girl.[34] Leonardo's legitimate half-brothers would follow their father's footsteps with a humanist schooling in Latin and the liberal arts. This would have gained them entry to the major Florentine guilds and to respectable careers in accountancy and the law. Leonardo's illegitimacy, however, barred him from an intellectual's education. His early childhood was spent in the countryside under the supervision of his grandparents, and sometime in his mid-teens it was decided that he would be trained as an artist.[35] This would eventually make him eligible for membership of the *Compagnia di San Luca*, a society of painters linked to the doctors' guild (the *Arte dei Medici e Speziali*), and allow him to set up his own artists' workshop.

We know that Leonardo must have been in Florence in 1469 at the age of seventeen because he was recorded as a dependant in Ser Piero's tax return.[36] At some point around that time it seems Ser Piero had signed a contract entering Leonardo into training with Andrea del Verrocchio.

Verrocchio had recently succeeded Donatello as the favourite artist of the Medici, and his workshop was one of the most successful in Florence.[37] This was partly because his output was so varied. Specialising in painting and sculpture as well as architecture, his was more like a factory than a studio. Moreover his workshop was famous beyond the borders of Tuscany as an educational centre for young artists. Leonardo would be trained in the theory of art, as well as a vast range of technical skills including chemistry, metallurgy, metalworking, plaster casting, leather working, mechanics, carpentry, drawing, painting, sculpting and modelling.[38]

Verrocchio's *bottega*, or workshop, could be found on Via Ghibellina in the parish of Sant' Ambrogio near the Church of Santa Croce in the east end of Florence.[39] Via Ghibellina is a long street that runs from what was, in the *quattrocento*, the upmarket area of the Bargello and the legal district, where Leonardo's father had his office. However the eastern end of the street passed through one of the poorest districts of the city. This was the artisan neighbourhood of Verrocchio's studio. Although just a short walk from the city centre, the Duomo and the grand Medici Palace, the flavour of the east end was very different. It was crowded, dusty and rather smelly, being situated near the tanneries, the sellers of sage and other herbs, the manufacturers of cooking pots and the brick works. It was a place of physical labour and camaraderie.[40] Typical of shops in that district, Verrocchio's *bottega* probably consisted of a large room opening onto the street with living quarters to the back or above. Leonardo would become one of a handful of junior apprentices training, working and sleeping under his master's roof.[41]

Verrocchio's *bottega* was also the site of intellectual exchange. Giorgio Vasari characterized him not only as an artist interested in painting and sculpture, but also as a *"studioso"* who devoted time to *"scienze"* and *"geometria"*, and *"musico perfettissimo"*.[42] Some say that he taught Leonardo to play the *lira da braccio* to an exceptional standard and to read and write in Italian.[43] An engraving by Enea Vico (1523-1567), *The Academy of Baccio Bandinelli* of c. 1544 (Fig. 15), now at the Metropolitan Museum in New York, dates from a generation later– Bandinelli was a lifelong rival of Michelangelo's[44]–yet it gives us a feel for the serious, scholarly intent in the Renaissance artist's studio. Reading, sketching and writing by the light of the fire, the men hunch over their papers. The skeletons strewn in the foreground speak of the growing interest in the study of anatomy, while plaster casts of ancient sculptures impress on the viewer the intellectual enterprise of Bandinelli and his team. Verrocchio, too, was part of a network of artists who were engaging

with the humanist interests of their patrons. We know Sandro Botticelli (c.1445-1510) was a close associate of Verrocchio's and the favourite of Lorenzo de' Pierfrancesco de' Medici (1463-1503). The brothers Antonio (1432-1498) and Piero (1444-before 1496) del Pollaiuolo were also friends of Verrocchio and worked for, among others, the Pucci family, banking associates of the Medici. Pietro Perugino (c. 1446/1450-1523), who would later train the young Raphael da Urbino (1483-1520), Francesco di Simone Fiorentino, Agnolo di Polo and Lorenzo di Credi were also members of Verrocchio's studio. [45] These were all men whose work exhibited a deepening understanding of contemporary philosophical debates, mathematically constructed single-point linear perspective, as well as the careful study of Classical sculpture. In the early years of Leonardo's training, Verrocchio was involved in various projects that brought him close to humanist circles: in 1466 he completed the tomb for Cosimo de' Medici and between 1468 and 1470 he was working on the famous bronze sculpture of *David*, completed in c.1475 (Fig. 16) for Lorenzo "the Magnificent". Perhaps using the teenage Leonardo as a model, [46] the sculpture was initially intended for Lorenzo's palace at Careggi, the same place where the Neo-Platonic school of Marsilio Ficino was flourishing.

In the midst of this bustle and debate Leonardo embarked on his practical training. An artist's education traditionally adhered to the curriculum set out by the early 15th-century text *Il Libro dell'Arte o Trattato della Pittura* (*The Book of the Artist: Treatise on Painting*) by Cennino Cennini (1360-1427). [47] Working initially as *garzone* or journeymen, students would run errands: back and forth to the workshop where frames were being carved and to the apothecary where the raw materials for paint could be bought. From linen, these young apprentices would make the paper for studies and cartoons. Later they would have learnt to grind pure pigments, such as semi-precious lapis lazuli rock, with pestle and mortar and then to mix the powder with egg yolk to make egg tempera paint. [48]

It must have been in Verrocchio's workshop that Leonardo mastered the basics of the artist's alchemy. We find in his notebooks passages carefully copied from Cennino Cennini's "recipe book":

> "Take oil of cypress, which you will then distil ... Have ready a large vase in which you put the distilled oil, with enough water to give it an amber colour. Cover it well so that it does not evaporate." [49]

In other places he wrote of more "alternative" experiments:

"Salts can be made from human excrement ... burned, calcified, stored and dried over a low fire; any excrement will yield salt ..." [50]

Having mastered the fundamentals, apprentices would have graduated to more delicate tasks: preparing a panel for painting with a ground of white calcium carbonate; transferring the *cartone* onto this panel ready for the older associates to paint. Drawing practice was also central to Verrocchio's curriculum. His studio was famous for highly-worked drapery studies. Describing Leonardo's early studies on *tela di lino* (fine linen), Vasari writes:

"Sometimes in making models of figures in clay, over which he would lay soft pieces of cloth dipped in clay, and then set himself patiently to draw them on a certain kind of very fine Rheims cloth, or prepared linen: and he executed them in black and white with the point of the brush, so that it was a marvel, as some of them by his hand, which I have in our book of drawings, still bear witness." [51]

An example of such a drawing can be seen at the British Museum, *Drapery Study for a Kneeling Figure in Profil Perdu* of c.1472-5 (Fig. 17) in grey-brown wash with white on linen. The sensitivity of the modelling, even at such an early stage in Leonardo's career, is astonishing. These close observational studies, with the focus on light and shadow, were at the heart of Leonardo's unusual painting technique. They were the basis for the highly developed undermodelling that later allowed him to create the astonishing three-dimensional effect seen in his *Virgin of the Rocks*. [52]

Another studio practice was drawing from plaster casts of the body. As in the engraving of *The Academy of Baccio Bandinelli*, we might imagine casts of body parts strewn across Verrocchio's studio floor. Making casts of each other–copies of hands, legs, arms–the apprentices were able to practise working from life-size models of the human body. Only after this were they allowed to draw from the living model. [53]

Once the basics of *disegno*, drawing and tonal design, had been accomplished students graduated to working in colour. In the 1460s and 1470s Verrocchio was experimenting with linseed oil as a binder for paint, although he used the translucent glazes merely to touch up and finish tempera work. The Pollaiuolo brothers were more consistent in their use of oil paint, however, and Leonardo may well have learned this technique from them. [54]

Finally, in c.1472, Verrocchio allowed Leonardo to put brush to panel and to contribute to a painting. This was *The Baptism of Christ* of c.1472 (Fig. 18), now in the Uffizi in Florence, [55] a collaborative workshop piece.

Whilst Verrocchio probably painted the central figures of Christ and St John, the peripheral sections were finished by other members of his studio.[56] It seems that Leonardo completed a small portion of the left foreground of the composition: the little angel, kneeling with his back to the viewer. He was probably retouching with oil a figure that was painted earlier by his master in tempera.[57] His handling of the paint, however, is incredibly subtle. The softness of the angel's face, the imperceptible join between neck and ear, the touch of shadow beneath the eyebrow, the tendrils of highlighted hair applied with the softest and slenderest of ermine brushes, the magically translucent shoulder buttons, all suggest the hand of the young Leonardo. The intensity of the angel's gaze, as he turns to look up at Christ, reveals an emotional life that marks him apart from the other figures. And his *contrapposto* pose, twisting around three planes, shows a new understanding of the human form, as if the little figure were turning in three-dimensional space. Vasari describes Leonardo painting an angel so superior to the rest of the work that "Andrea [Verrocchio resolved that he] would never touch colours again".[58] At any rate Verrocchio must have been impressed because, in 1472, at the age of nineteen, Leonardo was listed as obliged to pay his dues to the *Compagnia di San Luca*: he had been enrolled as a master painter.[59]

Leonardo stayed in Verrocchio's workshop for another four years.[60] During this time he began to develop the psychological naturalism that he would put into play when he reached Milan and painted *The Virgin of the Rocks*. In the collection of the British Museum in London there is a silverpoint drawing, *Profile of a Warrior in a Helmet* of c.1472-5 (Fig. 19), probably after a bas-relief by Verrocchio. The aggressive stare, the furrowed brow, the beaked and winged helmet of this warrior, are mesmerizing in their detail. Leonardo defines the angle of the cheekbone with directional hatching, marks so fine that you can barely see them with the naked eye. Drama bursts from the page. The hook of the nose is marked with a line so unwavering, so confident. It is a line that swells and bulges but is never broken, that seems to encapsulate a bullish intent. Still only twenty-three years old, Leonardo had a precocious and somewhat uncanny ability to pin down intense personality on paper. He was pushing the boundaries of style and medium. And his focus on this military subject gives us an early indication of the ambition and determination with which he would later pursue his career in Milan under the *condottiere* (military leader) Ludovico Sforza (1452-1508).

Meanwhile, Leonardo acquired a taste for humanism. He picked up a smattering of Latin in Verrocchio's workshop and was aware of the Neo-

Platonism that had begun to filter into artistic discussion. In 1476, at the age of twenty-four, he must have come closer to this intellectual milieu when he painted the *Portrait of Ginevra de' Benci* of c.1474-8 (Fig. 20), now held at the National Gallery of Art, Washington D. C. Ginevra, the daughter of a wealthy Florentine banker,[61] was the "platonic" lover of Bernardo Bembo (1433-1519), a Venetian diplomat who in turn knew Marsilio Ficino, the central player in Lorenzo de' Medici's coterie of humanist scholars. Bembo had an autographed copy of Ficino's book *De amore* (1484) and attended Ficino's Neo-Platonic academy in Careggi; they wrote a stream of letters to each other.[62] Leonardo made direct reference to Ficino's ideas on the back of the portrait of Ginevra. He painted the motto *"Virtutem forma decorat"* ("the form adorns virtue") curling around a scroll, a reference to the Neo-Platonic notion that outward physical beauty reflects inward moral and spiritual purity.[63] Perhaps with the hope that an opening at the Medici palace was just around the corner, in 1477 Leonardo set out on his own.

Breaking Away

In c.1477 Leonardo set up his own studio near Verrocchio's in the Santa Croce district of Florence.[64] He employed an apprentice in 1478, one Paolo di Leonardo. But Leonardo never moved closer than Ginevra de' Benci to the heart of Lorenzo de' Medici's intellectual circles. For some reason he was not accepted by the *de facto* ruler of Florence. When Lorenzo's favourite painters were sent to Rome in 1481 to decorate the Sistine Chapel, Leonardo was excluded. Instead Sandro Botticelli (1445-1510), Domenico Ghirlandaio (1449-1492) and Pietro Perugino (1469-1523) were chosen as Medici's official ambassadors,[65] charged with currying favour with the Papacy.

Perhaps Leonardo was overlooked because he could not be relied on to complete commissions. Since becoming *maestro* he had painted *The Annunciation* in 1475 (Fig. 21), two small panels of the Virgin and Child, *The Madonna of the Carnation* in c.1478 (Fig. 22), and *The Benois Madonna* in 1478 (Fig. 23); and the portrait of the beautiful Ginevra de' Benci (1474/1478). These were relatively small works. But in 1478 he was asked by the *Signoria* to paint a large altarpiece for their chapel in the *Palazzo Vecchio*, the Cappella di San Bernardo. Despite the huge prestige of this job, however, he never completed it. Even Leonardo's elusive father seems to have attempted to find his son work. In March 1481 Ser Piero da Vinci negotiated with his employers, the Augustinian monks at

San Donato at Scopeto, for Leonardo to paint the *Adoration of the Magi* (Fig. 24), now at the Uffizi in Florence.[66] This was a convoluted agreement. A saddle maker had made an endowment to San Donato. The monastery records from March 1481 note that Leonardo, in return for a share in the endowment property, was expected to complete the altarpiece in the space of twenty-four to thirty months, and to pay a deposit into the dowry bank for the saddle maker's granddaughter.[67] But this commission also fell through. It seems that Leonardo could not afford to buy the ingredients for the paint. He never paid the dowry deposit and was forced to do odd jobs for the monastery in return for grain and wine. In 1481 he simply abandoned the painting as a ghostly underdrawing.

Leonardo's unreliability when it came to completing commissions may have been the result of his absorption in other enterprises. Between 1478 and 1480 he was sketching wonderful inventions: we find *Studies for an Automobile* and *Studies of Hydraulic Devices* in his notebooks at this time (now at the Biblioteca Ambrosiana in Milan).[68] And he was making music. He played the *lira da braccio*, an early form of the violin, beautifully, and according to Vasari he used it to "accompan[y] his own charming improvised singing".[69] A fragmentary letter remains from Leonardo to the teenage musician Atalante Migliorotti (1466-1532) and it was probably he who, in c.1482, posed for Leonardo holding a lyre and wearing nothing else.[70] Leonardo also experimented with musical riddles and poetic ideas. There are half a dozen musical and linguistic games in his notebooks of the time, now held in Windsor. "*Amore sola mi fa remirare, la sol mi fa sollecita*", he wrote, "Only love makes me remember, it alone fires me up".[71] He used a combination of musical notation, letters and pictorial symbols to design this ditty and it can be played on a keyboard (DGAEFDE AGEFG). What seems clear is that he was not content to stay within the confines of a single discipline.

Perhaps Leonardo's lack of popularity at the Medici Palace was also the result of the questionable company he kept. In April 1476, while still under the protection of Verrocchio, Leonardo had been in trouble with the law. His name was on a list of young men accused of committing sodomy with a seventeen-year-old boy, Jacopo Saltarelli (born c.1459). Leonardo was in danger of imprisonment. The protégé and cousin of Lorenzo de' Medici, Leonardo Tornabuoni, was also implicated, and so de' Medici stepped in to get the young men off the hook.[72] But the shock of the experience probably hung over Leonardo. Then in 1478, soon after Leonardo set up his own studio, a sequel to the distasteful scandal occurred. His apprentice, Paolo, was exiled from Florence for "wicked"

behaviour only months after he had entered Leonardo's household.[73] The exact nature of this wickedness is unclear, but the implication is that it was homosexual activity. A whiff of scandal seems to have pervaded Leonardo's workshop. Lorenzo de' Medici got involved again to exile and imprison the boy.[74] By now Leonardo was probably on Lorenzo's radar as a member of a bad set.

By the early 1480s Leonardo was still barely making ends meet. His dreams must have leapt ahead of the reality of his life. A sense of entrapment by his artisan status echoes through his diary entries.

> "If indeed I have no power to quote from authors as they [scholars in general] have, it is a far bigger and more worthy thing to read by the light of experience, which is the instructress of their masters. They strut about, puffed up and pompous, decked out and adorned not with their own labours but with those of others and they will not even allow me my own."[75]

Leonardo's frustration is patent in this excerpt, and his illegitimacy and resulting lack of a liberal arts education seem to be part of the cause. He appears to have lived on the edge of ordered society, wanting to push boundaries, ready to break rules. In Florence, where one's social status was dictated by stringent guild membership, where success as an artist was entirely dependent on the taste of a few wealthy patrons, such as the Medici, and where any creative practice was regulated by guild guidelines, it seems understandable that Leonardo felt he would never make a name for himself in that city. And fame was clearly his ambition. Quoting Dante Alighieri's *Inferno* in his notebooks Leonardo wrote:

> "Lying in a feather bed will not bring you fame, nor staying beneath the quilt, and he who uses up his life without achieving fame leaves no more vestige of himself on earth than smoke in the air or foam upon the water."[76]

Perhaps Leonardo felt he would stand a better chance of success with a fresh start. In about 1482, taking with him the reputation of a brilliant Florentine training under the renowned Verrocchio, but with a thirst for more, Leonardo left the city of his boyhood and travelled to Milan.[77]

CHAPTER THREE

SFORZA'S MILAN

When Leonardo arrived in Milan in c.1482 it must have seemed very different from Florence. It was a feudal city-state and a military dictatorship. Its medieval walls, piled high with battlements, were only three miles in diameter, yet around 80,000 inhabitants were crammed within their precincts.[1] The power structure was also less stable. Milan had, only recently, in 1479, been seized by Ludovico Maria Sforza (1452-1508), a warlord with tenuous claims to the duchy.[2] Ludovico had ruthlessly beheaded his sister-in-law, Simonetta, in order to succeed as regent to his nephew, Gian Galeazzo Sforza (1469-1494).[3] And before Ludovico, his father Francesco had, in c.1450, wrestled the city from the grip of the Visconti family. The Sforza name went back only as far as Ludovico's grandfather who was a farmer turned mercenary. *"Sforzare"* itself means "to force" or "to compel" and had been adopted by the family as a fighting name.[4] This was no proto-democratic republic but an autocracy ruled with an iron fist.

Violence and Decadence

Strong political ties existed between Florence and Milan. In 1477, the year Leonardo had set up his own studio in Florence, Sforza had made his first attempt at capturing Milan. He was unsuccessful and had been exiled to Pisa, near Florence.[5] Paying his respects to Lorenzo de' Medici, Sforza would have ridden into the city decked out in pomp and splendour. Contrasting with the dark clothing of the Florentines, regulated as they were by strict sumptuary laws, Ludovico's attire would have appeared shockingly luxurious. The Sforza were famous for their lavish dress and dramatic ceremonial entrances. When Ludovico's father, Francesco, visited Florence in March 1471, the record of the event, "Le Liste dell' andata in Fiorenza", confirmed the presence of 800 horses carrying courtiers, chaplains, butlers, barbers, cooks, trumpeters, pipers, dog-handlers, falconers, ushers, pages, wardrobe-mistresses and footmen.[6] One can imagine that Ludovico's procession would have rivalled his father's, and that it must have scandalised and seduced the Florentines. Sforza was

welcomed by Lorenzo de' Medici and a friendship grew between the two men.[7] Both were illegitimate rulers of sorts, both were very ambitious. They must have been seen together in Florence: Lorenzo "The Magnificent" arm in arm with Ludovico "The Forceful", stepping daintily between Classical busts in the gardens of San Marco, planning their great ascent to power. De' Medici was interested in the future Duke's mercenary muscle, while Sforza was certainly awed by the "high" culture and sophistication of the Florentine banker.[8]

In the last months of 1481 when Sforza finally succeeded in storming his way back into Milan, the news would have arrived in Florence within a week. For Leonardo, frustrated and struggling with the commission for the *Adoration of the Magi*, this was perhaps the signal to jump ship. Sometime between September 1481 and April 1483 Leonardo left his studio and Verrocchio's artistic circles and set out for Milan.[9]

Leonardo would have needed permission from the *Signoria* to leave Florence. For this reason it is likely that he travelled as part of a group on political business. The retinue of Bernardo Rucellai (c.1448-1514) were despatched to Milan as Florentine envoys on behalf of the de' Medici in February 1482, charged with maintaining healthy links with the now powerful Ludovico Sforza.[10] Bernardo was Lorenzo de' Medici's brother-in-law and had commissioned designs from Leonardo previously.[11] Leonardo probably brought with him his apprentice and music student, the sixteen-year-old Atalante Migliorotti. According to Vasari, Migliorotti carried a silver lyre with a sound box in the shape of a horse's head, an exotic gift for Ludovico Sforza made by Leonardo himself.[12]

It would have taken them a week to cover 188 miles on horseback, over the Apennines to Bologna, then along the lowlands of the River Po to Milan. When they arrived, weary after the long journey, the travellers would have passed under the first gates of the medieval walls on the south side of the city, the *Porta Romana*. If Leonardo was in the company of Rucellai, he would have arrived during the freezing month of February 1482. Pushing north along the cramped streets towards the castle they would have met with celebrations, for it was the month of the Ambrosian carnival.

The red-stone monstrosity of the *Castello Sforzesco* would have made Florence's *Palazzo Vecchio* look like a doll's house. As the drawbridge crashed down behind the visitors they would have seen the immense enclosure within the castle's outer walls: several square miles of garden, a

small city in its own right. Across the gardens, and another moat, was the inner sanctum of private courtyards where Ludovico's own celebrations were taking place, guarded by soldiers and surrounded by courtiers. Milan was then famous for its musical culture. The salary list for the Milanese court in 1480 shows an impressively large group of musicians: twenty singers, seventeen trumpeters, and seven chamber musicians.[13] Leonardo may have hoped that his training on the lyre would be appreciated.

Leonardo would have recognized Sforza's face from paintings, if not from the fawning attention of servants. In a *Portrait of Ludovico Sforza* from the late 1400s (Fig. 25),[14] a miniature by Sforza's court painter, Ambrogio de Predis, we glimpse what Leonardo must have seen: the fashionable Lombard bowl haircut, the downturned lips, the long, beak-like nose and the swarthy skin that led to his nickname *"Il Moro"* ("The Moor" or "The Black"). Perhaps, amidst the celebrations, Leonardo had envisaged offering Ludovico a letter of introduction. He had certainly prepared such a document, probably while still in Florence.[15] That it was intended for Sforza seems clear: it is a *curriculum vitae* tailored to a warlord.

"My most illustrious Lord", Leonardo begins:

> "I have sufficiently seen and examined the inventions of all those who count themselves makers and masters of instruments of war, and I have found that in design and operation their machines are in no way different from those in common use. I therefore make bold, without ill-will to any, to offer my skills to Your Excellency, and to acquaint Your Lordship with my secrets, and will be glad to demonstrate effectively these things, at whatever time may be convenient to you ..."[16]

He follows his polite introduction with a list of his abilities; a list that he thinks will most attract the interest of Sforza "The Forceful":

> "I have methods of making very light and strong bridges ...
> When a siege is under way I know how to remove water from the trenches ...
> ... I have methods for destroying any fortress ...
> I have certain types of cannon extremely easy to carry ...
> I have ways of silently making underground tunnels and secret winding passages ...
> I will make armoured cars, totally unassailable ...
> I will make cannon and mortar and light artillery ...
> Where bombardments turn out to be impractical I will devise catapults ...

When the fight is at sea I have many kinds of highly efficient machines for attack and defence ..."[17]

It is a wish list for a warrior. As an afterthought, Leonardo remembers that he is also an artist and offers to design Sforza an equestrian monument in memory of his father:

"In painting I can do everything that is possible to do ... I would be able to begin work on the bronze horse which will be to the immortal glory and eternal honour of the Prince your father's happy memory and of the famous house of Sforza." [18]

Surely this was a proposal that Sforza could not refuse. Leonardo was clearly fired with enthusiasm and hope for a new life. He wanted to make a career for himself as a designer of instruments of mass destruction, an engineer of machines and implements: a thinker, not just a craftsman-painter. He was determined to make himself indispensable: he *would* be famous.

.........

But Sforza did not take the bait. Leonardo's CV, if it was received at all, must have fallen on deaf ears. Sforza had no proof that Leonardo could build these instruments of war, these bridges and dams. Nor is there any record of an official letter of introduction from the trusted Lorenzo de' Medici to Sforza. Given Leonardo's past encounters with Lorenzo perhaps this is not surprising. As far as de' Medici was concerned, he was still a young craftsman who needed to prove himself.

Leonardo was forced to take a step back and to strategize. He must have temporarily buried his hopes for a career as a military engineer and looked about him for a foot in the door. He was a foreigner in a strange city and needed to establish himself. His first move was probably to make links with fellow émigrés. He would have met a network of Florentines near the ex-pat hub of the Medici bank on Via Bossi.[19] He befriended the Tuscan architect, Donato Bramante (1444-1514)–"Donnino" Leonardo fondly called him–who would later redesign the Basilica of St Peter's in Rome. He might have shared stories with the historian, diplomat and traveller Benedetto Dei (1418-1492) and crossed paths with Piero di Vespucci, exiled from Florence after his involvement in the Pazzi conspiracy of 1478. [20] Perhaps for the first time Leonardo identified himself as a Florentine. He was on the lookout for useful contacts, anyone who had the ear of Ludovico Sforza.

Leonardo found his lucky break with the Milanese de Predis brothers. Evangelista and Ambrogio de Predis had a thriving family workshop just outside the southwest walls of Milan, in San Vincenzo in Prato. Evangelista made illuminated manuscripts in the Northern style and Ambrogio was the official portrait painter to Ludovico Sforza.[21] In c.1482, when Leonardo arrived in Milan, they probably also had their ears to the ground and their shop well stocked because there was news of a large commission afoot.

A clique of wealthy courtiers to Ludovico Sforza–including Corio, Casati and Pozzobonelli–had recently formed a brotherhood and named themselves the Confraternity of the Immaculate Conception. They were investing in the Church as proof of their steadfast faith. Practically speaking, they probably hoped this would outweigh the sins they were incurring on earth and secure them a place in heaven. On the 8th May 1479 the Confraternity had paid for the decoration of the ceiling of a new chapel attached to the Church of San Francesco Grande, the largest Franciscan church in Milan.[22] In 1480 they had commissioned the Milanese sculptor Giacomo del Maino (active 1469-1503), to make a wooden altarpiece for this chapel.[23] Although it no longer exists, we get a sense of what this huge architectonic structure might have looked like from Maino's later workshop pieces, for example his *Altar of the Immaculate Conception* from around 1495, now in the church of S. Maurizio, Ponte in Valtellina (Fig. 26). Gilded and polychrome, it would have been a sight to behold.[24] Soon the Confraternity would be looking for painters, equally impressive, to decorate it. The de Predis, as official court painters, would have been the natural choice for the commission. With Leonardo joining them, however, they would have become an even more attractive prospect. He was, after all, a Florentine: sophisticated, fashionable, talented, and heir to the Renaissance painting style developing under Lorenzo de' Medici.

On 25th of April 1483 Leonardo, in partnership with the de Predis, signed a contract with Prior Bartolomeo Scorlione and the Confraternity of the Immaculate Conception to paint the large altarpiece in their chapel. Within seven months the artists were expected to complete the decoration of the entire structure.[25] A *lista*–an inventory specifying all the painters' tasks–provides a description of the lost altarpiece. Not only were Leonardo and his team asked to provide a flat panel painting to be set into the carved framework (the part that Leonardo would complete), but also to gild and colour the sculpted sections, including statues of God the Father with angels, seraphim, and the Virgin, who had already been donated a gold, pearl and enamel necklace.[26] Payments of 40 *Lire* were to be paid in

regular, perhaps monthly, instalments with a bonus on completion of the job, the sum total amounting to 800 *Lire*.[27] The side panels were to be painted by Ambrogio and the gilding by Evangelista. But Leonardo was to be *maestro* and to complete the central panel in oil. The patrons specified in the contract that he was to depict: "Our Lady with her son and the angels ..."[28]

Apart from this, the precise subject matter and composition was left to Leonardo's discretion. This was to be his *magnum opus*, the first *Virgin of the Rocks*. It would be his first completed large-scale work and the painting that, he must have hoped, would finally secure his fame. Using every technical skill and stylistic innovation absorbed during his training in Florence, Leonardo would woo the Milanese and gain entry to the court of Ludovico Sforza. But, before he put brush to panel, he was faced with a dilemma.

Without Sin: The Iconography of the Immaculate Conception

The Confraternity must have wanted an altarpiece dedicated to the namesake of their brotherhood, the Immaculate Conception of the Virgin Mary.[29] But this Catholic doctrine–a belief that Mary was born without sin–had only recently gained credence in Milan and had never been visualized in painting before.

The Confraternity had stipulated that Leonardo was to depict "our Lady with her son and the angels".[30] But Leonardo did not do this: he only painted one angel, and in addition to Mary and Christ he also painted the infant St John the Baptist. Leonardo was able to get away with this creative intervention–and the instructions were so vague–specifically because there was no artistic precedent. Leonardo was expected to invent a new iconography for a new Catholic doctrine.[31]

The theology of the Virgin's Immaculate Conception was predicated by the problem of humankind's fall from grace through Original Sin. In the Brancacci Chapel in Florence there is a wonderfully dramatic rendition of *The Expulsion* in a fresco cycle from about 1425 by Masaccio, who was an early inspiration for Leonardo (Fig. 27). Having taken a bite from the forbidden apple, Adam and Eve are depicted being thrown out of the Garden of Eden by a slightly apologetic–yet firm–avenging angel. How devastated they look. The black hole of Eve's mouth, Adam's cringing face shielded by his hands, their hunched shoulders, all express their utter emotional agony. They are suddenly aware that they are naked, uncovered,

vulnerable. They are being expelled because they have disobeyed God. As punishment Eve will suffer tortuous pain during childbirth, as will her daughters, and their daughters, for the rest of time. Adam and Eve had committed *the* Original Sin: a blot that would be inherited by all humanity. This is the moment of the downfall of man–and woman–kind.

But the New Testament offered hope to the faithful, for there it was explained that Christ was born without Original Sin, an incarnation of God on earth, and was therefore able to save humanity. He was born pure because his mother was a virgin; miraculously, he was born of a woman but not of a man. In a painting of *The Annunciation* of c.1450-53 by Fra' Filippo Lippi (Fig. 28), a Florentine artist of the generation before Leonardo, there is a visual explanation for how this feat was achieved. Mary, showing humility, sits to receive her guest, the angel Gabriel. As he tells her the news of her pregnancy, a hand emerges from the top of the composition: the hand of God. From His fingertips a ray of light catapults the Holy Ghost, in the form of a dove, towards the Virgin's abdomen. Opening its beak, the bird spews out a stream of effervescent droplets that pass through a small hole in Mary's tunic–and Christ is conceived.[32]

But while Lippi was painting his *Annunciation*, debate in the Catholic Church was developing. Since Mary was chosen as a suitable candidate to bear the Saviour, she must also have been pure. She too must have been conceived miraculously–and immaculately–just as her son would be. In the years leading up to Leonardo's arrival in Milan the writings of the Franciscan theologian John Duns Scotus (1265-1308) were becoming increasingly popular. Scotus said that Mary, like Christ, was free from Original Sin. The religious Orders began to argue about the intricacies of Mary's immaculacy. The Dominicans were convinced that Mary's parents, Joachim and Anna, did in fact have "carnal relations" but that Mary was purified by God once already in the womb. The Franciscans, for whom *The Virgin of the Rocks* was painted, disagreed, believing that Mary was a pure vessel planted in Anne's womb by God Himself.[33]

Giotto, another artist who inspired Leonardo, had depicted the holy union between Mary's parents in his famous frescoes decorating the interior of the Scrovegni Chapel in Padua, completed in 1305. In *Anna and Joachim meeting at the Golden Gate* (Fig. 29), the couple meet at the Golden Gate of Jerusalem and share a passionate embrace. The closeness of their bodies, the tenderness of Anna's hands on her husband's face, suggests the poignancy of this moment. Perhaps a kiss was all that was needed. It was this reasoning that the Franciscan friar Fra Stefano da

Oleggio put forward in a series of persuasive sermons at the Church of San Francesco Grande in Milan in 1475, capturing the imagination of the wealthy Milanese of the Confraternity.[34] In 1480, only a few years before Leonardo started work on his masterpiece, the Milanese theologian Bernardo de' Busti formulated the office for the Feast of the Immaculate Conception, which was approved by Pope Sixtus IV that same year.[35]

In one image, therefore, Leonardo was expected to explain not only the moment of Mary's own pure conception and the virgin conception of Christ a generation afterwards, but also the reasons for this two-fold immaculacy: the original fall of mankind, mankind's salvation by Christ and of course the salvation of the contemporary Milanese viewers. This would involve a telescoping of time: a "cut" between the Old Testament and the New, and then a fast-forward to modern day.

It was traditional to tell the stories of the lives of Mary and Christ like a series of stills from a film reel, frame by frame, with each part of the narrative depicted separately. Giotto had done this in the Scrovegni Chapel: from the lives of Mary's own parents, Joachim and Anna, to that of Mary herself, to the Passion and Crucifixion of Christ and ending with the Last Judgment, the Christian story covers all four walls of the chapel, and can be read clockwise from east to west and from top to bottom in thirty-nine scenes. But Leonardo was expected to convey this entire life cycle at a glance, as part of a single central panel for an altarpiece. His task was to aid contemplation in stillness. Members of the Confraternity would kneel, perhaps for hours, in front of this single painting, their understanding and faith deepening moment by moment.

Leonardo's inclusion of John the Baptist was probably a hook that would have appealed to the Milanese consciousness. Stories from the early life of Christ and John had been sentimental subjects of apocryphal gospels and imaginative biographies in Milan for years.[36] One of these tales, popularised in fourteenth century Italy by Pietro Cavalca, told of a meeting between Christ and John as infants. Living as a hermit under the protection of the Angel Uriel, St John met Christ during the holy family's flight into Egypt, both children having evaded Herod's massacre of the innocents. John had paid homage to Jesus, who blessed his precursor and prophesied the Baptism. The pool in the foreground of Leonardo's *Virgin of the Rocks* may therefore prefigure Christ's baptism by his cousin.[37]

This apocryphal story offers one explanation for Leonardo's unusual landscape setting: an exotic wilderness suitable for John's mountain lair.[38]

Leonardo may have been inspired by the iconography of *The Rest on the Flight to Egypt*, where Mary was often shown in a rocky landscape. And he had probably seen Fra' Filippo Lippi's *Adoration in the Forest* (Fig. 30), painted in Florence in about 1459 for Cosimo de' Medici. Here Mary kneels in prayer over Jesus, overlooked by St John, within a dark and rocky woodland. But no artist, it seems, had depicted a cave setting.

Leonardo had a lifelong fascination with nature, and this extended to rocks and mountains. There is a sketch at the Royal Collection in Windsor, *A Rocky Ravine* of 1480-3 (Fig. 31),[39] perhaps drawn on his journey between Florence and Milan, where the jagged crags and pebbly riverbed are very similar to the rock formations in *The Virgin of the Rocks*. Yet Leonardo's notebooks suggest that his drawings of natural phenomena bore a meaning beyond his appreciation of their beauty, and that they had an allegorical function. A clue to the cave's meaning might be found in Leonardo's journal entry from many years later.[40] He writes around 1508:

> "We might say that the earth has a spirit of growth, and its flesh is the soil, its bones the arrangement and connection of the rocks of which the mountains are composed ... its blood the springs of water ... its breathing and ... pulses ... represented in the earth by the flow and ebb of the sea ..."[41]

Here Leonardo writes of Earth as a macrocosm of the human body. The two are intrinsically connected: both breathe with life. But the body that Leonardo describes seems to be specifically female. The "spirit of growth" suggests fertility; the "flow and ebb of the sea" hints at the menstrual cycle. *"Cavo"* ("cave") in contemporary Italian was interchangeable with the word "stomach".[42] Perhaps, then, the subterranean space is a visual metaphor for Mary's being. The rocks are her bones, the stream that gurgles towards us, her blood; the herbs and shrubbery reference her fertility. And the cave–protected, enclosed, hidden and untouched by man– symbolizes her virgin womb.[43]

If Leonardo's cavernous landscape is a metaphor for Mary's virginity it is also a reference to the Immaculate Conception of Christ. But Leonardo also needed to explain the purity of *Mary's* creation. A solution is suggested in a passage from the Old Testament, *Proverbs* (8:22-5). This was a popular passage quoted by Fra Stefano da Oleggio in his sermons in Milan to explain Mary's Immaculate Conception, and it would have been familiar to the Confraternity.[44] Here we read Wisdom's description of herself:

"The Lord possessed me in the beginning of his ways ... from the
beginning I was set up from eternity, and of old, before the earth was made
... The depths were not as yet and I was already conceived, neither had the
fountains of water yet sprung out. The mountains with their huge bulk had
not as yet been established, before the hills I was brought forth."[45]

The subject of this passage, Wisdom personified, was at the time
understood to be a prefiguration of Mary: she too would be "possessed" or
"conceived" by the Lord God. In this way the friar explained how she
existed before the beginning of time, before the creation of mountains and
water. Following this argument to its logical conclusion, the Franciscans
saw that Mary had been *designed* untainted, before Original Sin and the
fall of mankind. The primordial rock formations of Leonardo's *Virgin of
the Rocks* represent, therefore, this early moment of creation in the womb
of the earth: the pure and untouched place of Mary's own "conception" in
the mind of God.

Within this allegorical landscape the holy figures play out the
theological message, the intertwined life cycle of mother and earth and
Mary's place as mediator between man and God. Her importance is clear
from her position at the apex of the pyramidal composition. The softness
of her physiognomy and elegant swaying pose underline her worthiness of
this place. Another popularly quoted passage in sermons about the
Immacolata was from the *Song of Songs* (4:7), where the prophet Solomon
proclaims "Thou art fair, my love; there is no spot in thee".[46] Thus, beauty
was equated with purity, and Mary's loveliness was rendered theologically
essential. Raising her hand, Mary presents her child, his birth the result of
the second Immaculate Conception. Already, with the choice of cave
setting and with the presence of mother and son, Leonardo had the visual
ingredients to explain Mary's own Immaculate Conception and the purity
of Christ.

Seated before his mother, Jesus raises two fingers in blessing towards
the infant St John. Without his usual attributes, the sheepskin or the cross,
John becomes the "everyman", the human representative in this painting
of holy figures. Glancing outwards while pointing towards the kneeling St
John, the angel implies this association between the viewer (us) and the
mortal child. Following Mary's gaze towards John we are reminded that it
is for *him* (and ultimately for us) that Christ was born. And so John raises
his hands in thankful prayer.

The painting also alludes to the sacrifice that Jesus will have to suffer
in order to secure the salvation of mankind. The rocky ledge is like a

natural altar, and the blood-red cloak of the angel hints at Christ's inevitable death. Together they refer to the miracle of transubstantiation during Mass. In the chapel, at the altar below the painting, the bread and wine would have been believed to literally transform into the body and blood of Christ in the hands of the priest.[47] The dark atmosphere of the painting now becomes heavy with meaning. The earthy hues create an aura of solemnity that foretells the coming tragedy. The sensuality of the image–the touch of flesh on flesh, skin on rock, the damp leaves, the cool stone–makes the physical reality described by the painting, and the emotional reality of the relationships between the figures, even more poignant.

Beyond the figures there is another layer of Christian meaning embedded in the flora. The leaves and flowers are so naturalistically depicted that the individual species would have been identifiable to the Renaissance viewer.[48] The tripartite leaves of the columbine to the right of the Virgin's head were understood to represent the Trinity[49] and Christ,[50] their violet colour standing for passion and penance.[51] The spurs on the flowers symbolized the Holy Spirit.[52] Above Mary's hand the galium with its little yellow bell-flowers, commonly known as Our Lady's Bedstraw, was said to have been used by Mary to line the manger. Below the foot of Christ is a cyclamen with heart-shaped leaves, symbolic of love and devotion; and by his leg grows the primrose, symbolic of virtue. By St John's knee, an acanthus, traditionally placed on graves, was emblematic of the resurrection because of its speedy growth. Finally, in the ledges of the rocks, the hypericum or St John's wort, with its small dots of red on the yellow petals, was seen as representative of the blood of the martyred St John.[53] Once again Leonardo conveyed his message: Christ, the embodiment of the Holy Spirit, was born in a manger, suffered the passion, died and was resurrected for the salvation of the faithful. The flourishing of the plants offers hope for new life after death. And so the cycle is complete: from birth to death, from earth to flesh, and back again.

·········

When they saw Leonardo's central panel the Confraternity must have been amazed. Technically it was unsurpassed. But iconographically, too, it was revolutionary. For the first time in the history of western art Leonardo had visualised the theology of Mary's Immaculate Conception. From the minute petals of each flower to the rocky landscape, from the sensitive interplay of hand gesture and gazes to the naturalistic depictions of the human forms, Leonardo had created a masterpiece that explained the full

and subtle meaning of this Christian doctrine. The Confraternity would have been aware that here they were witnessing not only the Virgin's conception in the mind of God, but also the explanation for *why* her immaculacy was necessary. The neatness of the explanation, the compact visual description for something so complex, was brilliant.

Mysterious Disappearance

Only fragmentary evidence survives regarding the completion of Leonardo's first *Virgin of the Rocks*. A document does exist stating that the Confraternity had paid Leonardo and the de Predis brothers 730 of the 800 *Lire* originally agreed to for the entire decorative programme, however it is sadly damaged and the date is unrecognisable.[54]

No definitive mention of the painting appears in writing for about ten years. Plague ravaged Milan between 1484 and 1487.[55] The original members of the Confraternity were probably depleted. Then sometime between 1490 and 1495 another manuscript appeared. This was a letter signed by Giovanni Ambrogio de Predis and Leonardo da Vinci "the Florentine" and addressed directly to Ludovico Sforza.[56] It is a petition for additional funding. The painters claim that the 800 *Lire* originally agreed on was not enough: it had been entirely spent on materials, including gilding and the expensive ultramarine pigment, and there was not enough left over to pay Leonardo for his work on the central panel. They requested a further 1,200 *Lire* and a revaluation. A decade after the commission papers had been signed the altarpiece had still not reached its resting place in the chapel at San Francesco Grande; it seems that the parties involved had been wrangling over the painting's value without compromise for years. According to the de Predis and Leonardo in their letter, the Confraternity were still refusing to:

> "do anything with fairness, wishing as they do to value the [work] at only 25 ducats, [even though] it may be valued at 100 … They, [Leonardo and de Predis] humbly beseech Your Excellent Lordship that–seeing that the … [Confraternity] are not expert in such matters and that the blind cannot judge colours–[a final unbiased re-valuation] should be granted without further lapse of time … And [Leonardo and de Predis] believe that Your Lordship will be so minded and they commend themselves to You."[57]

The fact that the artists address themselves to Sforza directly suggests that the argument had reached boiling point. Their revaluation of the work at 100 *Ducats*, rather than the original 25, seems not to have been met

favourably by the Confraternity. The tone of the letter is abrasive to say the least. Perhaps to force a conclusion the painters hint that there is a buyer waiting in the wings who is willing to pay the full fee:

> "... this price of 100 *Ducats* has been offered by persons who wished to buy the said Our Lady: wherefore, the petitioners are constrained to have recourse to Your Lordship."[58]

The implication is that the artists will sell to the highest bidder if the Confraternity does not pay up. Apparently they are not prepared to wait any longer. The letter is overtly rude about the brotherhood–they "are not expert in such matters" and "the blind cannot judge colours" [59]–but flattering towards the Duke, suggesting that he has superior judgement and taste.

It seems that the Confraternity's money failed to materialize, but the mysterious competitor did. The identity of this buyer is still unknown. But it may well have been Ludovico Sforza himself. Only he would have had the finances and the political muscle to undermine the demands of a group of wealthy statesmen. [60] The letter of around 1490 is indicative of a growing rapport between Leonardo and Sforza. During the intervening years Leonardo had continued his quest to gain entry into inner court circles. Although we do not know the precise date at which Leonardo began working directly for Sforza, his paintings in the late 1480s and early 1490s attest to his social climbing and hint that he was already a court artist. In around 1485-90 he painted the gorgeous, wet-lipped *Musician* (Fig. 32), now at the Pinacoteca Ambrosiana, Milan. This might be the young Atalante Migliorotti whom he had brought from Florence bearing the golden lyre. Now a world-class performer, he must have frequented Sforza's court.[61] Or perhaps it was the musician and theorist Francesco Gaffurio (1451-1522), who had been given the prestigious post of choirmaster at Milan Cathedral in 1484.[62] By 1489-90 Leonardo had completed *Lady with an Ermine* (Fig. 33), a portrait of Cecilia Gallerani, the teenage mistress of Ludovico. By all accounts, Sforza was deeply in love with the young beauty, showering her with gifts and properties and continuing to visit her in her rooms in his *Castello* even after his marriage to Beatrice d'Este in 1491.[63] The painting is a sensual display of affection: with elegantly parted fingers she fondles an ermine at her breast, perhaps an allegory of her lover. [64] This painting in particular is proof that Leonardo was steadily moving closer to Sforza himself. The first stanza of a sonnet by Sforza's leading court poet at the time, Bernardo Bellincioni (1452-1492), celebrates this portrait and reaffirms the developing relationship between painter and ruler:

"Who stirs your wrath? Of whom are you envious,
Nature?
Of Vinci, who has portrayed one of your stars;
Cecelia, today so very beautiful, is she
Whose lovely eyes make the sun seem dark shadow.

The honour is yours, even if with his painting
It is he who makes her appear to listen and not to speak.
Think only that the more alive and beautiful she
remains–
The greater will be your glory–in every future age.

Give thanks therefore to Ludovico
And to the talent and the hand of Leonardo,
Who want to share her with those to come.

Everyone who sees her thus, though too late
To see her living, will say: this suffices for us
Now to understand what is nature and what art."[65]

Bellincioni's sentiment is hugely flattering towards Leonardo. Mentioning him by name in close succession to Sforza himself, the poet suggests that Leonardo's portrait of Cecilia rivals nature's own creations in its beauty. In fact the painted object is in some ways more valuable, since it will outlive the real woman. The poet also registers the significance of Leonardo's personal and unique touch–his "hand"–raising him above the status of craftsman to inspired creative. Bellincioni implies that Ludovico had commissioned the portrait from Leonardo, signifying Leonardo's dramatic rise in status. Perhaps this lay behind the artist's confident petition to Sforza for funds, the increasing value of *The Virgin of the Rocks* and of Leonardo's time.[66]

Sforza must have already been aware of the commission for the Confraternity of the Immaculate Conception. The brotherhood were, after all, members of his court. However, when the painters wrote to Ludovico directly in c.1490, his interest must have been aroused. Perhaps on receiving the request he demanded to see the painting for himself. *The Virgin of the Rocks* would have been brought to Sforza's chamber, swathed in fabric. Letting the cover slide to the floor to reveal the panel beneath, it would have been immediately apparent that this painting was in a different league from any work by Ludovico's Milanese artists. He could never before have witnessed such jewel-like detail as he saw in the leaves, or such magical and gloomy lighting.

Leonardo's painting would also have played to Sforza's famous Milanese fashion sense and his love of beautiful women. We can imagine the ruler's beady eye being instantly drawn to Mary's blue velvet cloak, the golden threaded neckline, the broach at her breast, the sling of golden silk tucked into her waistband; the angel's transparent sleeve and the glimpse of flesh beneath. He would have read the gestures and the cavernous landscape as laden with Christian symbolism. And, with a thrill of intellectual satisfaction, he must have recognized the symbolic meaning of the plant life.

There were other cultural references that Sforza alone would have noticed. Christ's twisting pose was reminiscent of a small Roman sculpture in marble, *Boy with a Goose* from the 3rd century BCE (Fig. 34), now at the Vatican Galleria dei Candelabri, Rome, which he would have seen when he visited the Medici collection in 1477. The presence of St John was also unusual. A patron saint of Florence, this must have been another reference to Leonardo's Florentine training and his connection to the "golden age" that was flourishing under the patronage of Lorenzo de' Medici.[67]

When he stood back to survey the whole composition Sforza must have been hooked since, as well as engaging his intellect and his sensual enjoyment, it would have appealed to his ego. Sforza must have realised that *he* was the fourth corner in the pyramidal composition. Standing before the painting he must have felt, if only for a second, that he was included in the circle of gazes; that he was standing in the presence of Christ. The forceful ruler, like the Confraternity and the de Predis before him, must have been convinced that Leonardo was indeed, as Vasari was later to proclaim, "marvellous and divinely inspired".[68]

Perhaps, having seen Leonardo's great masterpiece for himself, Sforza felt that no other artist would do for him. But in addition Sforza would have had a political use for the painting. He was, at this time, scheming; grooming his niece Bianca Maria (1472-1510) for an advantageous marriage to Maximilian I (1459-1519).[69] King of the Germans from 1486 and Holy Roman Emperor between 1508 and 1519, this prince was the most powerful man in Northern Europe and an avid collector of art.[70] *Portrait of Bianca Maria Sforza* by Ambrogio de Predis (Fig. 35) dates from c.1493 and is probably a betrothal portrait, showing the young girl in regal profile, swathed in velvet and adorned with pearls. The knot would be tied the following year. With Maximilian's protection, Sforza must have hoped to add another string to his bow and secure his power base in

Milan for years to come. A wedding present such as *The Virgin of the Rocks* would surely be favoured by such a ruler. It was, after all, an unrivalled creation by a Florentine Renaissance master. It would have shown respect but also act as propaganda, providing proof of Milan's cultural wealth. This, Sforza might say, was Bianca's rich heritage. The Sforza were a worthy match for any emperor. In 1493 Ambrogio de Predis is mentioned as being in Innsbruck at the court of Maximilian.[71] Perhaps he was delivering the painting personally. At any rate sometime between 1490 and 1494 the first *Virgin of the Rocks* was lost to the Confraternity forever.

PART 2

THE SECOND *VIRGIN OF THE ROCKS* C.1495-1499 (NATIONAL GALLERY, LONDON)

CHAPTER FOUR

A SECOND REVOLUTION IN PAINT

If the first *Virgin of the Rocks* was indeed bought by a mysterious third party, there is a clear explanation for why a second painting was needed. Leonardo was owed money and the Confraternity were waiting for their altarpiece. Yet the precise year in which Leonardo started work on his second *Virgin of the Rocks*, now at the National Gallery in London, is uncertain.

Conservation research undertaken by the National Gallery and published in 2011 shed new light on this question, as well as Leonardo's working process.[1] The panel was composed of four poplar panels[2] nailed together, the usual wood chosen for larger works probably because it was cheaper and wider than walnut wood timbers. The panels were assembled and then primed with gesso and glue to make a smooth ground on which to work.[3] Leonardo would have kept his original cartoon from the first *Virgin of the Rocks*, and could easily have used it for a second time. However, in 2011 an Infrared Reflectogram of the London panel revealed a fascinating, albeit short-lived, change in composition. Over the top of the gesso layer, painted with charcoal earth in a walnut oil binder, Leonardo added the outline for a *Virgin in Adoration* (Fig. 36).[4] With thick and fluid brush strokes he reworked Mary's pose in this underdrawing, positioning her higher. Her left arm is outstretched, she touches her breast with her right hand and she twists her head away from John and towards Christ. Her head is tilted, her lips slightly parted. She appears more dynamic than in the original version, even anguished. Over this monochrome outline Leonardo then applied the first *imprimatura*, a wash of lead white and some black pigment mixed together to cover the entire panel.[5] As it dried, the underdrawing would have shown through as a faint line to follow.

This alternative composition is interesting because it offers a clue to the dating of the second *Virgin of the Rocks*. Between 1496 and 1498 Leonardo was working on *The Last Supper* for Ludovico Sforza. A few years previously he drew a preparatory study for St Phillip, who would stand to the left of Christ in the mural. This red chalk drawing, *Head of a*

Youth of c.1491-3 (Fig. 37) in the Royal Collection at Windsor,[6] depicts a boy with his head tilted and lips parted as if in intense concentration. In the completed wall painting his hands touch his breast in distress. On close inspection, the features of St Philip are almost identical to Leonardo's second Madonna, although in reverse, and the hand gestures are very alike.[7] It seems Leonardo used the St Philip cartoon as the basis for both figures, suggesting that he started work on the second *Virgin of the Rocks* around the same time as his *Last Supper,* in the mid-1490s.

However, for reasons unknown, Leonardo thought better of the new design. Perhaps he feared the displeasure of the Confraternity. He washed over the first *imprimatura* with a second layer of creamy-grey priming to erase the design before making a second underdrawing closer to the composition of the original *Virgin of the Rocks*.[8] Leonardo did however make subtle changes to the composition at this point. He shifted the face of Christ to a regal profile, he removed the pointing finger of the angel, and he closed the roof of the cave so that much less sky is visible. He also readjusted the proportions of the angel's body, shortening his neck and aligning it with his spine. He turned his gaze inward so that he no longer engages with the viewer. He reworked the proportions of Mary's body so that her frame was bulkier: her shoulders became wider, her hips and knees more defined and visible beneath the fabric of her skirts.[9] He did away with the realism of the plant species in the first version in favour of idealized blooms, and simplified the rock formations.[10] Then with regular, broad strokes of the brush he fixed this final composition on the yellowy ground, which shows up on the X-ray as fine black particles in a brownish matrix.[11]

Having laid down these changes in his second underdrawing Leonardo added a further paint layer in lead-tin yellow. Then, when this preparation was dry, he worked it up with a monochrome wash, merging the outlines seamlessly with a translucent, dark brown Cassel earth. Still basing his method on the processes learnt from Verrocchio's Florentine workshop, Leonardo used these washes to form the basis of his tonal modelling.[12] It was at this point that his figures began to take on their sculptural form.

It seems Leonardo barely waited for this underdrawing to dry before starting to paint again. The brown glaze is drawn up into the paint layer above, as if only partly set when the next layers were applied.[13] He built up glazes of flesh colour on the bodies of the children, adding black pigment for the shadows and creating the highlights by thinning the top layer carefully to allow the light underlayer to show through.[14] This was a

fairly speedy process of tonal modelling, but allowed enough variation that their muscles appear to ripple beneath the skin.

In the first painting each part of the composition had been given equal weight in terms of detail, from each unique flower petal to the children's curls and the rocks in the background. But in the second painting Leonardo's short-hand, almost summary, modelling of the infants and the landscape would have left him more time to spend on the important focal points: the faces of Mary and the angel. In a manner perhaps truer to the experience of human vision itself, the periphery of the composition is less finished, the shrubbery behind St John even appearing blurred, while the central characters are now more crisply defined.

For Mary's robe Leonardo first applied a mid-tone of pure azurite blue mixed with lead white over the underdrawing.[15] This is a copper-based pigment that was mined in France and would have been brought to Milan by German traders.[16] The Confraternity had specified in the contract that Leonardo was to use the more expensive semi-precious ultramarine but, perhaps because funds were tight at this time, Leonardo decided on the cheaper option. Once the blue was dry he applied thin glazes of blackish paint for the shadows to show, for example, the curve of Mary's shoulder and the folds of material under her knees. Mixed with walnut oil, this darker paint was translucent, allowing the blue to show through from underneath. Yet, where Leonardo built up a number of these dark glazes, the blue sinks deeper into shadow until, in some sections, the original colour becomes almost invisible. This suppression of colour in areas of shadow was original. In the first *Virgin of the Rocks* Mary's cloak never completely lost its rich blue mid-tone, and the angel's mantle retained its vibrant red. But in the second painting Leonardo put into practice his new understanding of the behaviour of colour in areas of limited light. He wrote later on this subject:

"All colours placed in shady locations appear of equal darkness beside each other ... Just as all colours are tinged with the darkness of the shadows of night, so the shadow of any colour ends in that darkness ... colours situated in shadow show less variety amongst each other ..."[17]

So, in the second painting, the blue of Mary's cloak and the red of the angel's mantle become indistinguishable as they sink into the darkness.

More than ever before, it seems, Leonardo was bent on translating a scientific understanding of reality into paint. The process he used to depict light and shadow was, in fact, intended to mimic the behaviour of light in

the real world. There is a single light source coming from the top left of the panel, as if the light in the chapel itself were illuminating the figures within the painting. This light appears to touch the flank of the kneeling St John, the forehead of the Virgin, the tips of her pearly fingers, the front of Christ's shoulder. Coupled with the suppression of colour in the areas of shadow the result is a "tonal unity", a unification of space through light.

And just as the intensity of light increases from the outer region of a lit body towards a spotlight, so the building up of translucent glazes created a gradually increasing density of white pigment, emphasizing the highlights on the faces of Mary and the angel. In addition to the areas of dense black pigment, this created a heightened *chiaroscuro* in the second painting: the contrast between areas of dark and light is far more exaggerated than in the first version. The effect is similar to turning up the contrast on a digital camera. Leonardo made his intentions clear in this respect too: "From this intensification of light and shade the face gains greatly in relief … and in beauty." [18] As a result, Mary's face seems to glow out of the inky background. Her form appears as if carved and moulded in light giving her a new sense of monumentality. She appears more radiant, with a lunar perfection. Yet what she gains in pearly idealism she loses in softness. She is now flawless, but marble-cold.

By 1499 Leonardo had probably completed the majority of his second *Virgin of the Rocks*.[19] In that year Ludovico Sforza was ousted from power in Milan and Leonardo was forced to flee,[20] leaving the panel with the Confraternity. If this dating is accurate, sixteen years had passed since the first painting had been commissioned. It is very unlikely that Leonardo ever saw his two Virgins side by side. But if he had, he would have appreciated the startling changes in technique and style that had taken place over those intervening years. His new mastery of oil paint, his developed *chiaroscuro* and tonal unity, as well as his subtle shifts in composition, had led to a profound alteration in the mood of his second masterpiece. Leonardo's artistic maturation must be partly responsible. Yet a more complex set of circumstances lay behind this transformation.

CHAPTER FIVE

LEONARDO'S PERSONAL DEVELOPMENT: PASSIONS OF BODY AND SOUL

In the second painting the atmosphere seems changed: the air is stiller and more intense. There is a new sobriety, a sadness and sense of drama. The tone is more in keeping, in fact, with the religious narrative, a story of sacrifice. According to Fra Stefano Oleggio at the Church of San Francesco Grande,[1] the Immaculate Conception of Mary was the starting point in an inexorable life cycle; a plan in the mind of God that would involve the premature death of her only son. Without the distraction of the angel's pointing finger the viewer's eyes are drawn with a new magnetism to the wistful faces. St John seems to creep closer to Mary's side and the angel crouches lower, creating a more compact and intimate grouping. With the angel no longer looking outward the circle of communication between the figures is closed, intensifying their connection. In the first painting they were like self-conscious actors in a drama staged for the viewer. Here, however, we may observe, but not participate in, a private moment.

In the first painting, Mary's half-smile alluded to a sadness that was tinged with resignation. Wrapped in a softer, yellowy light and modelled with a narrower tonal range, she seemed shielded from the poignant reality. But in the second painting the cold, white light is uncompromising. Mary's solemn expression is magnified by her pallor and the shadows beneath her eyes. Her downcast gaze suggests introversion, as if she is painfully aware of her son's fate. The exaggerated *chiaroscuro* creates a monumentality and physical weightiness that also suggests a heaviness of heart. And by closing the gap at the top of the cave Leonardo was able to submerge the figures in shadow, creating a space that is both oppressive and charged.

.........

By 1499 Leonardo had developed an intense psychological naturalism in his painting. This was a conscious aim and can be understood as part of a

broader scientific project to comprehend the human being in all its wonderful complexity. In the early 1490s he writes of his longing to understand the interior world and essence of man: "... would that ... I were able to reveal the nature of man ... even as I describe his figure."[2] Later he came to realize that it was his artist's ability to capture and "describe" the outward appearance of the body that would allow him to do just that, since, he explains, "a figure ... expresses through his actions the passions of his mind."[3] But his profound personal development during those crucial years of 1490 to 1499 must also have contributed to the new poignancy in his second *Virgin of the Rocks*.

Love and Loss at the *Corte Vecchio*

Leonardo's lifestyle and circle of friends underwent a shift once he had become established in the court of Ludovico Sforza. In the early 1490s he moved into the *Corte Vecchio*, the grand yet dilapidated "Old Palace" in the very centre of the city.[4] On the south side of the *Duomo* piazza where the *Palazzo Reale* now stands, the *Corte Vecchio* had been the power centre of the Visconti dynasty until Sforza relocated to his immense red stone *Castello* to the north west of the city walls. We might imagine Leonardo as part of a large entourage riding through the cobbled streets of Milan towards his new home. But this time he must have been leading the procession. Now in his late thirties, he was no longer a hopeful young man with everything to prove but a respected court artist.

Leonardo may initially have had to share the palace with Sforza's nephew, Gian Galeazzo, but it seems that he nevertheless had the run of the place. Contemporary literature suggests that his tenancy was closely associated with his production of the great equestrian monument for Sforza. *Studies for casting an equestrian monument* (Fig. 38) and *A study for an equestrian monument,* c.1485-90 (Fig. 39) appear in Leonardo's notebooks at this time[5] and the court poet Baldassare Taccone wrote in around 1493: "See in the Corte how he [Ludovico] is having a great colossus out of metal in memory of his father."[6] Such a generous space would also allow Leonardo to indulge his larger projects, including plans for a flying machine that he hoped to launch from the roof of the *Corte Vecchio*.[7] At Windsor, on the same sheet of paper as Leonardo's musical picture puzzles, is a drawing of a ground plan that may well relate to the now-lost old palace. The measurements of the large ballroom, 127 paces long and 27 *braccia* wide, are particularly impressive; the equivalent to 300 feet long and 50 feet wide.[8] Such a space could certainly have housed

the models for Leonardo's huge bronze horse as well as other large-scale designs for the Duke.

The *Corte Vecchio* consisted of two courtyards surrounded by a moat.[9] From the battlements the views would have seemed endless. Far below in the *Duomo's* vast piazza, citizens scuttled about their business. Beyond that, the city walls contained a heaving mass of shops and residences. And beyond those walls were the mountains, hazy in the sun, melting into the horizon. The impassioned words of the young Leonardo seem to hang in the air:

> "Lying in a feather bed will not bring you fame, nor staying beneath the quilt, and he who uses up his life without achieving fame leaves no more vestige of himself on earth than smoke in the air or foam upon the water."[10]

But could Leonardo have imagined, as an illegitimate boy running errands in Verrocchio's workshop, that he would rise to such heights? The stringent guild regulations and saturated art market that restricted him in Florence were gone. The panoramic view, the open space spreading before him, must have brought home the reality of his newfound creative freedom and the seemingly limitless possibilities.[11]

In 1490 Leonardo's workshop at the *Corte Vecchio* would have swung into action. He probably kept the same suppliers for his equipment: the apothecary for the pure rock pigment. We can imagine him organising a rota for the kitchen, the buying of meat and pasta, setting up a standing order for kindling and wax for candles. He needed to be meticulously organized. He was running a fast-expanding *fabbrica* (factory) of artists and had many mouths to feed.[12]

In the far wing of the palace there would have been space for each apprentice-associate to have his own study or *studiolo*. Giovanni Antonio Boltraffio (born c. 1467) and Marco d' Oggiono, young Milanese artists who had been attracted by Leonardo's success, joined the *fabbrica* sometime between 1490 and 1492. They collaborated closely and, often working from Leonardo's own designs, whipped up paintings in the style of their master.[13] These would have been sold for relatively little to satisfy the growing demand for "a Leonardo" among the Milanese nobility. The young Francesco Galli from Naples joined them soon after the move and Tomasso di Giovanni Masini, known as Zoroastro, a metalworker and friend from Leonardo's Florentine days, re-joined the group in around 1492-93.[14]

In the far wing of the palace there would have been space for each
Zoroastro would have arrived in time to help with the casting of the

grand equestrian monument that was preoccupying Leonardo. A memorial to Ludovico's father, Francesco, it was to be the largest horse ever created using the lost-wax bronze casting method. Leonardo's Madrid notebook, dating from between 1491 and 1493, records the full-size clay model as measuring 12 *braccia* from hoof to head and about 24 feet high (three times life-size) and weighing 100 *meira* or about 75 tons.[15] This immense horse was a logistical and engineering feat on an industrial scale.

On the 18th of March 1493 Leonardo lists in his accounts several further additions to his household: Bartolomeo (probably Bartolomeo Suardi), the follower of Bramante known as Bramantino, Antonio, Piero, Leonardo, and a German, Giulio, a metal worker who would support Zoroastro. By the later 1490s a stream of new apprentices joined the fray: Galleazo, Benedetto, Loditti, Gianmaria and Gianpietro (probably Giovanni Pietro Rizzoli).[16] They were the cogs within this large business enterprise. Each had his specialism, his tasks and responsibilities. Together their work would form the core of the stock production of Leonardo's successful factory.

These men formed a close community. Living, working and eating together, probably in a similar manner to those in Verrocchio's workshop in Florence, this was a place where deep and lasting friendships were forged. Leonardo now had his own young apprentices to train in the art of *disegno*. Like Verrocchio, he inspired loyalty. He writes in his accounts in 1492 that Zoroastro "returns" to Milan, and in fact Zoroastro may well have been apprenticed to the young *maestro* in Florence as early as 1478. He is mentioned in a poem dedicated to Leonardo in 1496-8, and would work as Leonardo's *garzone* for his mural of *The Battle of Anghiari* as late as c.1506 when they returned briefly to Florence together.[17] Theirs was an association for life. At the *Corte Vecchio* the men and boys would have woken at dawn to make the most of the natural daylight, breakfasting together in front of the fire for warmth. Leonardo lists the items of household equipment: each had a pewter bowl and a place at the long oak table.[18] Leonardo's *fabbrica* must have been an environment of mutual respect and productive partnerships.

During the years 1490-99, Leonardo also embarked on what would be the longest and perhaps the most intense relationship of his adult life. On 22nd July 1490, St Magdalene's day, at the age of thirty-seven, he adopted the unruly ten-year-old, Giacomo Caprotti (1480-c.1524).[19] He would be a pupil, a dogsbody, and probably later a lover. He was known fondly by Leonardo as his "Salai", his "devil child".

The list of Salai's misdemeanours during the first year at the *Corte Vecchio* is the longest description of another person's activities in all of Leonardo's writing. He seems frustrated and bemused, but also rather smitten by the boy's impish behaviour. The narrative begins:

> "On the second day I had two chemises cut out for him, a pair of hose and a doublet, and when I put to one side the money to pay for these things, he stole it out of my purse, and it was never possible to make him confess to it, although I was quite certain of the fact.

> The following day I went to dinner with Giacomo Andrea and ... [Salai] ate enough for two and misbehaved for four, for he broke three cruets, spilled wine and after this came over to eat ...

> On 7th September he stole a pen worth 22 *Soldi* from Marco who was living with me. It was a silverpoint pen, and he took it from [Marco's] studio, and after Marco had searched all over for it, he found it in ... [Salai's] chest.

> Also when I was presented by Maestro Agostino da Pavia ... with a Turkish hide with which to make a pair of ankle boots, [Salai] stole it from me within a month and sold it to a cobbler for 20 *Soldi* with which money, according to his own confession, he bought aniseed sweets."[20]

In the margin Leonardo sums up the expenses the boy has amassed as well as an assessment of his behaviour so far: "thief, liar, obstinate, glutton".[21] Salai it seems, steals, wilfully misplaces equipment, wastes money on sweets and is generally a nuisance. Yet Leonardo continued to lavish him with gifts and clothes. The boy was at his side when he went to dinner with friends and was fed from the same table. Seven years after Salai's arrival at the *Corte Vecchio*, the usually frugal Leonardo was still splashing out on luxurious clothes for the handsome teenager. On 4th April 1497 he lists the makings of a gorgeous cloak under the title, "Salaino expenses": "4 *Braccia* of silver cloth; green velvet for the trim; ribbons; small rings".[22] After totting up these expenses he notes: "Salai stole the *Soldi*". We can imagine Salai as a rather grasping young man of seventeen: a young devil with a beautiful face.

According to Vasari, Salai was "a very attractive youth of unusual grace and looks, with beautiful hair which he wore curled in ringlets and which delighted his master".[23] Leonardo, it seems, was smitten. There is a drawing at Windsor, *The head of a youth in profile* of c.1510 (Fig. 40) in red and black chalk,[24] presumed to be Salai, with luscious pouting lips, softly curling hair, and a hint of mischief about the eyes. We might

imagine him waiting just long enough for Leonardo to capture the silhouette of his pretty face before darting out of the studio, through the ballroom, knocking over the maquettes as he went.

As Salai grew into a selfish and rather spoilt young man, there are records that suggest moments of tension and heartbreak. In the pages of the *Codex Atlanticus* of c.1508, in another's hand as if overhearing an argument, are written the words: "Salai, I want to rest, so no wars, no more wars, because I surrender."[25] During the years that Leonardo was painting his second *Virgin of the Rocks* he was absorbed in a relationship that was probably fraught yet deeply felt.

In 1493, another character appeared on the scene. Leonardo introduces her in his account book:

"On the 16th day of July.
Caterina came on the 16th day
Of July 1493."[26]

It has been suggested that this note signalled the arrival of Leonardo's mother,[27] a woman whom he had never before mentioned in his notebooks, and from whom he had probably been estranged since his early childhood. The rest we must imagine, since he never mentions her again. At the *Corte Vecchio* she would have been another mouth to feed, another chair at the kitchen table, another seat by the fire. When only two years later, in 1495, Caterina died, Leonardo paid the funeral expenses.[28] He must have met with the stark reality of his own mortality. Poignantly, the date of her death coincided with the period in which Leonardo started his second *Virgin of the Rocks*, a painting about the relationship between a mother and son.

So this was Leonardo's *fabbrica*: a commune, a school of artists working closely together like a family, a place where friendships were forged. It was here that he played the part of father, son, mentor, brother, and perhaps even lover.

Revealing the "Nature of Man"

These relationships must have found their way into Leonardo's drawings. As Vasari noted, Leonardo was so interested in the expressive potential of the human face that when he saw someone with a particularly unusual physiognomy he was

"capable of following them for an entire day so as to impress their features on his mind to then draw them from memory."[29]

A Man Tricked by Gypsies from 1490-93 (Fig. 41), a pen and ink drawing held by the Royal Collection Trust,[30] illustrates the link made by Leonardo between physiognomy and personality. Five men are huddled in a circle, one with protruding lower lip and puffy jowls, another with a hooked and bulbous nose, another has a gaping hole of a mouth and seems to scream with terrifying laughter; in each case the exaggerated features imply a moral decrepitude.[31] Leonardo was clearly fascinated by the expressive potential of the human face. And Vasari underscores the artist's unstoppable urge to observe his subjects, in context and through time. He must also have recorded the activities and interactions of his household: the sleepy rolling of their shoulders towards the fire in the mornings, their silent chewing, their limbs unfolding; and conversation during the evening meal, animated from their work, sometimes argumentative, sometimes thoughtful.

Since his Florentine days Leonardo had been in the habit of observing groups of people. In a *Study of male figures* (Fig. 42) in pen and ink over metalpoint from those years (c.1480), now held at the Louvre,[32] we see just such a scene around the dining table. The dry scratch of Leonardo's pen on the paper and the simplification of the feet and hands to single lines attest to the speed at which he was working: it is a snapshot, an intimate moment caught in a few seconds. It is easy to transpose this scene, perhaps observed from Verrocchio's studio, to Leonardo's own household in Milan.

On the left of the page sit a group of three men at a table. The third along–perhaps this is Marco–grips the hand of his bearded companion– perhaps Zoroastro. He forces his arm down onto the table, palm upwards, while with his left hand and with his brow furrowed in anger he points accusingly towards the third figure. The men lean in, closing the space between them, engrossed. Perhaps Salai has been causing mischief again; we know from Leonardo's notes that he was in trouble for stealing Marco's favourite silverpoint in 1490.[33] We can imagine Marco's words: *"If it wasn't Zoroastro, then it must have been you. Show me your hands!"* A younger man skids to a standstill to the right, hoping to diffuse the argument. *"It's OK! I've found it!"*

Leonardo sits outside this scene, apart from the action. He is unobtrusive, unobserved. But he was clearly absorbed by their

interchange. He writes in the early 1490s: in "action" and "movement" we see the "passion of [the] soul ... the mental state of the figure."[34] This expression of the mind–the internal–through the external physical appearance and actions of the body, is something that increasingly preoccupied Leonardo during his years in Milan. It was a subject that he dwelt on in his notebooks, and it was a central theme in a huge tome that he conceived in late 1489. This was a book that he intended to call *On the Human Form*. It was to be an immense project in which he set out to understand not just the anatomy and physiology of the human body, but how all the parts work in synergy to produce and express emotional experience.

On a sheet of drawings of *The muscles and nerves of the leg and head* from around 1490, we find diagrams that illustrate his understanding of the mind: *Vertical and Horizontal Sections of the Head to Show the Ventricles* (Fig. 43).[35] Over one hundred years before Descartes, Leonardo was attempting to explain the physiological mechanisms of a mind-body connection. In the lower half of the page is a cross-section of the head, a theoretical diagram owing much to Aristotle, mediated by medieval literature–by this time Leonardo may have owned a copy of the thirteenth century philosopher-theologian Albertus Magnus' *Philosophia naturalis* from which this idea is borrowed.[36] In the central void of the skull Leonardo draws three ventricles. The first, closest to the eyes, is the *"imprensiva"* and *"intelleto"* or "intellect". This was the receptor of impressions, the processor of sensory experience from the eyes and the rest of the body. According to Leonardo's diagram, these messages travel via the central ventricle, the *"sensus communis"*, the coordinator of sensory information, and finally on to be stored in the third, *"memoria"* or "memory".[37] The central ventricle, he explains, is the location of the soul:

> "The soul apparently resides in the region of judgment, and the region of judgment is to be located where all the senses run together, which is called the *sensus communis* ..."[38]

Leonardo believed that the soul could be located at the centre of the brain, an administrative hub receiving information from the rest of the body. Interestingly, there seems to be a clear parallel made between the soul's governing of bodily territory and the Duke's control and governance of Milan from his *Castello*.[39] For Leonardo, the body was a microcosm of the socio-political sphere. But, in turn, the soul or *sensus communis* might

be seen as a microcosm of the body. The "soul", as he argued, was fed by physical–bodily–impulses and *vice versa*. As Leonardo wrote, "all our knowledge has its foundation in our sensations".[40] The external impression of the world was imprinted on the body via the senses, which in turn informed the soul. Conversely, the dynamics of the soul (or the emotional experience of a person) were reflected on the external and physical appearance and movement of that person's body.

Of course Leonardo had reached an impasse with his diagram of the sectioned brain ventricles. He was clearly convinced of the existence of a mind-body connection, but could not prove it. Perhaps it was at this point that Leonardo was forced back to studying external expression in order to understand an unfathomable inner world. It was to be through his development of psychological naturalism in the visual art of painting that Leonardo would capture most truthfully the moments when the "soul" is laid bare.

·········

The painting that most famously shows Leonardo exploring the expression of emotion through physical gesture is his *Last Supper* of the mid-1490s (Fig. 44). The fleeting *Study of male figures* (c.1480-1), although painted about fifteen years earlier, might be thought of as an early preparatory drawing for this vast mural in the refectory of the convent of Santa Maria delle Grazie, Milan, for Ludovico Sforza. The finished painting depicts Jesus and his twelve disciples seated at their long dinner table sharing a meal. This is a Christian iconography that had been repeated countless times in Western art. Leonardo would have known Giotto's version, begun in c.1305, in the Scrovegni Chapel in Padua (Fig. 45), and Ghirlandaio's in the refectory of Ognissanti in Florence (Fig. 46), completed just before he left for Milan. Both have a calm stillness about them; the apostles seem to inhabit their own isolated worlds.

But Leonardo decided to do something radical. He chose a moment of *action* for his painting. The scene that we see in Sforza's monastery captures the split second after Jesus speaks those terrible words, "One among you will betray me" (Matthew 26:21-2). Leonardo had chosen this moment precisely because it allowed him to depict human emotion in a way that had never before been attempted.[41] The apostles appear horrified by Jesus' words. We can imagine their thoughts: *"How is it possible? Could they–his best friends–have committed Christ to certain death?"* As we look along the table, the range of feeling conveyed through facial

expression, body language and gesture is astonishing. On the far left Bartholomew leaps to his feet, leaning forward as if in shocked surprise. We can almost hear the thud of his palms on the tabletop. *"Did he hear correctly?"* James the Greater spreads his arms, furrowed brow and parted lips indicating a sense of appalled horror. On the far right, Matthew, half standing, gestures towards Christ while looking back to his companions with alarm. *"Did you know this was going to happen?"* Third to the right of Jesus, Philip, hunched over, head tilted, touches his breast with both hands. The sadness he feels appears to pain him to the core. And Judas, seated third from the left of Christ, pulls back guiltily from his companions. Grouped into threes, the men act and react to one another, their hands moving expressively. Against the backdrop of the static architectural setting their fluid movements leap into life.

It was during this period that Leonardo was starting work on his second *Virgin of the Rocks*. The fact that these two major works coincided is corroborated by the hidden underdrawing, rediscovered by the National Gallery in 2005 and confirmed in 2011.[42] We now know that around 1495 Leonardo reimagined the composition for the Confraternity, basing Mary's pose on that of St Philip in the *Last Supper*.[43] Raising Mary higher on her knees, tilting her head to the side, lifting her arms, he seems to have wanted to increase the intensity of her expression. In duplicating Philip's pose in Mary's, Leonardo was also exploring a parallel between their emotional states. Philip was anticipating the death of his best friend whilst Mary also foresees bereavement. Perhaps these sentiments chimed with Leonardo after the death of his mother that same year.

In the end Leonardo was not able to use his cartoon of Philip for the Virgin. And the result is probably less dramatic, less overtly expressive, than he initially intended. But he managed to create a new intensity of mood using other, more subtle, changes in composition, lighting and modelling. In some ways the quiet, self-contained nature of this scene is more charged than the *Last Supper*, with all its moving parts. Its simplicity strikes a more personal chord. While *The Last Supper* was a large-scale commission, *The Virgin of the Rocks* could be a more private exploration of a subject that was close to his own heart.

It was not until 1511, three years after the final completion of the second *Virgin of the Rocks*, and sixteen years after his mother's death, that Leonardo referred in writing to the intense emotional connection that he believed existed between parent and child. Below a diagram of a *Foetus, curled in the mother's womb* (Fig. 47),[44] he writes:

"The child ... receives life and is nourished from the life and food of the mother ... And a single soul governs these two bodies, and the desires and fears and pains are common to this creature as to all other animated parts. From this it arises that the thing desired by the mother is often found imprinted on those parts of the infant that have the same qualities in the mother at the time of her desire; and a sudden terror kills both mother and child. Therefore one concludes that the same soul governs and nourishes both bodies."[45]

Leonardo apparently felt sure that there was a bond that starts at the beginning of life itself, shaped during the growth of the child within the mother's womb. He implies that the *physical* connection, the sharing of food, generates an attachment or bond of the "soul", as he puts it. This is a bond so close that mother and child become, in effect, one: "a single soul". And because of this, their empathy for one another can be penetrating, fears and pains simply transferring, as if by osmosis, between the two: the terror of one might result in the death of both.

Yet when he wrote these words Leonardo had never seen a human foetus.[46] And even if he had, his anatomical research would never have provided proof for the root of this emotional connection. Leonardo's written notes record beliefs, extrapolations from his observation of parents and children; they must, to some extent, also express *his* experiences in love and loss.

·········

The realm of psychology was one that Leonardo would only ever discover through the science of his art, and never would he express it with more painful clarity than in his second *Virgin of the Rocks*. This painting acted as a catalyst for the development of a theory of mind that he would only put into words years later. With the second *Virgin of the Rocks*, Leonardo had succeeded in revealing "the nature of man" through the visual description of the human form. Perhaps more powerfully than ever before, or ever again, he had depicted on the painted surface the inner workings of the mind.

CHAPTER SIX

SCIENTIFIC RESEARCH:
THE MAGICIAN ALCHEMIST

One of the reasons why Leonardo's second Madonna evokes a more powerful response in the viewer is that she appears physically more realistic. In the first painting her hips and chest are connected by a serpentine line; she seems almost to be boneless. In the second there is a new sense of the bone structure beneath her skin, the architecture of her skeleton and the way her limbs hinge are more readable. She has a new anatomical naturalism.

In 1489, having already completed the first *Virgin of the Rocks*, Leonardo started to research human anatomy and physiology in a manner never before attempted by artists or medical professionals. His diagrams of the womb and his drawings of the ventricles of the brain were not isolated studies. They were part of an immense scientific project that unfolded during the same years in which he was working on the second *Virgin of the Rocks*. His first studies date to the late 1480s. By 1490, the year he set up his *fabbrica* in Milan, the scope of Leonardo's research had broadened and his resolve strengthened. He intended to publish his findings as a book, *On the Human Form*.

This interest stemmed partly from a realization that it would improve his artistic practice, and was probably central to the curriculum of his apprentices. Indeed, his writing style is like a manual for others to follow.[1] Beneath an anatomical drawing of the nerves of the shoulder and neck he writes later that

> "[a thorough understanding of anatomy] is as necessary to good draughtsmen as is the origin of words from Latin to good grammarians."[2]

However, this project was also an expression of a scientist's fascination with the mechanisms of the human body. In the introduction to his projected publication he explains the extensive nature of his plans. He would start with an analysis of the womb, and the growth of the child.

After that he would:

> "[d]escribe the grown man and woman, and their measurements, and the
> nature of their complexion, colour and physiognomy. Then how they are
> composed of veins, nerves, muscle and bones … Then in four drawings
> you will depict four universal conditions of man, that is: joy, with different
> ways of laughing. And draw the cause of laughter; weeping in different
> ways, with their causes; fighting, with the different movements of killing;
> flight, fear, ferocity, boldness, murder … Then draw labour, with pulling,
> pushing, carrying, stopping, supporting and similar things … Then describe
> attitudes and movement." [3]

So from the inside out he was intending to map the anatomy, physiology,
and appearance of the human being. Today around 5000 manuscript pages
are known to be by Leonardo, many of which relate to this project, an
unparalleled output by any artist of that period.[4]

Leonardo's interest in anatomy had its roots in Florence. In
Verrocchio's workshop, studies from life were a core part of the
apprentice's curriculum. Antonio del Pollaiuolo, from whom Leonardo
probably learnt his oil technique, had researched the human form, possibly
from dissections, in preparation for his engraving of the *Battle of the Nude
Men* (c.1465-1475). Leonardo may even have known Antonio Benivieni
(1443-1502), a friend of Lorenzo de' Medici's and a physician who
dissected the corpses of criminals after execution.[5]

Yet at this time dissection was a fairly unorthodox practice even in the
training of medical professionals. [6] Empirical observation was not
considered primarily useful, rather students still followed medieval texts.
Leonardo's intended research was also impractical.[7] Dissecting human
remains was unhygienic. There were no freezers, no fridges, and therefore
no clean way to store cadavers. Bodies would have started to smell within
a few days after death, and then to rot. There were no fixatives to harden
the tissues so that a limb could be sawn yet retain its shape. Dissection
would not have been possible in the heat of the summer, and would have
needed privacy. This was not feasible in Florence, where Leonardo was
probably living in relatively cramped workshop conditions. His diagrams
from his early attempts at dissection, dating from the mid-1480s in Milan,
show how the viscera–the entrails, heart, spleen, lungs and intestines–spilt
out across the dissection table.[8] The gruesomeness of these experiments
should not be underestimated. Leonardo writes in c.1508:

> "Though you may have a love for such things, you will perhaps be
> impeded by your stomach; and if this does not impede you, you will

perhaps be impeded by the fear of living through the night hours in the company of quartered and flayed corpses, fearful to behold."[9]

In order to undertake this work Leonardo needed privacy, protection, and uninterrupted time. It was only once he had completed the first *Virgin of the Rocks* in the mid 1480s and received the full support of Ludovico Sforza that he was able to start his ambitious project. In the spacious rooms of his *Corte Vecchio*, with his factory of apprentices and associates hard at work, Leonardo began his research in earnest. He was probably assisted in this project by his long-standing and trusted associate, Zoroastro. Publicly Zoroastro was working on plans to cast Leonardo's enormous equestrian monument in bronze. But he must also have made the tools of dissection. Leonardo drew these knives in around 1508-10, neatly laid out in a row: five blades with terrifying hooked ends varying in size from bone-crunching to fine-toothed and delicate.[10] We can imagine the chink of hammer on metal and the hiss of the kiln's furnace, and then the sharpening and filing of the blades in his private room in the castle. A contemporary witness later described Zoroastro's extraordinary workshop:

"In the middle of the room there is a large table cluttered with pots and flasks of all sorts, and paste and clay and Greek pitch and cinnabar, and the teeth of a hanged man, and roots. There is a plinth made of sulphur ... and on this stands a vessel of yellow amber, empty except for a serpent with four legs, which we take for a miracle."[11]

This was the lair of a magician alchemist, and it is the setting in which we might imagine Leonardo's clandestine activities. Here he started to delve into the origins of life itself.

Muscle and Bone

Leonardo's first dissections, dating from 1485 to 1490, were of animals: bears' feet and the arms of monkeys,[12] perhaps taken from Zoroastro's collection of exotic creatures. On a drawing from that time he records his analysis of a frog:

"The frog dies instantly when its spinal medulla is perforated. And previously it lived without head, without heart or any internal organs, or intestines or skin. Here therefore it appears lies the foundation of movement and life."[13]

Here, Leonardo's clinical detachment becomes apparent in his willingness to experiment upon a live animal in order to undertake a systematic, fair

test. He writes his observations around a drawing of the frog's vertebrae, the text exploding out on either side like the viscera of the animal, ideas tumbling onto the page.[14]

More useful when it came to painting *The Virgin of the Rocks*, because of its similarity to the human body, was a monkey. Sometime between 1485 and 1490, Leonardo recorded his progress on another sheet of manuscript in the Windsor Collection, *Studies of the nervous system* (Fig. 48).[15] Peeling off the flesh, he locates the muscle fibres that attach to the neck and ribs. He examines the pathway of nerves from the spine down the arm. He depicts the muscles on the surface of the limb and how they knit across the shoulder and elbow. The arm stretches outwards, like that of *The Virgin of the Rocks*. Finally, removing the flesh altogether, he records the skeleton of the hand with five fingers: the rounded ends of the radius, ulna, metacarpals and phalanges identified and labelled one by one. In a diagram of the structures of the neck he shows the lattice of muscles and nerves that join the lower jaw and collarbone. Although not wholly accurate at this stage, Leonardo's approach was highly detailed. Arranging the diagrams of the upper body at different stages of "undress", he was clearly fascinated by the architecture of the muscles and bones beneath the skin and how this shaped the visible, exterior, form of the body.

In these diagrams of the monkey's arm and neck, the shoulder and hand, Leonardo was exploring parts of the body that are exposed in the *Virgin of the Rocks*, allowing him to render them with new naturalism in the second painting. His developed understanding is evident in Mary's bulky right shoulder, the hollow at her throat, and the distinct knuckles of her hand as she reaches out towards the viewer. In the first painting the angel's spine appeared broken, with his head placed at an awkwardly high angle above his back. In the second painting his shoulder, neck and head are aligned, suggesting a better understanding of the supportive function of the spine.

Beyond the dissection of animals there is evidence that Leonardo was able to study human anatomy in the late 1480s and early 1490s. Milan had no medical school at this time, but he could have sourced his subjects from the many hospitals in the city. The Ospedale Maggiore, one of the largest hospitals in Europe, was under the patronage of Ludovico Sforza, making it very likely that Leonardo would have been allowed access. In about 1495 Leonardo writes on a sheet of manuscript:

"I have lifted off the muscle *a n* [*Sartorius*] … and I have uncovered *r t*

[*rectus femoris*]. Now attend to what lies below *m o* [*vastus lateralis*]."[16]

This note, accompanying a diagram of *Cross-sections of the leg* of c.1485-8 (Fig. 49), is probably the earliest evidence of human dissection by Leonardo. The limb is sectioned with precision: an unprecedented technique for representing the internal arrangement of muscles. It shows information that would be impossible to discover simply by looking at the surface of the limb,[17] and it presupposes a knowledge of human anatomy that would certainly have fed into his second painting of *The Virgin of the Rocks*.

Perhaps this was the same body from which Leonardo obtained a human skull. In 1489 Leonardo started making detailed *Studies of the cranium and skull* (Figs. 50-2). Eight in total survive on three sheets in the Windsor collection (Manuscript B).[18] There are profiles, cross sections, views from oblique angles and from above. These drawings have a new refinement and sensitivity in the handling of pen and ink; Leonardo was using a quill with a minute nib. They illustrate his absolute dedication to accuracy. In one drawing he scrutinizes the blood vessels of the face and the relationship between orbit and maxillary antrum–the eye socket and the jawbone. In another, he peers down into the cranium at the inter-cranial nerves and blood vessels. In yet another, with a frontal view, he draws a line down the centre of the skull, dividing it in two, exploring the deep cavities of the eye sockets and defining the indentations with directional hatching. The precision of the drawing, carefully modelled to describe hollows and jutting extensions of bone, is startling. Down to the numbering of the teeth, Leonardo was a perfectionist. In these drawings we see him learning the landscape of the skull, as if etching it onto his memory. When he came to paint the second *Virgin of the Rocks* Leonardo must have automatically incorporated this knowledge. We see this in the new sense of mass and three-dimensionality of Mary's head, and the indentation of the skull above her eye sockets shows a greater understanding of cranial anatomy.

Human Machines

Leonardo scrutinized different body parts in isolation to understand the structures beneath the skin. Yet as early as his first experiments with the frog he was aware that it was the animation of the different body parts that brought the human form to life. As he writes in about 1495, "Motion is the cause of every life".[19]

To this end his manuscripts of the early 1490s are peopled with little "action men": some run, some lift heavy weights, some pull, some push, some jump. Leonardo probably used his apprentices as models. As he moved around his model he captured the compression and extension of the limbs from different angles and at varying stages over time. Next to a diagram of a boy leaping, from about 1495, Leonardo notes:

> "When a man jumps high, the head has three times the velocity of the heel of the foot, ... and twice the velocity of the hips. This is because the three angles extend themselves at the same time of which the uppermost is where the torso joins the thighs in front, and the second is where the backs of the thighs join the back of the legs, and the third is where the fronts of the legs join the bones of the feet."[20]

This sense of the body consisting of planes hinged at specific angles, and where the joints act like fulcrums rotating these planes through space, is the beginning of Leonardo's vision of the human body as a machine. This interest went hand in hand with his involvement in architectural projects for Sforza. In 1489 when he and his friend, the architect Bramante, had been working on the problem of the *tiburio*, the crossing tower of Milan Cathedral, Leonardo's appetite for architectural puzzles had been aroused.[21] In 1490 he was involved in a number of other building projects. He would have been aware of Bramante's construction of the monastery of Santa Maria delle Grazie (1490-2) in Milan, where, in the refectory, he would later paint *The Last Supper*. Leonardo was also invited, along with Francesco di Giorgio Martini (c.1439-1501), to inspect the nearby Pavia Cathedral in preparation for the construction of its dome.[22] Parallel to his interest in the human body, Leonardo's notebooks from 1493 to 1497 include architectural doodles and countless pen and ink drawings for mechanical tools needed on building sites: a *Mechanical Device for the Transmission of Motion*, a *Mechanism for the Transmission of Power via Gears and Cranks* and a *Device for Raising a Mast* may all be found in the Codex Madrid I from c.1493-1497.[23] It has been suggested that he was even collating information for a treatise on mechanics.[24]

These ideas also found their way into Leonardo's work on the human body in motion. During the building work on Santa Maria delle Grazie he would have seen the stonemasons straining at their work, muscles and joints working like gears and levers. His understanding of mechanics now appears in his written description of the body. Next to a diagram of a man hammering he notes:

> "a figure which supports itself on its feet maintains an equality of matching

weights around the central line of its support."[25]

And he applied these ideas directly to his studio practice. In a description of a life-model with an outstretched arm, a pose directly relevant to *The Virgin of the Rocks*, he compares the human form to a mechanical one, a crane:

> "The navel always lies on the central line of the weight which is located above it … this is shown when an arm is extended, for the fist at the extremity of the arm has the same effect as is seen as the counter weight at the end of a crane. Hence as much weight as the accidental weight of the fist is necessarily thrust out to the other side of the navel."[26]

He even discusses the *contrapposto* pose of a model with similarly mechanistic language of balance and counterbalance:

> "If the hips, the pole of the man, are found to be posed such that the right is higher than the left you will ensure that the joint of the higher shoulder falls perpendicularly over the most uppermost part of the hips … and the pit of the throat will always be above the middle of the angle of the foot on which it is supported."[27]

Thus Leonardo saw the body as a mechanical instrument: the hips were poles, the arm was like a crane, and there were mathematical rules that predetermined its movement in space. This mechanistic approach could, he believed, explain the dynamics, and kinematics of the body.

When Leonardo began to work on his second *Virgin of the Rocks* his new understanding of the mechanical movement and alignment of the body would come into play. Whereas in the first painting Mary's body was rather mysterious and misaligned, in the second she appears as a known quantity. Gone is the shrouding darkness around her middle and the serpentine, boneless curve of her torso. Instead Mary's rib cage is immediately more readable and is stacked above her hips, her hips above her knees, while the pit of her throat is in line with both, creating a continuous "central line of support". Her extended arm–the "accidental weight" that Leonardo speaks of in his notes–is balanced by a tilting of her shoulders. The forward movement of her chest is countered by her retreating hips, an equal and opposite counterbalance. Leonardo could now combine an understanding of the architecture of human anatomy with its mechanical movement. Mary's form could be depicted as reacting to forces, in balance and counterbalance around a centre of gravity, just as a real body would respond.

"Super Vision": Artist as Scientist

Leonardo's research into the anatomy and mechanics of the human body could be applied directly in his second *Virgin of the Rocks*, resulting in a greater sense of naturalism. But his methods for recording his findings also marked a watershed moment for science, with important implications for the meaning of his second painting. His practical hands-on approach, moving away from a reliance on written tradition in favour of his own empirical observation, was revolutionary. In doing so he questioned the philosophers and thinkers still underpinning medical practice during the Italian Renaissance–people like Hippocrates, Aristotle and Galen–towards an approach still central to scientific research today. Even in his first dissection of the frog we get a sense of his systematic rigour. He was undertaking a "fair test", a process of thesis, antithesis and synthesis. And his notes suggest a clinical distance. When we consider the gruesome reality of the dissection table in comparison to the clean diagrams of his notebooks we get a sense of his emotional detachment in the name of science.[28]

In order to record his research accurately Leonardo required unparalleled skills in draughtsmanship and the mathematical conventions of perspective. In 1418 Filippo Brunelleschi, a generation older than Leonardo, had invented a system of single-point linear perspective that allowed the real, physical world to be mapped onto a two-dimensional picture plane.[29] The writer and architect, Leon Battista Alberti (1404-1472) and the painter Piero della Francesca (1415-1492) had then perfected and codified his approach.[30] This mathematical formula was a means of asserting the artist's power over his external environment. Crucially, this raised the artist's status above that of lowly craftsman to that of a "liberal artist" and intellectual. Piero della Francesca came closest to combining this new "science" of painting with the human form when he rigorously mapped the surface of the human head in his book *De Prospectiva Pingendi (On the Perspective for Painting)*, written around 1480. Using horizontal nodal points across the front and side elevations of the head and radial coordinates for views above and below, he was able to create a stereometric cage.[31] He had already expressed this knowledge implicitly when he used it in his painting of the *Resurrection of Christ* of c.1465 (Fig. 53), now in the Museo Civico, Sansepolcro, to render the heads of the sleeping soldiers at Christ's feet from four slightly different angles: he had married art and science, and thus proclaimed his scholarly capabilities.

But Piero della Francesca was interested in the surface of things. His was the science of "what?" Leonardo was after the "how" and the "why?" His was a higher order of thinking, a new critical questioning of reality. In his anatomical studies in Milan he began to develop beyond the science of Piero and Alberti.[32] In his transparencies, cutaways and sections of the limbs, Leonardo opened up the body, looking beyond–literally through– the surface of the skin with something akin to X-ray vision. This process denoted a thoroughly revolutionary "super-vision": a new level, or layer, of perception. The act of mark-making could now render the invisible visible, the internal external.

Leonardo also developed a new cinematographic depiction of the body's movement. Drawing the skull sequentially as he turned and tipped it, he gave his drawings a new temporal dimension, as if they were stills in a film reel. In his diagrams of a man hammering–swinging his arm over his head–he was developing a systematic means of framing action through time.[33] Knowledge now involved seeing an object in terms of space-time coordinates.[34] By capturing movement on a page, he had made transience permanent.

These scientific possibilities must have overlain the Christian message of Leonardo's second *Virgin of the Rocks*. The composition remained similar yet, having undertaken such extraordinary anatomical research in the intervening years, Leonardo's perception of the subject must have changed. In the same way that he could pin down the kinetic activity of a jumping man on a single page, so *The Virgin of the Rocks* reflected his ability to telescope time on a single panel. Past, present and future exist simultaneously in this painting. In one glance we see the moment humanity was conceived, and we glimpse the future fall and the end of the world as we know it.

.

In the years that Leonardo was working on the second *Virgin of the Rocks* he was also pushing the boundaries of visual art and of science and exploring the links between the two. In the Early Renaissance art had already become, as Alberti noted, a "window on the world",[35] a means of recreating the natural environment and the appearance of things in paint. In his first painting of *The Virgin of the Rocks* Leonardo's attention to the minute details of flowers and rocks had its origin in this Florentine *mimesis*. Yet, in his second masterpiece, Leonardo was using his understanding of human anatomy to provide a window to a *higher* level of

knowledge. His work expresses a new clinical and increasingly abstract understanding of reality, transforming the notion of *disegno*–the intellectual activity of painting and drawing–into an act of scientific research and recording. Leonardo's second *Virgin of the Rocks,* the physical object, was now emblematic of his search for an empirical and scientific "truth" and of his own superior place in the cosmos.

The artist had become a scientist.

CHAPTER SEVEN

A PHILOSOPHICAL JOURNEY

Leonardo's depiction of Mary in the second *Virgin of the Rocks* was more than a treatise on scientific accuracy. The pearly hue of her face hints at the supernatural. She seems to glow with an inner radiance. Her visage is perfectly symmetrical, unblemished. She is Leonardo's ideal. For the Christian audience this idealism was fitting for the mother of God. But there was a further philosophical dimension to her perfection.[1]

The Ideal Woman

In the years that Leonardo was working on the second *Virgin of the Rocks* his private world at the *Corte Vecchio* was filled with anatomical research. Unattended, save perhaps by the trusty Zoroastro, his dissections must have taken place behind closed doors. But publicly he was on a very different mission: to uncover the *ideal* proportions of the human figure. Running counter to his scientific observations of the individual workings of the body, this was a search for universal truth. In 1490 Leonardo began to develop a set of rules for bodily perfection, originally intended as the first section of his book, *On the Human Form*. The diagrams relating to this research found their way into another treatise, *On Painting*. Published posthumously by his follower, Francesco Melzi (1491-1570), it is written in the tone of an instruction manual for other artists and probably formed the basis of his apprentices' training.[2]

Leonardo started work on this manual in 1490, the same year that he completed the delicate drawings of the skull. Mapping the ideal form was not an original concept. Both Early Renaissance and Classical theorists had worked on this before. Leonardo now had a modest library and owned copies of the relevant texts: *Elementa pittura* and *De statua* were written by the Florentine architect of the Early Renaissance, Alberti, whose path Leonardo would certainly have crossed as a young man; *Ten Books on Architecture,* from the first century BCE, was written by the Roman architect, Vitruvius. The third book in his famous treatise related the ideal proportions of the male nude to the Doric Order in Greek architecture.

Leonardo clearly read these texts carefully because in his notebooks from the time, now held in the collection of drawings at Windsor, he makes a comparative study of the two theories. On one page from around 1490 he pens a diagram of two arms (*The Proportion of the Arm*).[3] It is simplified, sketchy, the spontaneous working-out of an idea. He annotates the upper drawing, showing that the distances from wrist to elbow, elbow to armpit and nipple to nipple are equal. Thus two feet equal one arm or *braccio*. The length of the whole arm, wrist to shoulder, is equal to one third of a man's height. These measurements are in Tuscan units and taken from Alberti's treatise.[4] Alternatively, in a diagram below, he annotates in *cubits*, Roman measurements, and describes how the distance from the centre of the chest to elbow and elbow to fingertip are equal, and that this measurement is one quarter of a man's height. This is from Vitruvius.[5] A larger diagram in pen and brown ink, depicting three men, standing, kneeling and sitting, is also based on Vitruvius' measurements. Leonardo writes:

> "When a man kneels he will diminish by the fourth part of his height. When a man kneels with his hands to his breast, the umbilicus will be the middle of his height, and similarly the points of his elbows."[6]

So, whilst Leonardo was interested in the relationships of different parts of the body to each other, he was also correlating different pre-existing proportional systems.[7] Attempting to combine Vitruvian measurements with observed reality,[8] Leonardo also set about collecting his own data. Crammed onto the pages of his notebooks from around the same time are hundreds of little figures for *Studies of human proportions* (Fig. 54).[9] From every conceivable angle and taking each part in isolation–the arms, the legs, then the trunk and the face–he divides and squares up the body for measurement. Every inch is examined.[10]

Then in c.1490 he worked up his investigations on proportion to a more finished state in his famous *Vitruvian Man* (Fig. 55), now in the Gallerie dell'Accademia, Venice. This was a presentation of his own academic treatise and a statement of his intellectual journey. Vitruvius had divided the male body into divisions of four equal *cubits*, perfectly inscribed within a square and a circle. At the centre of both was the navel. But Leonardo redesigned this diagram. Keeping the quarter divisions from head to toe, he reinvented the proportions of the arm. In Vitruvius' description the horizontal extension of the arms is measured from nipple to fingertip. Leonardo takes the measurement of the trunk from armpit to armpit and shoulder to just above the wrist as equal. Now the arm, from

the shoulder blade to just above the wrist, is one quarter of the man's height.[11] By 1490, after months of rigorous research combined with an interrogation of existing theory, Leonardo had established a system of proportion that would allow him–and his apprentices–to reproduce an ideal human body in art.

In the mid-1490s, when Leonardo started work on his second *Virgin of the Rocks,* he was able to use this formal template to depict the most perfect woman imaginable. He had processed and absorbed his research. He probably no longer needed to measure out the lengths as he marked up his cartoon, simply judging the proportions by eye as he worked. Once he had the original cartoon transferred to a new panel, Leonardo adjusted Mary's figure in line with these ideal proportions. In Leonardo's second *Virgin of the Rocks* her body relates almost identically to his variation on the Vitruvian rule. Now each part correlates with the modular *braccio.* Her height has been divided into four equal parts: the distances from the top of her head to collarbone, collarbone to hip and hip to knee are almost identical. The width of her shoulders and the length of her arms also match this module, a quarter of her height. The hands are smaller in relation to her body, with the distance from wrist to fingertip half the length of one module.

If we look back at the first painting, the body of the Virgin seems suddenly rather strange. Her outstretched hand seems too large in proportion to her head; her right arm, reaching around John's shoulder, appears almost dislocated: if it were straightened it would hang below her knees. In the second painting, however, Mary appears more convincing in terms of the relationship of each part of her body to the whole. In addition to scientific understanding, Leonardo's second *Virgin of the Rocks* embodied months of intense exploration into the mathematical proportions of ideal human beauty.

Intellectuals at Court

Leonardo's striving towards an ideal was intended for more than simply practical application in his painting, or beauty for beauty's sake. The year 1490, the period of his most concentrated research into the perfect human proportions, coincided with important developments in the artistic and cultural environment of Milan and in Leonardo's own philosophical outlook. As Sforza's court artist Leonardo at last entered the inner sanctum at the *Castello* and was among intellectuals. The humanism he encountered there would underpin his search for the ideal human form and transform

his approach to painting.

By the late 1480s the court of Milan was growing in economic prosperity and political stability. In 1489 Sforza founded new universities in Milan and Pavia where one could study medicine, jurisprudence, fine arts and letters. By 1490 Milan was one of the richest states in Italy with a yearly revenue of 600,000 ducats, almost equal to the total revenue of England (which had 700,000 ducats per annum).[12] And in 1491 Sforza secured a major alliance with Mantua when he married Beatrice d'Este (1475-1497),[13] thereby strengthening himself against the threat of Spain, France and the Holy Roman Empire. He was very much in love with his young wife at first,[14] and this happiness, as well as growing political stability, meant that Sforza shifted his focus from military funding to the beautification of his city. In the 1470s, during his temporary exile in Florence, Sforza had made friends with the cultured Lorenzo de' Medici, whose artistic collections so clearly spoke of his Classical heritage. Continuing communication between the two rulers, until Lorenzo died in 1492, encouraged the spread of artistic trends from Florence to Milan. By 1490 Milan was riding the wave of a humanist "renaissance" that had started in Florence fifty years before.[15]

Modelling himself on his Florentine mentor, Sforza hoped that his funding of art *all'antica* would be tangible proof of his connection with the great civilisations of the past. With this goal in mind Sforza sent his man Giovanni da Tolentino to Rome to research the ancient monuments of the Forum[16] and minted coins decorated with a Roman-inspired profile of his own swarthy visage in place of the great emperors. He also started a sculpture collection to rival de' Medici's and in 1495 a marble copy of a Greek *Leda* appeared in Milan.[17]

These new artworks were to be housed in a city that was also being re-modelled on Classical precedents. The redesign of a new square outside the *Castello* was to be perfectly proportioned following the rules set out by the Roman architect and author Vitruvius. And the Church of Santa Maria delle Grazie, completed by Leonardo's friend Donato Bramante between 1490-92, and for which Leonardo had made many designs,[18] displayed an enormous spherical dome that was inspired by the Pantheon in Rome.[19]

Leonardo, as official court artist, was of course central to this propaganda initiative. His identity as a Florentine was attractive in itself, since he came from the birthplace of the Renaissance. It was around this time that, fired up by his political success, Sforza accepted Leonardo's

proposal to design the equestrian monument to his father, Francesco.[20] Clearly referencing the famous horses of the *Dioscuri* in Rome's Piazza del Quirinale, Leonardo intended to outdo these Classical precedents in scale and dramatic impact. Weighing an immense 75 tons of bronze and rearing on its hind legs as if ready to gallop to victory, this monument was to place Sforza within an ancient tradition of military heroism[21] and secure Leonardo's fame forever. Writing of the equestrian statue, Sforza's court poet, Bellincioni, proclaimed his master's commitment to creating his new empire with Leonardo, the new Apelles,[22] at the helm:

> "Come, I say, to today's Athens in Milan! For here is the Ludovican Parnassus ... from Florence he has brought an Apelles."[23]

The revival of Classical visual culture in Milan was accompanied by many such displays of literary rhetoric. Bolstering Sforza's artistic campaign, a craze for Classical philosophy also spread through the court and the new universities. This, too, came via Florence. There, Marsilio Ficino, the philosopher to Cosimo and then Lorenzo de' Medici, was translating Plato into Latin for the educated elite at his famous Academy at Careggi. In October 1484 Ficino published his *Platonis Opera Omnia (Complete Works of Plato)*. This was a translation of Plato's full texts from Greek to Latin but more importantly it included Ficino's own commentaries, intended to guide the contemporary reader towards a Christian understanding of the Pagan originals. Sforza may have met Ficino in Florence in the 1470s. But even if he had not, Sforza's teacher and mentor Francesco Filelfo (1398-1481), an internationally-renown scholar of Greek based in Milan between 1440 and 1477, would have certainly been aware of Ficino's ideas. Via Filelfo, Ficino's writing on Neo-Platonism would have been widely read amongst the Milanese intelligentsia by 1490.[24]

During this period Leonardo underwent another transformation that would allow him to take part in contemporary philosophical debate. When he first arrived in Milan his ambition was to become an engineer, designer, architect, scientist and, above all else, an intellectual. The feeling that a glass ceiling had been placed upon his career because of his lack of formal humanist education was probably one of the reasons he left Florence. On his arrival in Milan, then, he sought not only to impress Sforza with his artistic skill but also to prepare himself for a life at court among such thinkers.

From the mid-1480s onwards, with characteristic discipline and determination, Leonardo taught himself Latin. In the *Codex Trivulzianus,* a

collection of manuscripts dating from between 1487 and 1490, Leonardo writes painstaking lists of Latin vocabulary: hundreds of words, some of which are translated into Italian, are accompanied by book titles.[25] One of these, *Donato,*[26] is probably a reference to the popular book of Latin grammar *De octo partibus orationis* by Aelius Donatus. Leonardo was putting himself through an intensive course in the international language of learning.

Alongside Leonardo's jottings from the late 1480s are other abbreviated book titles. As we might expect, his interests were diverse. He mentions *Lipidario* (perhaps a manual about precious stones), geography, natural science, the arts and inventions; he owns *Plinio,*[27] probably the *Historia Naturalis* by Pliny the Elder; *Dabacho,* a popular book on arithmetic; as well as popular romantic poetry–he has the *Morgante,* the epic poem of 1483 by Luigi Pulci (1432-1484), the friend of Lorenzo de' Medici and Benedetto Dei. [28] An ever-lengthening list of book titles indicates Leonardo's rapidly expanding library and his voracious hunger for knowledge. In pages from the *Codex Atlanticus* of c.1492 he mentions over forty books, including works on philosophy and religion–the Bible and Psalms–as well as technical and scientific texts.[29] We know from his diagrams on human proportions that Leonardo was certainly reading Alberti and Vitruvius. And in the *Codex Trivulzianus,* of about 1490, Leonardo not only makes a note of Francesco Filelfo's *Epistles* on two separate occasions but he also underscores the title of Ficino's book *Theologia platonica (Platonic Theology)* published earlier in 1482.[30]

By the early 1490's Leonardo clearly had the means to keep abreast of contemporary philosophical debate and was ambitiously pursuing his own education. He also emerged as a personality at court, his name becoming increasingly evident in contemporary rhetoric. It was at this time, writing of Leonardo's portrait of Sforza's lover Cecilia Gallerani, know as the *Lady with an Ermine* (c.1490, now at the National Museum, Kraków), that the official court poet Bernardo Bellincioni had proclaimed Leonardo a greater creator than Nature herself:

> "...
> Who stirs your wrath? Of whom are you envious,
> Nature?
> Of Vinci, who has portrayed one of your stars;
> Cecelia, today so very beautiful, is she
> Whose lovely eyes make the sun seem dark shadow."[31]

Dating from the mid 1490s a monogram of Leonardo's name appears.

Inscribed in the centre of a detailed knot pattern (Fig. 56), now at the British Museum in London, are the words: "The School of Leonardo da Vinci".[32] Probably designed by the artist himself, this emblem has been taken as visual evidence that Leonardo was now at the hub of a group of humanist scholars in Milan. A recently discovered manuscript from about 1513, Henrico Boscano's *Isola beata*,[33] notes the membership list of such a group during this period, including the court poet Bellincioni who died in 1492, the architect Donato Bramante, and Leonardo himself.[34] Leonardo's transformation from humble artist to court intellectual seems complete.

As the decade progressed Leonardo must have become increasingly caught up in this creative community. Between 1496 and 1499, the years that Leonardo started working on his second *Virgin of the Rocks*, there was a flurry of intellectual activity that cannot have escaped his attention. In 1492 Ficino had published his ardent love letters to Giovanni Cavalcanti (1444-1509) in his *Epistulae,* which popularized his concept of Platonic love.[35] In 1496, however, the wave of gossip following his "love metaphysics" peaked when he republished his *Complete Works of Plato*, choosing to dedicate his commentary on Plato's *Symposium* to Cavalcanti.[36]

Also in 1496 the famous mathematician and Neo-Platonist scholar, Luca Pacioli (1445-1517), arrived in Milan. Leonardo may well have been the one who invited him.[37] Over the next two years Pacioli completed his book *On Divine Proportion* (1496-8), which was illustrated by Leonardo himself (Fig. 57). It popularized Platonic creation theory and specifically related art and architecture to the mathematically perfect golden ratio, Phi.[38] Meanwhile, there were also developments in the philosophy of music. The internationally renowned musician Francesco Gaffurio, probably a friend of Leonardo's[39] and possibly even the subject of his *Portrait of a Musician* (c.1490), published a book of music theory called *Theoretica musicae* in 1496. In this book Gaffurio elaborated on the basis of musical harmony found in Pythagorean numerology. Contemporary philosophical developments in relation to mathematics, art and music had come together for the first time in Leonardo's life. He was at the height of his career, he had started to paint the *Last Supper*, he was overseeing architectural projects and the redesign of Sforza's perfect city, and the *Corte Vecchio* was crammed with scaffolding and casts for the largest Classically-inspired equestrian monument in history.

During the day the *Corte Vecchio* would have been full of apprentices and associates, hard at work on a variety of projects for the beautification

of Sforza's court. And in the evening, when Salai had been sent to bed and Zoroastro was busy with his alchemical experiments, we might imagine the candle-lit ballroom with Leonardo sitting at the centre of a group of philosophers, poets and architects. Perhaps Pacioli and Gaffurio were now also present, their discussion broken for a while by the sound of Gaffurio's counter-tenor accompanied by Leonardo's lyre. And somewhere in Leonardo's private *studiolo* the second *Virgin of the Rocks* was beginning to take shape.

"The Measure of All Things"

The philosophy of Plato and Pythagoras, as popularized by Gaffurio, Ficino and Filelfo, must have had a profound impact on Leonardo. Underpinning his work on the ideal body, reflected in his second Madonna, was a Platonic metaphysics, or theory of existence. Translated by Ficino in 1484 and republished in 1496 with his *Complete works of Plato*, it would have been available to Leonardo whilst he was working on the second *Virgin of the Rocks*. Central to the world-view presented in this literature was a belief in the ultimate beauty and truth of number and geometry.

In his book *Timeus*, a late work from the first century BCE, Plato explained that the foundation of the universe was intellect (*nous*), anthropomorphically embodied by the Divine Craftsman (*demiurge*). This god-like maker imposed mathematical order on a pre-existing chaos to generate the harmonious cosmos (*kosmos*). Plato saw our physical or material world as changing and imperfect compared to an "Idea" or ideal realm, which was mathematical and therefore immaterial, unchanging and eternal. Owing much to Pythagorean numerology, this ideal world was associated with the "One", sharing the qualities of indivisibility, wholeness and therefore perfection of the number 1.[40] These notions were arguably the inspiration behind Leonardo's attempt to define the human body mathematically.

Plato reasons that the Divine Craftsman created the World Soul out of various numerical ingredients, forming them into a long strip. Marked out into intervals this strip gave the seven integers 1, 2, 3, 4, 8, 9, 27. This was a perfect formula that contained the monad, source of all numbers, the first even and first odd number, and their squares and cubes; and importantly it could be arranged in the shape of a tetractys, an equilateral triangle. This tetractys, Pythagoras believed, was symbolic of the perfect soul. The equilateral triangles were then converted into three-dimensional, physical

forms, or polyhedra. Initial elements of the cosmos–earth, water, fire and air–were then made from multiples of these geometric bodies. The first and simplest was the tetrahedron or pyramid, the building block of fire; earth was made from the cube; air from the octahedron; and water from the icosahedron. There was also a fifth element "which God used in the delineation of the Universe",[41] the dodecahedron, probably because it was so similar to a perfect sphere. From the four basic elements all physical forms were created. At each stage of creation the objects moved further and further away from the origin, Number 1, and therefore their purity was compromised. However, since each different polyhedron was built from equilateral triangles–the same basic module–and each of these was generated by the same mathematical formula, eventually each physical body could be assimilated back into the "One". Thus according to Plato, the universe was harmonized through perfect mathematical and proportional relationships.[42]

It was this Platonic and Pythagorean notion of perfect number that informed and provided the impetus for Leonardo's drawing of the *Vitruvian Man* in 1490. More than simply a humanist reference to Classical–and therefore superior–knowledge, Leonardo's template for physical perfection explicitly referenced Platonic geometry. He inscribed the body of a man within a perfect circle to symbolize heavenly perfection and within a square to represent earth.[43] His arms and legs create inverted triangles, perhaps alluding to Pythagoras' tetractys and symbolic of the perfect World Soul.[44] The figure is encapsulated within these geometric forms because, according to Platonic theory, ideal physical proportions are born of perfect number. But he also exercises power over the space he inhabits, stretching out his limbs, re-aligning the forms, creating order out of chaos. Perhaps, then, he also represents the Divine Craftsman, sovereign of the universe, "the One". Already, in 1490, Leonardo, following Protagoras, was explicitly referring to the concept that man was the "measure of all things".[45] He saw the ideal human body, abiding by mathematical laws, as a microcosm of heavenly perfection. And the face, perhaps a self-portrait of Leonardo's own, hints that the artist might be seen as a mirror of the Divine Creator; a supreme intellect.

Linked to the concept of a mathematically harmonious universe was Plato's notion of musical harmony. In his book, *The Republic*, Plato described astronomy and music as "twinned" studies of sensual recognition: astronomy for the eyes, music for the ears, both requiring knowledge of numerical proportions.[46] In this Plato had again drawn on Pythagoras, the first to identify that the pitch of a musical note is in

proportion to the length of the string that produces it, and that intervals between harmonious sound frequencies form simple numerical ratios. In a theory known as the "Harmony of the Spheres", Pythagoras had proposed that the sun, moon and planets all emit their own unique hum or "orbital resonance" based on their orbital revolution[47] and that the quality of life on earth reflects the tenor of celestial sounds, which are physically imperceptible to the human ear.[48]

In the 1490s Leonardo's friend Franchino Gaffurio had brought these ideas to the fore in Milan. With an interest in the relationship between musical harmony, Pythagorean metaphysics and number theory, his *Theoretica Musicae* published in 1496 specifically highlighted the importance of mathematical relationships in musical harmony. He saw one particular set of numbers–6, 8, 9, 12–as an harmonic "world formula". These four numbers, he believed, represented the most perfect, three-fold, all-embracing equation because they contain the arithmetical 6, 9, 12, the harmonic 6, 8, 12 and the geometric proportions 6:8=9:12; and within the poles 6 and 12 were the ratios of the octave 1:2, the fifth 2:3 and the fourth 3:4. This related back to Pythagoras' tetractys, symbolising the world and the universe. Gaffurio saw these mathematical ratios as representing an image of world harmony.[49]

Leonardo's interest in numerology must have increased in 1496 when Luca Pacioli came to Milan. His book *On Divine Proportion* (1496-8) consciously drew on the creationist geometry of Plato's *Timeus* and Pythagoras' belief in the divinity of Number. In Part I of his treatise Pacioli declared Phi to be the mathematical basis of all art and architecture, while Part II specifically discussed the Platonic solids, the polyhedra, as the raw material of creation. He even saw their triangular faces as Platonic symbols of the perfect soul.[50]

Leonardo collaborated closely with Pacioli. He designed sixty plates to accompany *On Divine Proportion*, and Pacioli's forward to the 1509 edition was warmly complimentary of his friend's contribution. All the illustrations, he writes, were done by

> "that most worthy painter, perspectivist, architect, musician and master of all accomplishments Leonardo da Vinci Fiorentino, in Milan, where we worked together at the charge of the most excellent Duke …"[51]

The reciprocal nature of their friendship is also evident from Leonardo's notebooks of the time: "[I must] learn from Messer Luca how to multiply square roots"[52] he scribbles spontaneously, as if he might pop

over to see "Luca" at any moment. His intimate tone implies a free and equal sharing of ideas and locates Leonardo even more firmly within the humanist milieu of Milan.

When, in 1496, Leonardo was asked to paint *The Last Supper,* Pythagorean musical harmony and Platonic numerology must have been at the forefront of his mind. He was collaborating with Pacioli and probably in discussion with Gaffurio. Unsurprisingly, the composition for Leonardo's mural in the refectory of Santa Maria delle Grazie has been found to be closely based on harmonic number theory.[53] Leonardo jots down the Pythagorean sequence 12: 6: 4: 3 on a sketch for the mural,[54] and these ratios are repeated throughout the painting.[55] The entire surface of the wall can be divided into a grid, twelve units in width and six in height. The four tapestries on opposite walls and the three windows depicted behind Christ complete the sequence. The depth of the wall tapestries is also arranged according to these divisions so that, from the outside in, the widths of the tapestries follow the ratios 1:½:⅓:¼ or 12:6:4:3.[56] The coffered ceiling in the foreground measures six units within the total twelve, the rear wall four units, and the three windows at the back measure three units in total.[57] The perfect Pythagorean tetractys is perhaps also referenced in the rhythmical grouping of apostles into threes.

When Leonardo started work on his second *Virgin of the Rocks* during these same years his mind would have been full of philosophical associations. Mary's creation, too, must have been imbued with notions of Platonic and Pythagorean numerology. Her form had to be mathematically harmonious because she was an embodiment of the divine; the most perfect woman. Her re-imagined proportions–in line with the Vitruvian rule–lay claim to her origin in Plato's "Idea" realm of Number. And, in the second painting, Leonardo's subtly altered technique put more emphasis on the underlying geometry of the work. The developed *chiaroscuro* and the removal of the angel's pointing finger from the composition bring out the glowing faces: the triangular arrangement of the heads of Mary, St John and the angel leaps into focus. This triangular formation may also refer to the Pythagorean tetractys as discussed by Gaffurio, symbolizing the perfect Platonic Soul. The tetrahedron, the primary module of fire and the first element in Plato's theory of creation, alludes to Mary's place at the beginning of time. In fact Plato's original four elements are all present. In addition to fire, Leonardo gives us the water in the running stream, the rocky earth, and the almost tangibly thick air of the cave. Overlaying the Biblical references to the Psalms, Leonardo gave Mary's Immaculate Conception a philosophical dimension in this second painting. Through

number and geometry, she had become as close to the origin–the "One"–as was physically possible.

A Stairway to Heaven

Leonardo's reference to Neo-Platonism and Pythagorean numerology in his painting illustrated his own intellectual prowess and would have been interpreted in this way by his humanist patrons. This intellectualism was itself seen as a means of reaching towards the divine. This was a concept that had been discussed at length in Plato's *The Republic*, translated by Ficino and republished in 1496. In Book 10 Plato clarifies the hierarchical nature of his metaphysics, otherwise known as his "Theory of Forms". He believed that there were two realms, the physical and the ideal or "Idea" realm. The physical realm–the world that we live in–was an imperfect copy of the "Idea", the realm of immaterial ideal forms and of Number. It was this world of immaterial, perfect forms, the progenitor of the physical world, that was the ultimate reality and goal of mankind.[58] Although one's soul would only truly be freed after death, in one's lifetime it was through mathematical knowledge and the exercise of the intellect that man might reach towards the Idea world and "the One".[59]

Of particular relevance to Leonardo was the powerful visual metaphor that Plato used to explain this hierarchy of existence: the "Allegory of the Cave".[60] Inside an enclosed pit human figures sit shackled with their faces to the wall. High up behind them is the opening to the cave, symbolic of the path to enlightenment. Between the prisoners and the mouth of the cave, other figures pass in front of a lighted fire, casting shadows before the captives' eyes. Having never seen life beyond the cave, the prisoners think that these flickering forms are "real" when the true "Idea" or ideal realm exists outside the cave altogether. We humans, Plato was explaining, exist in a world of shifting shadows, separated from the truth by our ignorance. The only way to escape this trap is through knowledge via the exercise of intellect, and an awareness of our own limitations. The philosopher, Plato argued, was a rational thinker, able to go some way towards reaching the Idea realm due to his cultivation of superior understanding.[61]

Of course, following these ideas to their logical conclusion, art was discarded. Talking about poetry, but probably referring to visual art forms too, Plato saw art as a false copy, a *mimesis*, of life and therefore one step further removed from the Idea realm along his metaphysical hierarchy. In the wrong hands it could be used to trick the uneducated masses and was

therefore dangerous.[62]

But during the Renaissance this denigration of art could not be accepted. Visual art was central to the maintenance of power by the ruling elite. Contemporary Neo-Platonic philosopher, Ficino, was paid by Cosimo de' Medici to reread Plato in a manner that would support the patron's use of art.[63] In 1492 Leonardo had made a note of Ficino's *Theologia Platonica* and underscored it.[64] In this text Ficino offered an alternative reading of Plato and a chink of hope for art. He saw the possibility of assimilation with "the One" through the mystical experience of the soul. Inhabiting the body but separate from it, immaterial and immortal, the soul would allow humans to travel towards a perfect state.[65] Ficino wrote: "The more the mind is separated from the body the better its condition."[66] One means by which the mind could be separated from the body was through an ecstatic state brought about by experiencing beauty in the physical realm, and by falling in love.

Ficino had already developed these ideas in *De amore* (*On Love*), his commentary on Plato's *Symposium*, published in 1484, soon after Leonardo came to Florence.[67] In this text, love is defined by Ficino, following Plato, as a

"desire for beauty ... For it is the same God whose beauty all things desire, and in possessing whom all things rest. From there, therefore, our desire is kindled."[68]

Beauty, then, is a physical manifestation of a Good Soul and a gift from God. The more worthy the Soul, the more beautiful the individual and the more attractive to others. Ficino continues:

"The splendour of the highest good is refulgent in individual things, and where it blazes the more fittingly, there it especially attracts someone gazing upon it ..."[69]

This was a development of Plato's ideas on the modularity and contingency of physical reality, according to which the physical realm is harmonically and proportionately related to ideal beauty and the Idea realm, Good, Number and ultimately God.

With this theory Ficino was offering a positive spin on the enjoyment of physical and visual pleasures. By attracting the viewer, the beautiful woman would literally draw her lover towards the Good and a higher metaphysical state. She

"excites his consideration, seizes and occupies him as he approaches, and compels him both to venerate such splendour as the divinity beyond all others, and to strive for nothing else but to lay aside his former nature and to become that splendour itself."[70]

According to Ficino, beauty is used by God as a "bait" or "hook" to attract lovers towards goodness and ultimately towards heaven. Once this attraction has taken place, the lover's

"… soul burns with a divine radiance which is reflected in the man of beauty as in a mirror, … Caught up by that radiance secretly as by a hook, he is drawn upwards in order to become God."[71]

This concept of Platonic love was popular in Leonardo's Florence and in Milan. The educated elite seized upon the notion as a means to validate extramarital love affairs and the pleasure of looking.[72] Ludovico Sforza's relationships, including his affair with Cecilia Gallerani whom Leonardo had painted, were discussed in these terms.[73] In marriage portraits of the time it was accepted that a painter would idealize and beautify the bride. Since outward beauty was a sign of inner virtue it was only right that the depiction of a woman's face should reflect the purity of her soul.[74] At court the gossip surrounding Ficino's homosexual love letters to Cavalcanti in his *Epistulai* must have lent a frisson of excitement to this philosophy that cannot have escaped Leonardo, at this time in the midst of his tempestuous relationship with the beautiful Salai.

Leonardo clearly knew of Ficino's "love metaphysics" from his time in Florence. On the verso of his portrait of Ginevra de' Benci from around 1474-1478 the young Leonardo had painted a scroll inscribed with the motto *"Virtutem Forma Decorat"* ("beauty adorns virtue"). But from the early 1490s, as Leonardo was drawn into the intellectual circles of Sforza's court, his ideas on this topic matured. Published later as part of his book *On Painting*, he contributed to the contemporary debate known as *il paragone* on the relative merits of the different art forms.[75] We might imagine this sort of discussion taking place at one of those candle-lit evenings at Leonardo's *Academia* at the *Corte Vecchio* where musicians, painters, architects, and mathematician-philosophers met. Leonardo, perhaps in response to the poet Bellincioni, pours fourth on the superior qualities of painting. Crucially, he does so in the language of Ficino, with reference to love and beauty:

"Do you not know that our soul is composed of harmony, and that harmony cannot be generated other than when the proportions of the form

are seen and heard instantaneously? ... [Poetry] does not satisfy the mind of the listener or viewer in the same way as the proportionality of the very beautiful parts composing the divine beauty of this face before me, and which by contrast are conjoined instantaneously, giving me such delight with their divine proportions. I judge therefore that there is nothing on earth made by man which can rank higher."[76]

Here Leonardo describes the immediate impact of painted beauty on the viewer in the language of Neo-Platonic metaphysics. The simultaneity of the viewing experience and the immediacy of visual appreciation move the viewer far more than the reader of a poem because, like the soul, physical beauty combines perfectly proportioned parts to form a balanced whole. Physical beauty then, for Leonardo, as for Ficino, was an embodiment of the "divine" and the bridge from the physical to the Idea realm.

However, Leonardo was taking these ideas one step further in that he was relating them to painting. Unlike Plato, who discarded art because of its *mimetic* qualities, Leonardo developed Ficino's appreciation of physical beauty, arguing that a painting, like beauty in a real woman, could draw the soul towards the divine. He writes:

"If the poet says that he can inflame men with love, the painter has the power to do the same ... in that he can place in front of the lover the true likeness of one who is beloved, often making him kiss and speak to it. This would never happen with the same beauties set before him by the writer. So much greater is the *power of painting over a man's mind* that he may be *enchanted* and *enraptured* by a painting that does not [even] represent a real woman."[77] [Author's italics.]

Leonardo refers to Ficino's ideas again: a man can be "hooked", "enraptured", "enchanted" by painted beauty and is attracted towards it. Aware as we are of Leonardo's knowledge of Ficino, it requires but a small leap to see that he might have considered painted beauty to lead the viewer towards God. Since beauty is inherently Good, a painting, like a beautiful woman, must have the power to draw the viewer's soul higher, towards the Idea realm. In fact painted beauty was perhaps even more powerful than human beauty. Leonardo writes:

"Time will destroy the harmony of human beauty in a few years, but this does not occur with such beauty imitated by the painter, because time will long preserve it. And the eye ... [will continue to] derive as much true pleasure from the depicted beauty as from the living beauty denied to it."[78]

Leonardo must have been persuasive since, writing of Leonardo's *Portrait of Cecilia Gallerani* (otherwise known as *Lady with an Ermine*), the poet Bellincioni echoed the painter's sentiment:

> "... Think only that the more alive and beautiful she remains–
> The greater will be your glory–in every future age.
>
> Give thanks therefore to Ludovico
> And to the Talented Leonardo,
> Who want to share her with those to come.
>
> Everyone who sees her thus, though too late
> To see her living, will say: this suffices for us
> Now to understand what is nature and what art."[79]

Thus, for Leonardo, painting could embody a greater spirit of the Good than any living loveliness. Like the living it could incite devotion yet in addition, outliving natural beauty, it could have a positive impact on many more viewers over a far longer period of time. By implication then, a painter was, morally and spiritually, as well as technically, closer to the Divine Craftsman than any other being.

.........

The first *Virgin of the Rocks* had been a window onto the world: a copy of the physical universe, reflecting an Aristotelian appreciation of nature. In the second painting Mary has undergone a metamorphosis. She is now generalized and idealized, every blemish or sign of individuality in her face and body has been erased. Gone are the stray curls at her temple, the awkward sway of her hips. Her perfect, mathematical proportions, her symmetrical features, her monumentality and pearly hue must have been a reflection of Leonardo's new Neo-Platonic outlook.

In line with Ficino Leonardo was offering hope through ideal beauty. Whereas corporeality was a trap for Plato, the physical painting was, for Leonardo, a pathway to freedom and truth. His depiction of Mary's perfection would act like a "hook". Magnetized by her loveliness the viewer would fall in love with the painted Virgin, and his soul would be drawn upwards towards heaven. Our eyes return again and again to Mary's beautiful features at the apex of the pyramid of faces; she shines out in the darkness like a beacon. Past her shoulder the opening of the cave offers a glimpse of the path that leads towards the "One". And perhaps the cave, once simply a reference to the Biblical Psalms and an imagined

prelapsarian land, had become a reminder of Plato's Allegory of the Cave. The *Immaculata* was also an antidote to human ignorance.

And beyond the image of perfection in the form of Mary was the perceived perfection of the painted object itself, a summation of years of work, of research and intellectual process. This was great *disegno*. It was no longer simply an Albertian window on the natural world but a stairway to heaven, a lasting talisman that would survive for hundreds of years to come. Leonardo had become a creator touched by divinity. In his own words:

> "The divinity which is the science of painting transmutes the painter's mind into a resemblance of the divine mind ..."[80]

PART 3:

THE COMPLETION OF THE SECOND *VIRGIN OF THE ROCKS* C.1499-1508

CHAPTER EIGHT

TROUBLE AT COURT

In the second *Virgin of the Rocks* Mary's once peachy cheeks have become deathly pale, her sweet half smile is no longer. The cave, once open and airy, is now closed overhead, the shadows dangerously deep. The welcoming angel now looks inwards. The cycle of life and death seems monotonous, unavoidable, terrifyingly real.

Betrayal

On 22nd October 1494 Sforza became Duke.[1] Leonardo sketched a dog and a snake in his notebook. The dog cowers back as if preparing for the serpent to attack. The motto inscribed on the scroll hung around the dog's neck reads *"per non disobbedire"* ("not to disobey").[2] It is the sort of design that might have appeared on a shield for a mock battle as part of a ducal pageant. The snake was the heraldic device of the Visconti and probably represented Milan and Sforza. The dog traditionally stands for loyalty or obedience. The message is clear: Milan should remain faithful to Ludovico.[3] Yet ironically this piece of propaganda hints at Sforza's lack of confidence and a need for affirmation. In the following years Leonardo sketched many such mottos.[4] His original role as cultural ambassador, herald of the Renaissance, seems to have shifted. His *fabbrica* was increasingly seen by Ludovico as an instrument of propaganda. There was a sense that Sforza's political optimism of the previous years had been premature. Already his rule was beginning to crumble.

As early as 1492 cracks were beginning to show beneath the smooth exterior of Sforza's autocracy. On 9th April Lorenzo de' Medici, Sforza's committed ally in Florence, died.[5] Ludovico could no longer count on Florentine support. Underlying tension between Sforza and his cousin Alfonso King of Naples began to mount. Alfonso's daughter, Duchess Isabelle, was the wife of Gian Galeazzo, Ludovico's nephew and the hereditary Duke of Milan. Ludovico was keeping both Isabelle and Gian Galeazzo virtual prisoners in Pavia while he ruled from the *Castello* in

Milan.[6] On 21st October 1494 Gian Galeazzo, aged only twenty-five, died suddenly and on 22nd October Ludovico was immediately proclaimed Duke. Many suspected that he had poisoned his own nephew to secure his title.[7] Sforza was afraid that Alfonso, enraged by the brutal treatment of his daughter, would stage a coup. An invasion of Milan by Naples loomed on the horizon.[8]

Sforza had sabotaged any possibility of reconciliation with Alfonzo when he invited King Charles VIII of France (1470-1498) to Milan. Charles arrived on 21st October in Pavia, where Sforza and his wife Beatrice d' Este entertained the King and his military leader Compte de Ligny with pomp and ceremony.[9] Charles was on his way to Naples with his powerful army, intending to claim Alfonso's territory. Sforza's alliance with Charles would, he hoped, afford him protection from southern attack.[10]

But the arrival of the French in Italy sent shock waves through the Italian states. Piero de' Medici (1472-1503), son and successor of Lorenzo, signed a treaty with Charles, offering him Pisa in a bid to persuade the French to bypass Florence.[11] But the treaty caused such horror among the Florentine citizens that Piero and his brothers were forced to flee under cover of night on 9th November 1494.[12] The Medici had been ousted. Violent mobs ransacked their palace. In their wake the Dominican monk Girolamo Savonarola (1452-1498), known as "the hound of the Lord",[13] filled the power vacuum, taking the credit for intercepting Charles' planned rout. He stoked hysteria by pronouncing the French army a precursor to Armageddon. There would follow the terrifying Bonfire of the Vanities on 7th February 1497, in which Savonarola stage-managed the public burning of artworks and books in the *Piazza della Signoria* to "purge" the sinful Republic.[14] Events would take on an alarming religious as well as political tone.

In the east the Venetians began to mobilize their devastating forces in preparation for bloody combat. Sforza's father-in-law, Ercole d' Este, Duke of Ferrara (1431-1505), was also concerned by Sforza's alliance with Charles. Not only was he fearful of the advanced French weaponry, but also of the potential threat of the now-armed Venetians. On 1st November 1494 Ercole arrived in Milan to negotiate with his son-in-law. The Duke of Ferrara was a force to be reckoned with. With a formidable army of his own, he was also incredibly rich, and Ludovico owed him somewhere in the region of 3000 *ducats*.[15] Sensing that his greed for power was beginning to have dangerous repercussions Sforza tried to

placate Ferrara. He offered Ercole a gift in the form of enough bronze to make cannon to defend his land against any potential invasion.[16] Ferrara was satisfied, at least temporarily.

But with this simple decision Sforza destroyed over ten years of artistic planning on the part of Leonardo. For, where was Sforza to obtain this bronze but from the supply meant for casting the sculpture that would have made Leonardo famous: his equestrian monument. On 17th November 1494 Ferrara's diplomatic records include the following note:

> "The Duke of Ferrara ... has ordered ... Albergeto, to make him 3 small cannon, one in the French style and 2 in another style. He has received from the Duke [Ludovico] a gift of 100 *meira* of metal, which had been purchased to make the Horse in memory of Duke Francesco ..."[17]

Leonardo's ambition to create the greatest military monument in history had been crushed. This must have been a terrible disappointment to him. Perhaps it was at this point that his loyalty to Sforza began to wane.

From then on letters from Leonardo to the Duke exhibit a new tension. Apparently ripped in two by a frustrated hand, perhaps never sent, the fragments of one note seem metaphoric of their tense relationship. When pieced together they read as follows:

> "... of the reward of my service ... Because I am unable to be ...
> My Lord, knowing Your Excellency's mind to be occupied ...
> ... to remind your Lordship with my small matters and I should have maintained silence ...
> ... that my silence should have been the cause of making your Lordship angry ...
> ... my life in your service.
> I hold myself ever in readiness to obey ...
> ... of the horse I say nothing because I know the times ..."[18]

Leonardo's irritation is patent. The letter hints at the artist absenting himself from court on his own business and the Duke's anger in response. A reminder of the unfinished equestrian monument–"the horse"–clearly at the forefront of Leonardo's mind, is cited as an example of unfulfilled promises. Leonardo's reference to "the times" and the Duke's "preoccupation" suggests he is aware of Milan's political vulnerability. Yet even this does not sooth Leonardo's disappointment.

Perhaps Sforza began to feel that his time was running out. He was now an old man of sixty-eight. In addition to the mounting political

tension, the duke experienced a personal loss. On 2nd January 1497 his beloved wife, Beatrice d' Este, died after giving birth to a stillborn baby.[19] Overnight the rhetoric at court changed dramatically. From a humanist focus on Classical learning the talk was now of Sforza's religiosity. He spent more and more time at the monastery of Santa Maria delle Grazie, the mausoleum of the Sforza dynasty where his wife was buried and where he himself planned to be laid to rest. It was time to pray.

Marino Sanuto (1466-1536), the contemporary Venetian historian, writing in August 1497 seven months after Beatrice's death, remarked that since his loss the Duke had become an altered man:

> "He is very religious, recites offices daily, observes fasts, and lives chastely and devoutly. His rooms are still hung with black, and he takes all his meals standing, and wears a long black cloak. He goes every day to visit the church where his wife is buried, and never leaves this undone, and much of his time is spent with the friars of the convent." [20]

The Dominican historian, Padre Rovegnatino, alive at the time, corroborates this change in the Duke's outlook, recording how during the following year Ludovico continued to visit the convent twice a week, on Tuesdays, the day of the week on which his wife died, which he kept as a fast, and on Saturday, when he dined with the prior Giovanni da Tortona and his successor Vincenzo Baldelli.[21] Twice weekly, then, the Duke passed in mourning from the grounds of his castle to the monastery, often sharing a silent meal with the monks in their long, cold refectory.

For the east end of the room he commissioned Leonardo to paint *The Last Supper* (1495-1497). The subject of this painting would have seemed particularly poignant to Sforza. It depicts the beginning of the Passion cycle, a sunset meal when Christ foretells the end of his life and predicts that one of his friends will betray him. Sforza might have read the parallels between Christ's doom and his own, and perhaps he was comforted by the comparison. At any rate the sombreness of Leonardo's masterpiece must have reflected the mood of impending disaster in Sforza's court.

As Leonardo worked, debates concerning his payment arose again. It seems Sforza's finances were much reduced.[22] On the 8th of June 1496 Leonardo seems to have lost his cool. One of the Duke's secretaries writes that "The painter ... caused something of a scandal today, and for this reason he has left".[23] Another segment of a letter from Leonardo to Sforza may explain the unusual behaviour described in the previous note:

"It vexes me greatly that you should have found me in need, and ... that my having to earn my living has forced me to interrupt the work and to attend to lesser matters instead of following up the work which your Lordship entrusted to me."[24]

The preferred "work" here probably relates to *The Last Supper*, and the "lesser matters" the scheme of interior decoration for Beatrice's *camerini* at the *Castello Sforzesco*, which he had been ordered to complete at the same time. The tone of vexation, originating from financial pressure and creative constraint, adds to the picture of diminishing rapport between Leonardo and his employer. And finally another note follows:

"Perhaps your Excellency did not give further orders to Messer Gualtieri [the Duke's dispenser of funds] believing I had money enough ... If your Lordship thought I had money, your Lordship was deceived."[25]

Abrupt and sarcastic, this note illustrates that communication between ruler and artist had become more strained than ever.

Sforza's depleted coffers spoke of the precariousness of his rule. Leonardo must have been aware that his own safety, as well as his financial security, hung in the balance. As he worked on *The Last Supper* and struggled to finish the *camerini*, the disgruntled artist must have started to consider alternative patrons whom he might turn to if Sforza fell. It can be no coincidence that it was at this time, in the mid 1490s, that Leonardo returned to the Confraternity of the Immaculate Conception at San Francesco Grande. *The Virgin of the Rocks* was a religious commission that would be safe even if power changed hands. He must have sensed that this was the end of an era. The forceful ruler who had launched Leonardo's career was on his way out. Leonardo's hometown of Florence was in the grip of religious turmoil. The Italian Wars were dawning. The great armies of Europe were mobilising. Change was in the air.

Escape

In early 1499 news reached Sforza that the new King of France, Louis XII, previously the Duke of Orleans, was mustering forces to invade Italy. He had a claim to the Duchy of Milan.[26] Previous alliances with France would not save Sforza now. As the French troops amassed on the borders Leonardo started to wind up his affairs. Dispensing small sums of money, he lists on 1st April 1499:

"Salai 20 *Lire*
For Fazio 2 *Lire*
Bartolomeo 4 *Lire*
Arigo 15 *Lire*"[27]

Meanwhile Sforza was anxiously preparing for the arrival of the French. In a note, probably from this time, Leonardo records artillery practice:

"In the park of the Duke of Milan I saw a 700 pound cannon-ball shot from the height of one *braccio*. It bounced 28 times ..."[28]

The Duke's arrangements were in vain. On 30th August Milan was in chaos. An anti-Sforza faction had grouped. Sforza's treasurer was murdered. On 2nd September Ludovico made his escape. He headed towards Innsbruck where he probably hoped to find safety with Maximilian I, the Holy Roman Emperor, still married to Sforza's niece.[29] On 6th September, with no resistance, Milan fell to the French.[30]

On 7th September 1499 the chronicler Corio writes:

"The mob gathered at the house of Ambrogio Curzio, and destroyed it completely, so that almost nothing of value could be found there; and the same was done to the garden of Bergonzio Botta, the Duke's master of payments, and to the palazzo and stables of Galeazzo Sanseverino, and to the house of Mariolo, Ludovico's chamberlain, recently built and not yet completed."[31]

Leonardo knew these men personally. He had probably designed Mariolo's house, which was next to his own estate.[32] Milan must have waited in terrified anticipation as the French King prepared to enter the city. On 6th October Louis XII and his military leader, Comte de Ligny, entered through the gates of Milan and crossed the drawbridge of the *Castello* in triumph.[33] They remained for about six weeks, a period of intense anxiety for those who had been close to Sforza.

Ever the pragmatist, it seems that Leonardo speedily made links with the occupiers. Since the premature death of Gian Galleazo in 1494, his widow, the Duchess Isabelle, and her son Francesco had been housed in a far wing of Leonardo's *Corte Vecchio*. They were the first to be "liberated" when the French arrived. It seems that Leonardo went out of his way to nurture a friendship with his neighbours. In 1499 he writes: "The Bath House of the Duchess ... to heat the water for the stove of the Duchess add three parts of hot water to four parts of cold water".[34] He was doing her favours, making her comfortable. Other notes from that year

suggest he was beginning to network in earnest. In a memo from this period he writes:

> "Find Ingil and tell him you will wait for him at Amor and that you will go to him to Ilopan."[35]

He was probably referring to Comte de Ligny, who he had met in 1494 when Charles VIII had visited Milan. Now, it seems, Leonardo wanted to make contact again and to join him in Napoli ("Ilopan"). Perhaps it was also at this time that he met Cesare Borgia (1475-1507), the son of the Pope, currently head of a squadron of the French army, and for whom he would later work as a military engineer.

Leonardo was almost certainly collaborating with the French. So, when in December 1499 rumours of Sforza's return percolated through Milan,[36] Leonardo must have thought it best to make a speedy exit. Loyalist factions were rooting for Sforza. He was expected to arrive with Swiss mercenaries and the backing of the Holy Roman Emperor.[37] In December 1499 Leonardo wrote a "to do" list in preparation for imminent departure. The final line, in particular, has an air of urgency:

> "Have 2 boxes made.
> Muleteer's blankets–or better, use the bedspreads. There are 3 of them, and you will leave one of them at Vinci.
> Take the braziers from the Grazie.
> Get the Theatre of Verona from Giovanni Lombardo.
> Buy tablecloths and towels, caps and shoes, 4 pairs of hose, a chamois jerkin and skins to make others.
> Alessandro's lathe.
> Sell what you cannot take with you."[38]

On 14th December Leonardo transferred 600 *florins* to an account in Florence at the Ospedale di Santa Maria Nuova.[39] He must have waited anxiously for several weeks before he heard news that the money, via a bill of exchange, had been safely deposited on 7th and 5th of January 1500.[40] Then, after eighteen years of absence, Leonardo left Milan for home.

.

In 1499, large areas of Leonardo's second *Virgin of the Rocks* remained incomplete: the hand of the angel propping up Christ's back is defined by a swift flick of the brush from the original underdrawing that shows through the top layer of paint. The landscape behind St John's shoulder is

little more than blocked in. The outer limit of Christ's forearm is loosely drawn with a sweeping stroke of the brush, still visible below the upper wash. Leonardo's practice of shading the figures before determining their final contours is clear; glazes of brown pigment in linseed oil extend like a web between Christ's toes.[41] The contours of the Virgin's extended left hand, too, appear undetermined; the effect is like that of a moving body caught in a blurred photograph. The underdrawing, still visible, has not been aligned with the ghostly highlighted fingers above. In his hasty escape Leonardo had left his second masterpiece unfinished.

Leonardo left the second *Virgin of the Rocks* in the care of the Confraternity at San Francesco Grande. He would not return until 1506.[42] The brotherhood would have to wait for nearly a decade before Leonardo would complete the commission. Its unfinished state was, in itself, a reflection of the political turmoil of the times.

CHAPTER NINE

INTERNATIONAL FAME

Between 1499 and 1506 Leonardo did not set eyes on *The Virgin of the Rocks*. However his frenetic activity during those years was in some ways the result of this painting. The Confraternity's commission had, after all, secured his fame. The first painting had grabbed Sforza's fancy and propelled Leonardo towards a grand career as court painter in Milan. It had allowed him the freedom to experiment in the realms of dissection and to develop his philosophical interests, which were then expressed in the second painting. When he left Milan, Leonardo was sought after by the richest and most influential patrons in Europe. He had become an international celebrity.

Clash of the Titans

Leonardo stopped off briefly in Mantua between December 1499 and January 1500, staying at the court of Sforza's sister-in-law, Isabelle d' Este, Marchioness of Mantua (1474-1539).[1] She was a rich, independent and fiercely ambitious young stateswoman with one of the finest collections of art in Europe.[2] In return for her hospitality Leonardo drew her portrait (Fig. 58), now at the Louvre in Paris, in the tradition of the Classical profile bust. From that time onwards Isabelle greedily coveted "a Leonardo" to add to her *camerino*. In 1501 correspondence between Isabella and her messenger Fra Pietro Novellara to Leonardo in Florence tells of a dance of pursuance and evasion. Isabelle had written to Leonardo personally, hoping in vain for a picture in the style "...devout and sweet as is naturally his [ie Leonardo's]".[3] Yet her demanding letters, ultimately frustrated, left a trail behind Leonardo as he flitted between states.

When Leonardo arrived back in Florence in April 1500[4] his fame had preceded him. He was immediately taken in by the Servite Friars at Santissima Annunziata, one of the richest monasteries in Florence, as an honoured guest, and commissioned to design an altarpiece for their church. When he finally completed the cartoon for *The Virgin and Child with St Anne* in c.1506 (now at the National Gallery in London), its public

reception was extraordinary. Vasari writes:

> "He kept them waiting for a long time without even starting anything, then
> he finally did the cartoon showing Our Lady with St Anne and the Infant
> Christ. This work not only won the astonished admiration of all the artists,
> but when it was finished for two days it attracted to the room where it was
> exhibited a crowd of men and women, young and old, who flocked there
> as if they were attending a great festival, to gaze in amazement at the
> marvels he had created."[5]

Such was the buzz that surrounded Leonardo. And this was not even a
finished work but a drawing. Here was the artist-genius.[6] Leonardo's
unique talents–the marks made by his *hand*–were now valued as much as a
completed painting. His elusive personality was intriguing in itself. In
1501-2 the humanist poet, Ugolino Verino, voiced the widely accepted
opinion that "Leonardo possibly surpasses everyone ..."[7]

Despite his warm reception Leonardo did not stay in Florence for long.
In 1502 he was in Romagna in the service of none other than the son of
Pope Alexander VI, the infamous Duke, Cesare Borgia.[8] Borgia's
character was made legendary by Leonardo's friend Niccolo Machiavelli
(1469-1527) in his book, *The Prince*, published later in 1532. Borgia was a
man unchallenged, invincible:

> "He arrives in one place before anyone knows he has left the other ... he
> is victorious and formidable."[9]

In 1501 Borgia had taken Camerino and set his sights on Bologna. The
Florentine *Signoria*, fearful that Florence might be next, may well have
promoted Leonardo's association with this warmonger for tactical
purposes. As a military engineer Leonardo went with Borgia, and finally
the projects that he had dreamed of as a young man were realised. He built
a canal from Cesena to the Porto Cesenatico, a vast engineering feat of the
kind he had written about in his CV of the early 1480s. He was given a
free passport to travel through Borgia's lands in August and was party to
the design of weaponry.[10] He must have witnessed terrible acts of violence
by the Borgia army during this period. It was an exciting albeit a
dangerous time for the middle-aged Leonardo.

Yet Borgia's power crumbled when the new Pope, Julius II (1443-
1513), succeeded in August 1503. Exhausted and probably rather relieved,
Leonardo returned to Florence where he started to paint the now
mythologized *Mona Lisa* between 1503-6 (Fig. 59). Fifty years later the
work acquired an iconic status. Vasari, in 1550, wrote of Leonardo's

magical ability to transform an inanimate painting into a real, breathing woman:

> "On looking closely at the pit of her throat one could swear that the pulses were beating."[11]

Vasari had never actually seen the painting, and he describes her beautiful eyebrows, when she has none. Yet his report, steeped in drama, reflects the hype that surrounded Leonardo during these years.

Then, in 1503, Leonardo was given a commission that reflected his now giant status. Promising to be the largest-scale painting and one of the most prestigious jobs of his life, this was to be a mural depicting *The Battle of Anghiari* for the *Sala del Gran Consiglio* of the *Palazzo della Signoria*, the Council Chamber of the Florentine government.[12] It was to commemorate the historic victory of the Florentine Republic against their enemies, the Pisans, in 1440. In undertaking this commission Leonardo would be poised in battle himself, pitted against the young Michelangelo who was asked to paint the opposite wall.[13] We can imagine these two men: Leonardo, in his early fifties, civil and private, sharing an uncomfortable space with the aggressively ambitious and rather brutish Michelangelo in his late twenties. The atmosphere must have been electric as the citizens of Florence prepared for this spectacle: the titans of the Tuscan Renaissance in fierce combat.

Leonardo's experience of war under Borgia must have fed into his preparation for this project. In a study for the mural (c.1503-4), *Study of the Heads of Two Soldiers*, now in Budapest, Szépmüséveszeti (Fig. 60), Leonardo depicts a man screaming: his mouth gapes open, teeth bared and forehead contorted in agony.[14] Also linked to this commission are studies of the human body that illustrate Leonardo's ever-growing understanding of anatomy. A drawing of *A male nude, and a partial study of the left leg* in red chalk on red-prepared paper in the Royal Collection (Fig. 61)[15] dates from this time, and is evidence of a particular interest in the neck and shoulder region. The model stands, holding a stick in each hand to prop up his arms and take the strain off his shoulders, allowing Leonardo to show the shoulder muscles in a relaxed state and the rounded cuffs of the shoulder blades. In the neck, the sternocleidomastoid and omohyoid muscles and the jugular notch are clearly depicted.[16] In another sketch, *The muscles of the shoulder, torso and leg* of c.1504-6 (Fig. 62), with a small compositional study directly relating to *The Battle of Anghiari* in the left corner, Leonardo focuses in on this same anatomical area.[17] The arm is

cut away to show the external abdominal obliques of the trunk. Five muscle bodies on the shoulder are labelled: *a* is the clavicular portion of the pectoralis major; *b, c, d* and *o* are portions of the deltoid.[18] With this highly defined muscle bulk Leonardo's models become supermen, representing the body politic of the Florentine nation.[19]

Having worked up many such preparatory drawings into a finished cartoon, in June 1505 Leonardo started to paint the mural, and his own transformation from lowly craftsman to celebrity artist of the Italian Renaissance seems to have been complete. Standing in the Council Chamber, the control-room of the Florentine Republic, he might have imagined the crenelated tower of this medieval fortress reaching towards the sky above his head. The city that had once outlawed him seemed finally to have embraced their wandering genius.

………

But Leonardo was never to finish the commission for the Great Council Chamber. Perhaps the intensity of the competition and the publicity it attracted was too much pressure to bear. The stakes were high. He probably suspected the *Signoria* of staging this artistic battle specifically to force him to finish the work. His history of not completing commissions probably still coloured his reputation. He may have resented the association with Michelangelo. Perhaps, too, Leonardo anticipated a technical embarrassment. As with *The Last Supper*, where his use of linseed oil rather than fresco was already proving disastrous,[20] maybe he foresaw that the painting was destined not to stick.[21] The strain of such a large project so soon after the exhausting experience of Borgia employment, coupled with a new taste for engineering, may have felt too much like a chore. And the economic environment in Florence was unattractive. It was a time of financial stress after Savonarola's theocracy and the Medici were still outlawed. Several of the guilds were bankrupt. A costly war with Pisa, given to the French in 1494, had depleted the treasury.[22] Leonardo must have longed for the intellectual and financial freedom that he had enjoyed in the early years under Sforza. When, in 1506, a letter arrived from the French court in Milan asking him to return,[23] Leonardo was probably happy to oblige.

The French King, Louis XII, was now in power. Perhaps Leonardo hoped this might be the patron he had been looking for. He asked the *Signoria* for permission to leave Florence for a period of no longer than three months, [24] promising to resume work on the *Anghiar*i fresco

thereafter. He left many of his possessions, including his now vast collection of manuscripts, in the bank vaults at the Ospedale di Santa Maria Nuova as assurance against his return[25] and he set out on the week-long journey to Milan across the Apennines once more.

An Honoured Guest

The letter from the Confraternity of 1506 was the upshot of a continuing dispute over *The Virgin of the Rocks* that had been brewing in Milan whilst Leonardo was away. In 1503, as Leonardo was painting the *Mona Lisa* and preparing the cartoons for the *Anghiari* fresco, Ambrogio de Predis was launching another complaint, this time addressed to Louis XII of France (1462-1515), demanding additional payment. Louis ordered the judge Bernardino de' Busti to investigate. In 1506 the court order ruled against the painters. The central panel–Leonardo's painting–was found to be *"imperfetto"*, that is "unfinished" or "not good enough". Leonardo, in absentia, was ordered to complete it within two years [26] and the Confraternity to pay the painters a slightly increased fee of 200 *Lire*. The deadline for completion was now 26th April 1508.[27]

When Leonardo returned to Milan in 1506 he was greeted with great enthusiasm by the French governor of Milan, the energetic thirty-three year-old Charles d'Amboise, an art connoisseur and lover of beauty. Leonardo became an honoured guest in the enormous red brick *Castello*. His reputation now preceded him and he was treated with awe and respect. Charles writes ecstatically of Leonardo:

> "We loved him before meeting him in person, and now that we have been in his company, and can speak from experience of his varied talents, we see in truth that his name, though already famous for painting, has not received sufficient praise for the many other gifts he possesses, which are of an extraordinary power."[28]

Leonardo was once more swept up in the excitement of court life, but this time the court of a European superpower. Great opportunities now presented themselves. Charles wanted him to design a summer villa outside the Porta Venezia.[29] It was to have pleasure gardens, musical fountains and airy rooms. This was a vast project and the French governor was willing to pay highly for Leonardo's time.[30] Louis XII had been so impressed by *The Last Supper* that he had initially wanted it taken from the wall and brought to France. Having heard great things from d'Amboise, the King ordered two Madonnas in oil paint by the "hand" of

Leonardo.[31] It became clear that Leonardo would need to stay in Milan for longer than three months if he was to fulfil his new obligations to the French.

A string of letters now flew between the French Count in Milan and the *Signoria* in Florence, negotiating Leonardo's extended stay. When faced with the political might of the French monarchy, the Florentine governor Soderini did not stand a chance. Leonardo was still in Milan in October. When, on 9th October, Soderini wrote an angry letter requesting Leonardo's immediate return on the grounds that the artist had not "behaved as he should have done towards the Republic"[32] the French King himself got involved. A letter dated 14th January 1507 from Louis XII to d'Amboise states that:

> "we have necessary need of Leonardo ... Please write to him that he should not leave the city [Milan] before our arrival ..."[33]

The *Signoria* was forced to back down and grudgingly, in a final letter of 22nd January 1507, permitted Leonardo to stay.[34]

This was a boon indeed for Leonardo. But it did not necessarily bode well for the completion of *The Virgin of the Rocks*. The Milanese Confraternity could hardly have competed with the will of a King. Unsurprisingly, by 1507 tension had developed between Leonardo and Ambrogio de Predis, his collaborator, to such a degree that they needed a mediator.[35] The quarrel seems to have been about the apportioning of payments for *The Virgin of the Rocks*. Apparently Leonardo had not put much, if any, time into the painting since his arrival in Milan. On 26th August 1507, when the Confraternity paid their first instalment of the readjusted fee, the money was collected by Ambrogio.[36] By implication he at least had fulfilled his part of the bargain.

Memories

On 26th of August 1507, however, Leonardo was unable to collect his payment because he was no longer in Milan.[37] Just as *The Virgin of the Rocks* seemed near completion he was forced to return once more to Florence. It was not the doing of the *Signoria*, however, but a family matter that drew him there. His favourite uncle Francesco had died suddenly earlier in 1507, naming Leonardo as his sole heir. But the legitimate sons of Ser Piero, Leonardo's father, contested his claim to Francesco's fortune and there ensued a vicious legal battle between

Leonardo and his half-brothers. Leonardo apparently hoped to resolve this dispute in person.[38]

Against the backdrop of legal minutiae and emotional confrontations Leonardo's stay in Florence did afford him the opportunity to revisit his intellectual research. He had left his vast store of manuscripts, amassed over the previous twenty years, in the vaults of the Florentine bank. He now collected them and retired to his lodgings at the Palazzo Martelli, the home of a wealthy mathematician friend, where he was staying with Salai.[39] Here he started to organize his notebooks. This was a mammoth task and to help him in the project Leonardo employed a scribe and administrative assistant, Francesco Melzi (c.1491-1570). This young man had travelled with him from Milan to Florence and would prove a loyal friend and scribe for the rest of Leonardo's life.[40] Together they compiled the *Codex Leicester*, now owned by Bill Gates, on geophysics. Leonardo reread earlier musings, copying out notes into a neater format. Famously, probably at around this time, he made the poetic analogy between the earth and the human form:

> "we might say that the earth has a spirit of growth, and that its flesh is the soil, its bones are the … rock, its cartilage is the tufa, its blood the veins of its waters. The lake of blood that lies around the heart is the ocean. Its breathing is by the increase and decrease of blood in its pulses, and even so in the earth is the ebb and flow of the sea."[41]

These were the ideas that had held such importance for the Christian interpretation of *The Virgin of the Rocks*, where the cave in which Mary sits becomes the "*cavo*" or "womb" of the earth.

Leonardo also returned to the scientific study of the human form. Early in 1508, at the Ospedale di Santa Maria Nuova, he dissected the body of a two year-old child,[42] looking into the vascular system and further developing the multiple views and transparencies that he had explored in the early 1490s. It was here too that he watched a man, more than one hundred years old, die in his sleep and made "an anatomy to see the cause of a death so sweet".[43]

Leonardo's interlude in Florence must have been full of powerful memories, a consolidation of learning as well as a time of new discoveries. In his mind scientific research must have become intermingled with earlier mystical theories. The ideas, as he himself writes, seemed repetitive, circular, inter-related; they were somehow both finite and never-ending in a manner that made them difficult to categorise.

"I fear that before I have completed this I shall have repeated the same thing several times ... because the subjects are so many."[44]

………

The deadline for *The Virgin of the Rocks* was fast approaching. Leonardo still owed Louis XII two paintings, and Charles d'Amboise wanted him back in Milan. In the spring of 1508 Leonardo drew upon his French allies for legal support. A signed letter from the King of France to the Florentine *Signoria* supported Leonardo's case against his half-brothers,[45] and d'Amboise followed this up with a request that the artist return *subito*. Pressure from the French seems to have worked once more because early in 1508 Leonardo sent a letter in the care of Salai to d'Amboise, signalling that the dispute was almost resolved and that he would be back by Easter, the end of April 1508. At around that time Leonardo left Florence again, taking his manuscripts with him.

The Final Touches

When Leonardo arrived in Milan in April 1508, twenty-five years had passed since he had first presented himself at the Sforza court. He was now a man in late middle-age and this would be his last stay in that city. He had said goodbye to his family in Florence; his favourite uncle was dead. It was time to complete the commission for the Confraternity of the Immaculate Conception and to conclude his affairs in Milan. The altarpiece was probably already in place in the chapel in San Francesco Grande[46] and Leonardo's central panel was the only section yet to be completed.

The painting, as it stood, had been judged "imperfect" by the Confraternity, and there were stipulations that must now be met before Leonardo would be released from his responsibilities. The 1483 contract stated that Leonardo was to use expensive ultramarine-containing paint. The most valuable pigment at that time, ultramarine was made by grinding the semi-precious stone Lapis Lazuli to powder before mixing it with an oil binder. Its name came from the Latin *ultramarinus*, literally meaning "beyond the sea", because it was imported into Europe from mines in Afghanistan by Italian traders during the fourteenth and fifteenth centuries. It was usually used for the most precious areas of a panel painting, such as the robes of the Virgin, to symbolize her holiness.[47]

In the mid-1490s, probably to cut corners as funds dwindled, Leonardo had painted the first layer of sky and Mary's robes in the cheaper azurite blue.[48] In 1508 however, he needed to rectify this. It is thought that he may have employed assistants to paint a second layer of ultramarine directly onto the underlayer of lead white and azurite. This second, more expensive, paint layer forms a lip under the arched edge of the frame, while the azurite continues beneath it: apparently the ultramarine was applied in situ when the painting was already in the frame.[49] On the right of the composition too, an upper layer of ultramarine bound in walnut oil peeps over the edge of the brown rocks beneath.[50] And over the Virgin's draperies a second layer was applied in natural ultramarine-containing paint.[51] Leonardo now widened Mary's right shoulder, in line with his latest anatomical studies for *The Battle of Anghiari*, and tucked her skirts closer around her knees by superimposing a layer of brown over the blue at her left knee.[52]

He also introduced the haloes in mordant gilding, probably with the help of an apprentice. A thin curve of oil adhesive or mordant would have been brushed on in the shape of the halo and allowed to thicken. Meanwhile a leaf of flattened gold was prepared and then laid on the sticky mordant. When dry the gold was brushed lightly to remove any excess. A combination of tin and gold leaf was used for the cross.[53] For the Confraternity the gilding would enhance the religious message of the painting while adding to its retail value. This was probably an exercise in box-ticking for Leonardo.[54]

The brotherhood would have wanted proof of Leonardo's unique authorship, something to show that the celebrity Florentine had worked his magic on their panel. It could have been at this point that Leonardo, with the finest ermine brush, delicately applied the threads of gold to the angel's shoulder and the flecks of ginger to the children's curls. As delicate as cobweb traces, these minute strokes could only have been painted by Leonardo. We might imagine him, with a knowing air, using his fingertips to smudge the chalky white highlights of the Virgin's cheeks and the shoulder of Christ. Now no one could dispute the fact that this panel had been touched by the "hand" of the "genius" himself.[55]

The Confraternity must have been satisfied. The artist courted by the greatest rulers in Europe had put his mark upon their panel. On 18th August 1508 there appears another legal document releasing the Confraternity from its earlier contract with the painters.[56] The altarpiece in its entirety could now hang in its rightful place above the altar in the

Chapel of the Immaculate Conception in the Church of San Francesco Grande. Twenty-five years of hard work, intellectual and artistic endeavour, personal growth and political manoeuvring had come to fruition. The second *Virgin of the Rocks* was officially complete.[57]

POST SCRIPT

"The most eagerly awaited exhibition in living memory"

Perhaps unsurprisingly this was not the end of the story. The second *Virgin of the Rocks* did not stay in the Chapel of the Immaculate Conception for long. The Confraternity were still loath to pay up. As an alternative, in lieu of payment, the artists were allowed to make yet another copy. This they would then be able to sell for cash. The Confraternity promised to

> "deposit the said painting in a room in the convent of San Francesco for a period of up to four months so that Dominus Leonardus and his assistants can make a copy of it, except that on holy days it is to be restored to its place."[1]

That day the painters signed an agreement stating that Ambrogio de Predis would make this copy at his own expense and that Leonardo would direct him. The proceeds from this work would then be divided between them.[2] The location of this third copy is still a mystery. Perhaps it is the painting now held at the Biblioteca Ambrosiana in Milan or it could even be the version in a private collection in Switzerland.[3]

In 1576 the chapel was demolished and the second *Virgin of the Rocks* was re-housed in a chapel in the body of San Francesco Grande. It was so heavy that a bier was needed to raise it.[4] The suppression of the Confraternity in 1781 led to more changes. As part of a wave of Catholic reform and the redistribution of the wealth of confraternities to the poor the belongings of the Confraternity of the Immaculate Conception, including the altarpiece, were annexed by the Hospital of Santa Caterina alla Ruota.[5] In July 1785 Gavin Hamilton, the Scottish collector and Neo-Classical artist known for his Grand Tour portraits, came across the altarpiece when he visited Santa Caterina alla Ruota. He bought it from the administrative director Count Cicogna for 1,582 *Lire* and carried it back to England.[6] Hamilton almost immediately passed it on to Lord Lansdowne.[7] In 1808 it was purchased by the Earl of Suffolk whose descendants sold it to the National Gallery in London in 1880 for 9000 guineas.[8] There it formed the core of the national collection in England where the Italian Renaissance style was seen as the height of fashion. The side panels of the

altarpiece, with angels painted by Ambrogio de Predis, remained in the Church of San Francesco Grande until 1798 when the church was secularized. They were confiscated by the Fondo di Religione of the Napoleonic government and then bought by Cavalier Melzi in 1809. In 1898 they were bought by the National Gallery in London and reunited with Leonardo's central panel.[9]

The story of the first painting and its path to the Louvre in Paris is yet more mysterious. We know that it was in the French Royal Collection from 1627.[10] It probably disappeared from Milan sometime around 1490. It is almost certain that the Confraternity never received the picture. If they had it, that would have been the end of the story. The "disappearance" would have been mentioned in the legal documents.

It is likely that in c.1492 Sforza gave it to Maximilian I, Holy Roman Emperor, perhaps as a wedding present. Ambrogio de Predis was present at Maximilian's court at Innsbruck in 1493 and may have been delivering the painting in person.[11] Or it could be that Louis XII acquired it in around 1500-1503. In any case, since 1627 the first *Virgin of the Rocks* has remained at the Louvre, unmoved for over four hundred years.[12]

That was until 2011. Between November 9th 2011 and February 5th 2012 the National Gallery in London ran a blockbuster exhibition, "Leonardo da Vinci, Painter at the Court of Milan". Curated by Luke Syson, it brought together the largest number of Leonardo's paintings ever seen in one exhibition, including international loans never before seen in the UK. The climax of this exhibition was the room where hung the two paintings of *The Virgin of the Rocks*. For the first time in history Leonardo's two masterpieces were united under one roof. Facing one another across a vast, darkened space, accompanied by the echoing tones of recorded plainsong, they seemed to speak to each other: the same subject, a single commission, yet worlds apart. The extent of Leonardo's stylistic development over those twenty-five years could not have been made more clearly. The Director of the National Gallery, Dr. Nicholas Penny said:

> "I am quite sure that the experience of seeing these masterpieces juxtaposed will be one that none of us will ever forget, or that will ever be repeated."[13]

The enormity of this moment was not lost on the press. *The Independent* newspaper proclaimed: "Reunited after centuries, the pair now face each other across a space … as charged as the one between the

forefingers of God and Adam on Michelangelo's Sistine Chapel ceiling."[14] *The Guardian's* Laura Cumming wrote, "The National Gallery's once-in-a-lifetime show is a revelation from first to last".[15] *The Telegraph's* Richard Dorment pronounced the exhibition: "… the most eagerly awaited London exhibition in living memory".[16]

As forecast, the success of the National Gallery exhibition was record-breaking. Vasari had described the hype surrounding Leonardo when the cartoon of *The Virgin and Child with St Anne* was first unveiled in Florence in 1501:

> "When it was finished for two days it attracted to the room where it was exhibited a crowd of men and women, young and old, who flocked there as if they were attending a great festival, to gaze in amazement at the marvels he had created."[17]

But in 2011, public fascination far exceeded anything previously experienced. Visitors from around the world queued at dawn in London's Trafalgar Square to claim their tickets. Decisions to extend opening hours and to open the exhibition on 1st January 2012 were implemented to satisfy the additional 20% demand above normal capacity. The show was broadcast in 40 cinemas across the UK in order to bring the exhibition to the widest possible audience and to satisfy the hundreds who had not managed to secure tickets. In total it attracted 323,897 visitors,[18] more than six times the numbers normally admitted to exhibitions at the Sainsbury Wing,[19] and a huge portion of the year's total five million visitors. Five hundred years after its completion *The Virgin of the Rocks* was an international sensation.

Bringing together two such important works by Leonardo represented more than a breakthrough in art historical scholarship. It was a diplomatic triumph, made possible by the generosity of the Louvre in lending their *Virgin of the Rocks*, and the result of five years of negotiations with museums in Italy, France, the US, Russia and Poland, to persuade them to lend their masterpieces. Since *The Virgin of the Rocks'* conception, it had been used as a political tool: first by Leonardo to secure the patronage of Sforza, then by Sforza himself to exhibit Milanese cultural supremacy and to woo Maximilian I, and later as a bargaining chip to entice Leonardo back to Milan. But in 2011 the *Virgin of the Rocks* became an icon of British culture. At a time of deep economic uncertainty, continuing depression in the markets, and crippling inaction in the Eurozone, Leonardo's *Virgin of the Rocks* came to be seen as a symbol of unity, collaboration and cultural wealth in the global marketplace.

Life after *The Virgin of the Rocks*: Politics and Artistic Status

Leonardo's life had always been a careful dance with power and the story of *The Virgin of the Rocks* was no exception. From his early years Leonardo trod a delicate line between creative independence and financial reliance on his patrons. Realizing that he would never thrive under Lorenzo de' Medici in Florence he took a chance with the ambitious Ludovico Sforza in Milan, a ruler with huge financial prospects, military might, and an equestrian monument to design. The first *Virgin of the Rocks* of c.1483 had been as much an attempt to impress Sforza as to fulfil the Confraternity's religious aspirations. In 1484, around the time that the first painting was completed, Sforza had invited Charles VII of France to Milan, seeking his protection from Alfonso, King of Naples. There followed tension between the Italian States and the superpower, France. As the decade progressed Sforza was, ironically, in need of support *against* the French. When in the early 1490s the first *Virgin of the Rocks* disappeared it was probably Sforza himself who "liberated" the masterpiece in a bid to secure the support of the Holy Roman Emperor.[20] The painting had already become a pawn in international politics.

The creation of the second *Virgin of the Rocks* was, then, a by-product of Sforza's power politics. Its protracted first stage of painting, between c.1484 and 1499, was the result of Leonardo's preoccupation with Sforza's requirements and the intellectual independence his post as court painter afforded him. In the end Sforza's attempt to retain control of his territories was futile when faced with the superior weaponry of the French. His flight in 1499 led to Leonardo's own swift exit from the city, leaving the fate of the second painting hanging in the balance. Later it was the political stability afforded by French occupation and the artistic taste of the French ambassador Charles d'Amboise, that made possible Leonardo's return to Milan in 1508 and the completion of the altarpiece.

The patronage of the French had, perhaps ironically, allowed Leonardo to reduce his artistic output so that the second *Virgin of the Rocks* was in fact one of his last paintings. This makes its survival even more poignant. After 1508 Leonardo all but retired from menial matters of the brush and concentrated almost exclusively on his intellectual research. During the next few years in French Milan he worked on a manuscript entitled *The World and its Waters*, on the *Codex Arundel*, and, he wrote, "this winter of 1510 I believe I shall finish all this anatomy".[21] From Milan it was a short journey to Pavia, where he spent many months attending the anatomy

lectures of Marcantonio della Torre (1481-1511), with whom he collaborated very closely until della Torre's death in 1511.[22]

We might say that *The Virgin of the Rocks* had started a prosperous cycle of patronage and status. Yet just when Leonardo's reputation seemed to have peaked, it rose still higher. In 1513, after the death of Charles d'Amboise, Leonardo was summoned to Rome by the new Pope, Giovanni de' Medici (Leo X).[23] Leonardo was to become the jewel in the crown of the High Renaissance. Rome, a hive of artistic activity, was in the midst of a second "Golden Age". Michelangelo had recently completed the Sistine Chapel ceiling (1508-12), Raphael was hard at work on the Papal apartments or *Stanze* (1511-14), and Bramante was planning the new St Peter's Basilica. But Leonardo's immense stature within this city of culture is illustrated clearly in one of the most iconic paintings of the Roman High Renaissance, Raphael's *School of Athens* (Fig. 63), completed in 1511 for Pope Julius II, the second Julius Caesar, the Emperor of the Catholic domain, the great "warrior pope".[24]

In the papal apartments, on the wall above Pope Julius II's collection of philosophical texts in his *Stanza della Segnatura*, Raphael painted in fresco a polyphonic composition. Over twenty philosophers of the Classical world are represented in a hubbub of discussion under an immense barrel vault. Interestingly, Raphael painted the faces of contemporary artists onto the bodies of these Classical philosophers, a reference to what he saw as the quite literal "rebirth" of superior Classical culture in Julius II's court. In the lower left corner Pythagoras, with the face of Leonardo's friend, the architect Bramante, teaches youngsters geometry; Zoroastro, with the features of Michelangelo, sits brooding central stage, and Raphael himself peers out from a group on the right. But towering above all the others, the focal point of the composition, are Plato and Aristotle, the fathers of Classical philosophy. Plato has the features and beard of Leonardo.[25] At the court of the most powerful man in the western world, Leonardo was seen as the true heir to Classical culture.

This was the scene on which Leonardo entered in 1513. In Raphael's painting Leonardo looks down over his younger contemporaries, spatially removed and a generation older, revered yet alone in thought. When Leonardo arrived in Rome at the age of sixty-one he does seem to have remained aloof from the frenetic competition of the younger artists. He was housed at the Palazzo Belvedere along with his now large entourage (a list of additional items needed in his new accommodation included four dining tables, eight stools and three benches).[26] We might imagine him

enjoying the seclusion of this palace with its spacious rooms and wild gardens dotted with the Pope's famous Classical sculpture collection. His notebooks show a preoccupation with floods and torrents and he continued his anatomical research at the hospital of Santo Spirito.[27] In the suffocating heat of the Roman summer of 1515 his health started to decline. Later, in 1517, we hear from Cardinal Antonio de Beatis, the amanuensis of Luigi of Aragon, that Leonardo's right arm had some time previously been paralysed, perhaps by a stroke.[28] His painting ceased entirely.

Yet Leonardo's worth was no longer measured by his artistic output. It was merely his presence that was required. It was in this state of delicate health and incredible fame that Leonardo met his last great patron and another thread in the story of the *Virgin of the Rocks* was tied up. In October 1515 he began the journey to Florence and Bologna as part of the entourage of Pope Leo X, bound for a historic summit with the new King François I of France. Arriving on December 7, 1515, this was a meeting of superpowers.[29] Their mission: to broker a peace treaty for Christianity after the political instability of the past twenty years, a tumultuous period that had, in part, been unleashed by Ludovico Sforza. Here then, Sforza's involvement in the story of Leonardo's life had come full circle.

The feisty twenty-one-year-old monarch took an instant liking to the elderly Leonardo, regarding him it seems as something of a magician, celebrity and playmate. The full range of Leonardo's talents was finally acknowledged by this young Frenchman.[30] Sometime in August or September 1516, at the age of sixty-four, Leonardo embarked on the longest journey of his life. Accompanied by Melzi and his Milanese servant Battista de Vilanis, he headed north through the mountains with François I to settle in the Loire Valley as "Painter to the King".[31] The Mannerist sculptor Benvenuto Cellini (1500-1571), who later worked for François, recalled the King's own memories of Leonardo:

"Because he was a man of such plentiful and great talents, and had some knowledge of Latin and Greek, *King François was completely besotted* with those great virtues of Leonardo's, and took such pleasure in hearing him discourse that there were few days in the year when he was parted from him, which was one of the reasons why Leonardo did not manage to pursue to the end his miraculous studies, done with such discipline. I cannot resist repeating the words which I heard the King say of him. He said he could never believe there was another man born in this world who knew as much as Leonardo, and not only of sculpture, painting and architecture, and that truly he was a great philosopher."[32] [Author's emphasis.]

Comfortably settled, with an immense pension of 1000 *scudi* per annum,[33] Leonardo lived his last years with security and companionship. In 1519 he died at his manor house, half a mile south of the great royal residency of Amboise at Cloux, a veritable tourist attraction.[34] His fame now outshone any living artist, a fame that had, in many ways, started with *The Virgin of the Rocks*.

BIOGRAPHY OF LEONARDO

1452: On 15th April, Leonardo is born near the hilltop town of Vinci, Tuscany, the illegitimate son of a notary, Ser Piero di Antonio da Vinci (b.1426) and a peasant girl, Caterina di Meo Lippi.

1457: According to his grandfather's tax declaration, Leonardo lives with his father.

1469: Ser Piero rents a house on Via delle Prestanze (now the Via dei Gondi), in the city of Florence and, probably around the same time, Leonardo starts an apprenticeship in the workshop of Andrea del Verrocchio.

1472: Leonardo enters the *Compagnia di San Luca*, a society of painters linked to the doctors' guild (the *Arte dei Medici e Speziali*) in Florence. He is now eligible to set up his own workshop in Florence. He continues to work for Verrocchio, helping to complete works such as the *Baptism of Christ.*

1476: In April Leonardo is anonymously accused of homosexual activity with the seventeen-year-old painters' assistant, Jacopo Saltarelli. The same accusation was repeated in June, however Leonardo was never charged.

1478: Leonardo completes the *Portrait of Ginevre de' Benci* (1478-80) for Bernardo Bembo.

1481: In March Leonardo is commissioned to paint a large altarpiece with the *Adoration of the Magi* for San Donato a Scopeto, a church outside the city walls of Florence. Leonardo does not complete this painting.

1482: Leonardo moves from Florence to Milan and offers his services to Ludovico Sforza, the ruler of Milan.

1483: 25th April Leonardo signs a contract, along with the Milanese brothers Ambrogio and Evangelista de Predis, promising to complete the altarpainting known as the *Virgin of the Rocks* (now at the Louvre, Paris). The commission was from the Confraternity of the Immaculate Conception for their chapel in the Church of San Francesco Grande, Milan. This first version was probably completed by c.1486.

1489: Leonardo starts work on the *Equestrian Monument* commissioned by Ludovico Sforza. Leonardo is now probably working as a court artist and completes the portrait of Sforza's lover, Cecelia Ghalerani, also

known as the *Lady with an Ermine*. He is also responsible for designing pageants and heraldry. As official court artist, Leonardo moves into the *Corte Vecchio* in the centre of Milan, where he sets up his *fabbrica* or factory-like workshop.

1490-93: On 22nd July 1490, aged thirty-seven, Leonardo adopts the ten-year-old, Giacomo Caprotti who he calls Salai ("little devil"). Leonardo and the de Predis brothers petition Sforza to support their claim for additional funding towards the *Virgin of the Rocks*. The painters claim that their money has been used for gilding the frame, amongst other necessary work, and there is not enough left to pay Leonardo for the central panel. The Confraternity do not pay up, however a mysterious competitor, perhaps Sforza himself, steps in to take the painting. The first *Virgin of the Rocks* is lost to the Confraternity. Leonardo starts his anatomical research for his book, *On the Human Form*.

1495: Leonardo's mother, who had probably arrived at the *Corte Vecchio* in 1493, dies.

1495-8: Leonardo is commissioned by Ludovico Sforza to paint the *Last Supper* in the refectory of the monastery of Santa Maria delle Grazie, Milan. Leonardo works with Luca Paccioli on his book, *On Divine Proportion* (published 1498). Having taught himself the rudiments of Latin in order to read philosophical and scientific texts, Leonardo takes centre stage in intellectual court circles and creates the knot pattern, *School of Leonardo da Vinci*. Sforza's power base starts to crumble, as does the relationship between Leonardo and the Duke. At around this same time Leonardo starts work on the second *Virgin of the Rocks* (now at the National Gallery, London) to replace the one lost.

1499: Ludovico Sforza flees Milan in the wake of the French King, Louis XII. Leonardo escapes Milan in December, probably leaving the still unfinished second *Virgin of the Rocks* with the Confraternity. He makes a brief stop in Mantua at the court of Isabelle d' Este (where he paints her portrait), but continues on quickly to Venice.

1500: In April Leonardo arrives in Florence. Here he lives with the Servite monks at the Church of SS. Annunziata whilst completing their commission for a cartoon of the *Virgin and Child with St Anne.*

1502: At around this time Leonardo sets out on his travels around Italy as an architect and military engineer to the formidable mercenary leader Cesare Borgio.

1503: Leonardo returns to Florence in March and starts to paint the *Mona Lisa*. In October Leonardo starts to paint the most prestigious and monumental of all his paintings, the *Battle of Anghiari*, a mural for the

Great Council Chamber of the *Palazzo Vecchio*, Florence. His status is vastly increased since his early years in that city.

1506: Leonardo gains permission from the *Gonafaloniere* of Florence, Soderini, to visit Milan for three months. This is in response to a court order that set a deadline for the completion of the second **Virgin of the Rocks** at 26th April 1508. Leonardo leaves the **Battle of Anghiari** incomplete and stays away longer than three months. Leonardo is welcomed by the French governor in Milan, Charles d'Amboise and put to work designing a summer villa in Milan. Leonardo does not have time to work on the **Virgin of the Rocks**.

1507: On account of family disputes over inheritance after the death of his uncle, Leonardo returns to Florence. The Florentine *Signoria* attempt to keep him there, however, following an intervention by the King of France, Leonardo is allowed to return to Milan.

1508: In April Leonardo arrives back in Milan to put the finishing touches to the second **Virgin of the Rocks** (now at the National Gallery, London), including the gilding and a second layer of lapis lazuli for the sky and Mary's gown. On 18th August it is finally completed. Leonardo remains in Milan working for Charles d' Amboise.

1513: After the death of Charles d'Amboise in 1511 and the expulsion of the French from Milan in 1512, Leonardo goes to Rome with his new patron, Giuliano de' Medici, brother of Pope Leo X, where he lives as part of the papal court in the Palazzo Belvedere.

1516: With the death of his patron, Giuliano de' Medici, Leonardo takes up an offer from the French King, François I, and travels to his court in France. Here he is given a comfortable manor house at Cloux near the royal palace of Amboise, and is on friendly terms with the King.

1519: On 2nd May Leonardo dies in Cloux with, as legend would have it, the King of France at his deathbed.

1520-30: Leonardo leaves his manuscripts to his pupil Francesco Melzi, who organises them and compiles the **Treatise on Painting**, a collection of practical and theoretical instructions for painters. Salai inherits most of the paintings. On the violent death of Salai in Milan in 1525 Leonardo's estate is found to contain, amongst other paintings, the **Virgin and Child with St Anne**, **St John the Baptist**, **Leda and the Swan**, and the **Mona Lisa**. After this, possibly in the 1530s, the King of France acquired some of these paintings, which still remain in the Louvre today.

NOTES

Acknowledgements and Foreword

[1] Richard A. Turner, *Inventing Leonardo: Anatomy of a Legend* (Berkley: University of California Press, 1992).

[2] Traditionally (see, for example, Kenneth Clark, *Leonardo da Vinci*, intro. Martin Kemp (London: Penguin 1989)) the Louvre's *Virgin of the Rocks* has been seen as technically superior. Following recent technical research in preparation for the National Gallery Leonardo exhibition of 2011, scholars have accepted the London version as primarily by the hand of Leonardo himself, and as illustrative of a more mature style. See Jill Dunkerton, "Leonardo in Verrocchio's Workshop: Re-examining the Technical Evidence," in "Leonardo da Vinci: Pupil, Painter, Master," *National Gallery Technical Bulletin* 32 (2011): 4-31.

[3] Erwin Panofsky proposed that, beyond the symbolic, or iconographical, level of artistic meaning (such as the Christian iconography of a work), there is a culturally specific, iconological level. This can only truly be understood with an appreciation of the personal, cultural and socio-political environment in which an artwork is produced at a particular moment in history. See Erwin Panofsky, *Studies in Iconology* (Oxford: Oxford University Press, 1939).

[4] Ernst Gombrich, *Art and Illusion* (London: Phaidon, 1960).

[5] Penny Huntsman, *Thinking About Art: A Thematic Guide to Art History* (London: Wiley, 2015).

Chapter One: Exploding the Limits of Painting

[1] Recent histories of the senses include: Robert Jutte, *A History of the Senses: From Antiquity to Cyberspace* (London: Wiley, 2004); Susan Harvey, *Scenting Salvation: Ancient Christianity and the Olfactory Imagination* (California: University of California Press, 2006); C.M. Woolgar, *The Senses in Late Medieval England* (New Haven: Yale University Press, 2006); and Alain Corbin, *The Foul and the Fragrant: Odor and the French Social Imagination* (Boston: Harvard University Press, 1986). These are the spearheads of a growing scholarly interest in the importance of sensation in cultural history. In *The Sensory World of Italian Renaissance Art* (London: Reaktion Books, 2010), 7, François Quiviger discusses the integral place of multi-sensory experience in Italian Renaissance life, particularly in relation to faith, where "images increasingly served as aids to vivid empathic imagining of the sentient body of a human suffering god".

[2] For a discussion of the sensory experience of Renaissance prayer, see François Quiviger, *The Sensory World of Italian Renaissance Art* (London: Reaktion Books, 2010).

[3] For a discussion of the "top-down" processing of images by the brain see Eric R. Kandel, "Top-down processing of information: using memory to find meaning" in Eric R. Kandel, *The Age of Insight. The quest to understand the unconscious in art, mind and brain* (Random House: New York, 2012), 304.

[4] Giorgio Vasari, *Life of Leonardo da Vinci*, 1568, trans. George Bull in *Giorgio Vasari, Lives of the Artists, Vol. 1* (London: Penguin, 1965), 266.

[5] Charles Nicholl, *Leonardo da Vinci: The Flights of the Mind* (London: Allen Lane, 2004), 201; William A. Embolden, *Leonardo da Vinci on Plants and Gardens* (Portland: Timber Press, 1987), 125-32.

[6] James Cameron in Eddie Wrenn, "Avatar: How James Cameron's 3D film could change the face of cinema forever,"
Daily Mail online, August 26, 2009, accessed November 2015.
http://www.dailymail.co.uk/tvshowbiz/article-1208038/Avatar-How-James-Camerons-3D-film-change-face-cinema-forever.html#ixzz3PIqFJHw7.

[7] Ibid.

[8] For a discussion of painting practice in medieval and Early Renaissance Italy see David Bomford, et al., *Italian Painting before 1400*. Exh. Cat. (London: National Gallery Publications, 1989).

[9] Metalpoint, much faded, and pen and ink on prepared paper X6866/Cat. 30. Royal Collection, Windsor.

[10] Leonardo, *The drapery of a kneeling figure* c.1491-4, brush and black ink with white heightening on pale blue prepared paper, Royal Collection, Windsor, RC 912521. Accessed July 6, 2017.
https://www.royalcollection.org.uk/collection/search#/2/collection/912521/the-drapery-of-a-kneeling-figure

[11] Vasari (1550) writes that Leonardo "sometimes made clay models, draping the figures with rags dipped in plaster, and then drawing them painstakingly on fine Rheims cloth or prepared linen. These drawings were done in black and white with the point of the brush, and the results were marvellous, as one can see from the examples I have in my book of drawings". In Frank Zöllner, *Leonardo da Vinci. The Graphic Work* (Cologne: Taschen, 2011), 354.

[12] Zöllner, *Leonardo. The Graphic Work*, 354.

[13] 'The Burlington House Cartoon' or *The Virgin and Child with Saint Anne and the Infant Saint John the Baptist*, c.1499-1500, Charcoal (and wash?) heightened with white chalk on paper, mounted on canvas, 141.5 x 104.6 cm, NG6337. Accessed July 7, 2017. https://www.nationalgallery.org.uk/paintings/leonardo-da-vinci-the-burlington-house-cartoon

[14] The dating of *The Burlington Cartoon* is debatable. Luke Syson (in Luke Syson and Larry Keith, *Leonardo Da Vinci: Painter at the Court of Milan* (London: National Gallery, 2011)) suggests the date of c.1499-1500. However, Kenneth Clark (in *Leonardo da Vinci* (London: Penguin, 1988)) disputes this, suggesting a date of c.1505-7.

[15] For a discussion of painting practice in medieval and Early Renaissance Italy see David Bomford et al. *Italian Painting before 1400*. Exh. Cat. (London: National Gallery Publications, 1989).

[16] For a detailed analysis of Leonardo's painting technique see Jill Dunkerton, "Leonardo da Vinci: Pupil, Painter and Master" in "Leonardo in Verrocchio's Workshop: Re-examining the Technical Evidence," *National Gallery Technical Bulletin,* 32 (2011): 4-31.

[17] Susan Jones, "Painting in Oil in the Low Countries and Its Spread to Southern Europe," *Heilbrunn Timeline of Art History* (Metropolitan Museum of Art, 2012). Accessed May 8, 2017. http://www.metmuseum.org/toah/hd/optg/hd_optg.htm
In Naples, Niccolò Colantonio had adopted oil technique by about 1445, perhaps as a result of links with the Netherlandish artist Bartélemy d'Eyck, who in all likelihood had been in the city around 1440, and who was possibly related to Jan van Eyck. Colantonio himself may have taught the Sicilian Antonello da Messina. There is also evidence for the use of oil paint by the Ferrarese painter Cosmè Tura in the late 1450s, who seems to have made a study of the technique of Rogier van der Weyden, whose works were collected by Tura's patron, Leonello d'Este. For additional evidence regarding the introduction of oil paint into Italy from Flanders see Charles Lock Eastlake, *Materials for a History of Oil Painting*, Volume 1 (London: Longman, 1847), 214-6. Accessed May 8, 2017.
https://archive.org/details/materialsforahi03eastgoog

[18] For analysis of painting technique in Verrocchio's workshop see Dunkerton, "Leonardo da Vinci: Pupil, Painter and Master".

[19] Jennifer Meagher, "Italian Painting of the Later Middle Ages," *Heilbrunn Timeline of Art History* (Metropolitan Museum of Art, 2010). Accessed May 8, 2017. http://www.metmuseum.org/toah/hd/iptg/hd_iptg.htm

[20] For a discussion of the advantages of oil painting see Jones, "Painting in Oil in the Low Countries and Its Spread to Southern Europe."

[21] Leonardo in Martin Kemp, *Leonardo On Painting* (New Haven: Yale University Press, 1989), 71.

[22] Leonardo in Michael Ryan et al. Exh. Cat. *Leonardo, The Codex Leicester; An Exhibition at the Chester Beatty Library 12 June-12 August 2007* (London: Scala Publishers, 2007), 18.

[23] Leonardo in Kemp, *Leonardo On Painting*, 83.

[24] James Cameron in Eddie Wrenn, "Avatar: How James Cameron's 3D film could change the face of cinema forever," *Daily Mail online*, August 26, 2009. Accessed November 2015.
http://www.dailymail.co.uk/tvshowbiz/article-1208038/Avatar-How-James-Camerons-3D-film-change-face-cinema-forever.html#ixzz3PIqFJHw7.

Chapter Two: Leonardo's Florence

[1] Marsilio Ficino, "Letter to Paul of Middelburg," 1492, in *The Letters of Marsilio Ficino,* 2: Liber III (London: Shepheard-Walwyn, 1991).

[2] For detailed information on the guild system in Florence see John M. Najemy, *A History of Florence 1200-1575* (London: Wiley-Blackwell, 2008), 39.

[3] Luca Pacioli, *Summa de arithmetica, geometria, proportioni et proportionalita* (Venice, 1494), ed. and trans. Jeremy Cripps (Seattle: Pacioli Society, 1994). Accessed April 20, 2017. http://jeremycripps.com/docs/Summa.pdf

[4] Najemy, *A History of Florence 1200-1575*, 76.

[5] Najemy, *A History of Florence 1200-1575*. It is important to remember that a sizeable number of adult males were not citizens. Nobles were not able to vote, nor could non-guild members (*sottoposti*). This was not a democracy in today's sense of the word, however it was considerably more "fair" than alternative contemporary models of governance. For historical background on the guild system in Florence see also Stanley Joseph Fahey, *From medieval corporatism to civic humanism: Merchant and guild culture in fourteenth-and fifteenth-century Florence,* PhD, State University of New York at Binghamton, 2011. Accessed May 12, 2017. 3491075.http://search.proquest.com/openview/d16aa8ff34df550cc5b893915603a9f a/1?pq-origsite=gscholar&cbl=18750&diss=y

[6] For a detailed analysis of civic responsibility within Florentine society during the 1400s see Philip Gavitt, *Charity and Children in Renaissance Florence: The Ospedale Degli Innocenti 1410-1536* (Ann Arbor: University of Michigan Press, 1990).

[7] Leonardo Bruni, *Panegyric to the City of Florence,* 1403-4. Accessed April 28, 2015. http://www.york.ac.uk/teaching/history/pjpg/bruni.pdf

[8] Ibid.

[9] Leonardo Bruni, "Historiarum Florentini populi libri XII" in *Leonardo Bruni, History of the Florentine People*, ed. and trans. James Hankins (Boston: Harvard University Press, 2007).

[10] Donald E. Brown, *Hierarchy, history, and human nature: The social origins of historical consciousness* (Tucson: University of Arizona Press, 1988).

[11] Protagoras, "Truth" (also known as "Refutations"), Plato, *Theaetetus* 151e, Sextus *Against the Mathematicians* VII.60 (=DK 80B1), in C.C.W. Taylor and Mi-Kyoung Lee, Edward N. Zalta ed., "The Sophists", *The Stanford Encyclopedia of Philosophy* (Winter 2016 Edition). Accessed April 20, 2015. https://plato.stanford.edu/entries/sophists/#Pro

[12] Najemy, *A History of Florence,* 367.

[13] Raymond Adrien de Roover, *The rise and decline of the Medici Bank: 1397-1494* (New York City, Toronto: W. W. Norton & Company, 1966), 52-3.

[14] Ibid., 106.

[15] Ibid., 230.

[16] Ibid., 234.

[17] Stuart M. McManus, "Byzantines in the Florentine polis: Ideology, Statecraft and Ritual during the Council of Florence," *The Journal of the Oxford University History Society,* 6 (Michaelmas 2008/Hilary 2009): 4-6.

[18] James Hankins, "Cosimo de' Medici and the 'Platonic Academy'," *Journal of the Warburg and Courtauld Institutes,* 53 (1990): 144.

[19] Caroline Elam, "Lorenzo de' Medici's Sculpture Garden," *Mitteilungen des Kunsthistorischen Institutes in Florenz* 36: 1/2 (1992): 41.

[20] Sarah Blake McHam, "Donatello's Bronze 'David' and 'Judith' as Metaphors of

Medici Rule in Florence," *The Art Bulletin,* 83:1 (2001): 32-47.

[21] Ross King, *Brunelleschi's Dome: The story of the great cathedral in Florence* (New York: Random House, 2010).

[22] This is made clear in Bruni's text, "Historiarum Florentini".

[23] Verónica Uribe Hanabergh, "The belvedere torso's influence as an accidental fragment in art, from the renaissance to the xixth century," *Ensayos: Historia y Teoría del Arte,* 23 (2012): 74-99.

[24] Martin Davies, "Making sense of Pliny in the Quattrocento," *Renaissance Studies,* 9 (1995): 240-241.

[25] Pliny the Elder, "Naturalis Historia," Bk. 35 Ch. 36, in John Bostock ed. *Pliny the Elder, The Natural History* (Boston: Harvard University Press, 1938).

[26] Rudolph Wittkower, "Brunelleschi and 'Proportion in Perspective'," *Journal of the Warburg and Courtauld Institutes,* 16: 3/4 (1953): 288.

[27] Leon Battista Alberti, *Della Pittura,* 1435, ed. and trans. Martin Kemp as *On Painting* (London: Penguin, 1991).

[28] Michael Baxandall, *Painting and Experience in Fifteenth-Century Italy* (Oxford: Oxford University Press, 1972). Baxandall famously set the premise for the social history of art proposed here.

[29] Sarah Brooks, "Icons and Iconoclasm in Byzantium," *Heilbrunn Timeline of Art History* (New York: The Metropolitan Museum of Art, 2009). Accessed May 21, 2017. http://www.metmuseum.org/toah/hd/icon/hd_icon.htm

[30] Jane Andrews Aiken, "The Perspective Construction of Masaccio's 'Trinity' Fresco and Medieval Astronomical Graphics," *Artibus et Historiae* 16:31 (1995): 171-187.

[31] John Coolidge, "Further Observations on Masaccio's 'Trinity'," *The Art Bulletin,* 48: 3/4 (Sep. - Dec., 1966): 382-384. Coolidge provides a bibliography of scholarship on Masaccio's *Trinity* and raises the debate concerning Lenzi patronage.

[32] National Gallery in London, NG3046. Accessed July 6, 2017. https://www.nationalgallery.org.uk/paintings/masaccio-the-virgin-and-child

[33] Most of what we do know comes from Vasari whose biographies are coloured by his overarching aim to describe the improvement and supremacy of Tuscan art.

[34] Martin Kemp has recently uncovered Caterina's identity. See Martin Kemp, *Mona Lisa: The People and the Painting* (Oxford: Oxford University Press, 2017).

[35] Ibid. Kemp suggests that Leonardo arrived in Florence no earlier than 1464, and possibly some time after this date.

[36] Luca Beltrami, *Documenti e memorie riguardanti la vita e le opere di Leonardo da Vinci* (Milan: Fratelli Treves, 1919), 2, doc. 3. See also Jill Dunkerton, "Leonardo in Verrocchio's Workshop: Re-examining the Technical Evidence," in "Leonardo da Vinci: Pupil, Painter and Master," *National Gallery Technical Bulletin* 32 (2011): 4-31. Accessed June 13, 2017. https://www.nationalgallery.org.uk/upload/pdf/dunkerton2011.pdf

[37] Ibid.

[38] Ibid. For more general information about the artist and his studio see Andrew Martindale, *The Rise of the Artist in the Middle Ages and Early Renaissance* (New York: McGraw-Hill, 1972).

[39] Charles Nicholl, *Leonardo da Vinci: Flights of the Mind* (London: Allen Lane, 2004), 73.

[40] Nicholl, *Leonardo da Vinci*, 73; David A. Brown, "Leonardo apprendista," *Lettura Vinciana 39* (Florence: Giunti, 2000): 13; Luca Landucci, *A Florentine diary from 1450 to 1516 by Luca Landucci continued by an anonymous writer till 1542 with notes by Iodoco del Badia*, trans. Alice de Rosen Jervis (London: J.M. Dent & Sons; New York: E.P. Dutton & Co., 1927), 176.

[41] Ibid.

[42] Ibid.

[43] Nicholl (*Leonardo da Vinci*, 157) suggests that, since there was a strong tradition of music making in the artist workshop, Leonardo likely played the *lira da braccio*, and that Verrocchio probably taught him. Alternatively, Leonardo may have gained his schooling in his grandparents' house.

[44] Enea Vico, "The Academy of Baccio Bandinelli" c.1544, in *Heilbrunn Timeline of Art History* (New York: The Metropolitan Museum of Art, 2000). Accessed April 1, 2017. http://www.metmuseum.org/toah/works-of-art/17.50.16-35.

[45] See Giorgio Vasari, *Lives of the Artists*, III (1568), ed. Milanesi (Florence: Giunti, 1978), 371-72.

[46] Nicholl, *Leonardo da Vinci*, 75. This is speculation based on the practice of using studio apprentices as models, and the approximate dating of this sculpture when Leonardo was training under Verrocchio.

[47] Cennino Cenini, "Il Libro dell'Arte o Trattato della Pittura" (1433) trans. Mary P. Merrifield, *Treatise on Painting* (London: Robson, Levey and Franklyn, 1844). Accessed April 1, 2017. https://archive.org/stream/atreatiseonpain00merrgoog#page/n3/mode/2up

[48] Ashok Roy, ed., "Leonardo da Vinci; Pupil, Painter and Master," *National Gallery Technical Bulletin* 32 (2011). See A. Bernacchioni, "Le Botteghe di Pittura: Luoghi, Strutture e Attività," 23–33, and A. Padoa Rizzo, "La Bottega come Luogo di Formazione," 53–9, in Luchinat C. Acidini ed., *Maestri e botteghe. Pittura a Firenze alla fine del Quattrocento*, Exh. Cat. (Florence: Palazzo Strozzi, 1992). For the fluctuating staffing levels and discussion of the nomenclature of various workshop assistants in Neri di Bicci's busy bottega, see Anabel Thomas, *The Painter's Practice in Renaissance Tuscany* (Cambridge: Cambridge University Press, 1995), 81-93.

[49] Leonardo, *Codex Forster*, CF, I, fol. 43r (Victoria and Albert Museum, London) in *The Notebooks of Leonardo da Vinci* ed. and trans. John Paul Richter, *The Literary Works of Leonardo da Vinci* (London: Sampson Low, Marston, Searle & Rivington, 1883). Accessed April 1, 2017. http://warburg.sas.ac.uk/pdf/cnm22b2242052v1.pdf; Michael White, *Leonardo: The First Scientist* (London: Abacus, 2001), 63.

[50] Leonardo, *Codex Ashburnham* I&II, MS 2038, 23r. (Biblioteque Nationale, Paris); White, *Leonardo*, 63.

[51] Giorgio Vasari, *Lives*, trans. Gaston. du C. de Vere, I (London: Everyman, 1996), 626.

[52] Donatello was probably the first sculptor to use real fabric to cast the draperies of his figures (for example with his *Judith and Holofernes,* in Palazzo Vecchio, Florence).

[53] Frances Ames-Lewis, *Drawing in Early Renaissance Italy.* 2nd ed. (New Haven: Yale University Press, 2000). Carmen C. Bambach, *Drawing and Painting in the Italian Renaissance Workshop: Theory and Practice, 1300-1600* (New York: Cambridge University Press, 1999); Carmen Bambach, "Renaissance Drawings: Material and Function," in *Heilbrunn Timeline of Art History* (New York: The Metropolitan Museum of Art, 2000). Accessed April 1, 2017. http://www.metmuseum.org/toah/hd/drwg/hd_drwg.htm

[54] Dunkerton, "Leonardo in Verrocchio's Workshop."

[55] Martin Kemp (correspondence with author, Sept. 2016) suggests that this date is disputable, and may be too early.

[56] Dunkerton, "Leonardo in Verrocchio's Workshop."

[57] Ibid. See also Martin Kemp, *Leonardo da Vinci: The Marvelous Works of Nature and Man* (Oxford: Oxford University Press, 2007), 37. Kemp notes that, following recent technical examination, Leonardo's hand can be discerned in the oil finish of major portions of the tempera picture, especially in the final surface of Christ's body and in the "foreground water, which eddies so convincingly around Christ's ankles."

[58] Vasari, trans. Bull, *Lives,* 258.

[59] Kemp, *Marvelous Works,* 1 and 21.

[60] Ibid., 21.

[61] See website of National Gallery of Art, Washington D. C. Accessed July 7, 2017. https://www.nga.gov/content/ngaweb/Collection/art-object-page.50724.html

[62] Nicholl, *Leonardo,* 113; Bembo's copy of Ficino's *De amore* is at the Bodleian Library in Oxford, Can. Class. Lat. 156. On Bembo see Nella Giannetto, *Bernardo Bembo, umanista e politico Veneziano* (Florence: Leo S. Olschki, 1985).

[63] Kemp, *Marvellous Works,* 29.

[64] Nicholl, *Leonardo da Vinci,* 131.

[65] John Monfasani "A Description of the Sistine Chapel under Pope Sixtus IV", *Artibus et Historiae,* 4: 7 (1983): 9-18.

[66] Kemp, *Marvelous Works,* 43.

[67] Ibid., 168-169; Archivo di Stato, Florence, Corporazioni religiose soppresse ASF 140/3, 74r, 75, 77v, 79r, 81v; Edoardo Villata, *Leonardo da Vinci. I documenti e le testimonianze contemporanee,* ed. E. Villata, presented by P.C. Marani (Milan: Raccolta Vinciana, 1999), no. 14-17; Kemp, *Marvelous Works,* 43. Kemp writes that this was an unusually complex agreement. A saddle maker had made an endowment to S. Donato. The monastery records from March 1481 note that Leonardo, for a share in the endowment property, was expected to complete the altarpiece in the space of 24-30 months, and to pay a deposit into the dowry bank for the saddle maker's granddaughter.

[68] Leonardo, *Codex Atlanticus,* CA fol. 812r/296v-a, and fol.7r/386r-a (Biblioteca Ambrosiana, Milan) respectively, in Zöllner, *Leonardo, the Graphic Work,* 579.

[69] Vasari trans. Bull, *Lives,* 254.

[70] Leonardo, *Codex Atlanticus*, CA888r/324r (Biblioteca Ambrosiana, Milan). On Migliorotti see Carlo Vecce, *Leonardo* (Rome: Salerno Editrice, 2006), 72-5; a fragmentary letter from Leonardo to the boy exists also in *Codex Atlanticus*, CA 890r/325r-b (Biblioteca Ambrosiana, Milan); mentioned in Nicholl, *Leonardo*, 159.

[71] Leonardo, Royal Library, Windsor, RL 12697; RL 12699: "amo [drawing of a fish hook]; re sol la mi fa re mi [musical notes]; rare [written]; la sol mi fa sol [musical notes]; lecita [written]," trans. Nicholl, *Leonardo*, 159.

[72] Nicholl, *Leonardo*, 118-20, suggests this link. Kemp (in correspondence with the author, Sept. 2016) notes that this anonymous complaint was suspended, re-examined, and not pursued for legal reasons.

[73] Nicholl, *Leonardo*, 118-20.

[74] Ibid.

[75] Leonardo, *Codex Atlanticus*, CA folio 117r b. (Biblioteca Ambrosiana, Milan); quoted in Clifford Conner, *A People's History of Science: Miners, Midwives, and Low Mechanicks* (New York: Nation Books, 2005), 54. This diary entry may well refer to a later date when Leonardo was already in Milan, however Leonardo's frustration at his lack of a liberal arts education must surely have been felt from as early as his artisan training in Florence.

[76] Dante Alighieri, *Divine Comedy* (completed 1320), Canto XXIV, lines 47-51: "... Seggendo in piuma/in fama non si vien, né sotto coltre,/sanza la qual chi sua vita consuma/cotal vestigo in/terra di sé lascia/qual fummo in aere ed in acqua la schiuma." Leonardo quotes this section of the *Inferno*, the first section of the *Divine Comedy*, in his notebooks in c. 1492-3, held at the Royal Library, Windsor, RL fol. 12349v, trans. in Nicholl, *Leonardo*, 184. See also National Gallery of Ireland, RCIN 912349 *Studies for casting an equestrian monument* (recto), *Further casting studies, and lines of poetry* (verso) c.1492-3. Accessed April 8, 2017. https://www.royalcollection.org.uk/collection/themes/exhibitions/leonardo-da-vinci/national-gallery-of-ireland-dublin/studies-for-casting-an-equestrian-monument-recto-further-casting-studies-and-lines-of-poetry-verso

[77] Carlo Vecce, *Leonardo* (Rome: Salerno Editrice, 2006), 75-6; Carlo Pedretti, *Leonardo da Vinci: Fragments at Windsor Castle from the Codex Atlanticus* (London: Phaidon, 1957), 34. For a letter connecting Rucellai and Leonardo see Benvenuto della Glopaja, "Libro di machine" where a machine is said to have been sent by Leonardo to Rucellai.

Chapter Three: Sforza's Milan

[1] Charles Nicholl, *Leonardo da Vinci: The Flights of the Mind* (London: Allen Lane, 2004), 187.

[2] Julia Cartwright, *Beatrice d'Este, Duchess of Milan 1475-1497: A Study of the Renaissance* (London: J. M. Dent & Sons, 1920), 24. Accessed May 4, 2017. http://www.gutenberg.org/files/25622/25622-h/25622-h.htm#FNanchor_70_70

[3] Cartwright, *Beatrice d'Este, Duchess of Milan*, 23.

[4] Nicholl, *Leonardo*, 186.

[5] Cartwright, *Beatrice d'Este, Duchess of Milan*, 21.

[6] Nicholl, *Leonardo*, 93. For more information about the Milanese court of Sforza see Francesco Malaguzzi-Valeri, *La corte di Ludovico il Moro: La vita privata e l'arte a Milano nella secunda metà del quattrocento* (Milan: Ulrico Hoepli, 1913-23). Accessed April 17, 2017. https://archive.org/details/lacortedilodovic01mala

[7] Cartwright, *Beatrice d'Este, Duchess of Milan*, 21. Cartwright writes of the support and council offered to Sforza by Lorenzo de' Medici during the former's exile in Pisa.

[8] Francesco Malaguzzi-Valeri, *La corte di Ludovico il Moro: La vita privata e l'arte a Milano nella secunda metà del quattrocento* (Milan: Ulrico Hoepli, 1913-23). Accessed April 17, 2017. https://archive.org/details/lacortedilodovic01mala

[9] Carlo Vecce, *Leonardo* (Rome: Salerno Editrice, 2006), 75-6; Carlo Pedretti, *Leonardo da Vinci: Fragments at Windsor Castle from the Codex Atlanticus* (London: Phaidon, 1957), 34.

[10] Carlo Vecce, *Leonardo* (Rome: Salerno Editrice, 2006), 75-6; Carlo Pedretti, *Leonardo da Vinci: Fragments at Windsor Castle from the Codex Atlanticus* (London: Phaidon, 1957), 34. As previously, for a letter connecting Rucellai and Leonardo see Benvenuto della Glopaja, "Libro di machine" where a machine is said to have been sent by Leonardo to Rucellai.

[11] Ibid.

[12] Vasari, trans. Bull, *Lives*, 261: "Leonardo took with him a lyre that he had made himself, mostly of silver, in the shape of a horse's head (a very strange and novel design) so that the sound should be more sonorous and resonant." A drawing of such a lyre can be found in Leonardo's notebooks c.1487-90, *Codex Ashburnham* 1875/1, MS 2184, fol. CR (Paris, Bibliotheque de'Institut de France), in Zöllner, *Leonardo, the Graphic Work*, 486.

[13] David Fallows, *Josquin* (Turnhout: Brepols, 2009).

[14] Miniature from the "Grammatica Latina" by Elio Donato (late 1400s), now in the Castle Trivulzio Library (code 2167).

[15] Martin Kemp, *Leonardo da Vinci: The Marvelous Works of Nature and Man* (Oxford: Oxford University Press, 2007), 38.

[16] Leonardo "On Painting", in Martin Kemp, *Leonardo on Painting* (Yale: New Haven, 1989), 250.

[17] Ibid.

[18] Ibid.

[19] Nicholl, *Leonardo*, 193-6.

[20] Ibid.

[21] Ibid., 196.

[22] Luke Syson and Larry Keith, *Leonardo Da Vinci: Painter at the Court of Milan* (London: National Gallery, 2011), 168.

[23] Ibid.

[24] Ibid.

[25] Kemp, *Marvelous Works*, 74.

[26] Syson and Keith, *Painter at the Court of Milan*, 168; Grazioso Sironi, *Nuovi documenti riguardanti la "Vergine delle rocce" di Leonardo da Vinci* (Firenze: Giunti Barbèra, 1981).

[27] Syson and Keith, *Painter at the Court of Milan*, 168.

[28] Leonardo, "On Painting," in Kemp, *Leonardo on Painting*, 268-70.

[29] Syson and Keith, *Painter at the Court of Milan*, 169. Syson writes that, given the painting "occupied the most important space in the altarpiece, it would be odd indeed if it were not intended to prompt contemplation of the mystery of the Immaculate Conception. Certainly, when described in situ in the sixteenth and seventeenth centuries it is called a "Conception" or a "Madonna" indiscriminately".

[30] Leonardo in Kemp, *Leonardo on Painting*, 268-70.

[31] Syson and Keith, *Painter at the Court of Milan*, 168.

[32] For beliefs surrounding the virgin conception of Mary in the Middle Ages and Renaissance see Susan von Rohr Scaff, "The Virgin Annunciate in Italian Art of the Late Middle Ages and Renaissance," *College Literature* 29: 3 (Summer, 2002): 109-123.

[33] John Duns Scotus: "The Blessed Mother of God ... was never at enmity [with God] whether actually on account of actual sins or originally–because of original sin. She would have been had she not been preserved." Duns Scotus, *Ordinatio*, III d.3 q.1, in Carlo Balic, O.F.M., "The Mediaeval Controversy over the Immaculate Conception up to the Death of Scotus," in Edward O'Connor, C.S.C., *The Dogma of the Immaculate Conception: History and Significance* (South Bend: University of Notre Dame Press, 1958), 208-209. For a summary of the Catholic dogma of the Immaculate Conception see Frederick M. Jelly, O.P. "The Roman Catholic Dogma of Mary's Immaculate Conception," in *The One Mediator, The Saints, and Mary: Lutherans and Catholics in Dialogue VIII*, ed. H. George Anderson, J. Francis Stafford, Joseph A. Burgess (Minneapolis: Augsburg, 1992); and Edward O. P. Schillebeeck, *Mary, Mother of the Redemption* (New York: Sheed & Ward, 1964).

[34] Syson and Keith, *Painter at the Court of Milan*, 168. The debate is also discussed by Jill Dunkerton in *Giotto to Dürer: Early Renaissance Painting in The National Gallery* (London: National Gallery, 1991), 64.

[35] Kemp, *Marvelous Works*, 75.

[36] Kemp, *Marvelous Works*, 75. Here Kemp puts forward this reading of the symbolism within *The Virgin of the Rocks*.

[37] Ibid.

[38] Kemp, *Marvelous Works*, 76.

[39] Leonardo, c.1480-3, Royal Library Windsor, RL 12395.

[40] Patricia Emison, "Leonardo's landscape in the 'Virgin of the Rocks,'" *Zeitschrift für Kunstgeschichte* 56: 1 (1993): 116-118.

[41] Leonardo, c.1508, Royal Library, Windsor, RL 34r, in John Paul Richter, *The Literary Works of Leonardo da Vinci* (London: Sampson Low, Marston, Searle & Rivington, 1983), no. 1000.

[42] Emison, "Leonardo's landscape in the 'Virgin of the Rocks'." Emison notes that the Italian word *"Cavo"* was used by Lorenzo de' Medici as an adjective to describe the stomach (*"ventre"*): *"la terra drento al cavo ventre adusta."* See Lorenzo de' Medici, "Ambra", stanza 18, trans. Jon Thiem, *Lorenzo de' Medici: Selected Poems and Prose* (Pennsylvania: Pennsylvania State University, 1991) 131.

[43] Emison, "Leonardo's landscape in the 'Virgin of the Rocks'. Emison notes that it was Frederick Hartt, in *A History of Italian Renaissance Art: Painting, Sculpture, Architecture* (London: Thames and Hudson, 1970), who was the first to read Leonardo's cave as an "allegory of the immaculate womb of Mary, through which divine light filters to transfigure our dark mortality".

[44] Syson and Keith, *Painter at the Court of Milan*, 170.

[45] Ibid., 169.

[46] Ibid.

[47] The notion of transubstantiation was under discussion through the 1500s, yet it maintained its central place in Catholic doctrine. See James F. McCue, "The Doctrine of Transubstantiation from Berengar through Trent: The Point at Issue," *The Harvard Theological Review* 61: 3 (July 1968): 385-430, 407.

[48] Nicholl, *Leonardo*, 210.

[49] Lottlisa Behling "Die Pflanze in der mittelalterlichen Tafelmalerei," 2nd edn., *Journal of Experimental Botany online* (Köln, Graz: Böhlau, 1967). Accessed April 1, 2017. http://jxb.oxfordjournals.org/content/60/6/1535.full#ref-4; Riklef Kandeler and Ullrich R. Wolfram, "Symbolism of plants: examples from European-Mediterranean culture presented with biology and history of art, MAY: Columbine," *Journal of Experimental Botany*, 60: 6 (2009): 1535-1536. Accessed April 1, 2017. http://jxb.oxfordjournals.org/content/60/6/1535.full

[50] Agaleia K. Löber, *Erscheinung und Bedeutung der Akelei in der mittelalterlichen Kunst* (Köln, Wien: Böhlau, 1988), in Riklef Kandeler and Ullrich R. Wolfram, "Symbolism of plants."

[51] Johannes Pawlik, "Theorie der Farbe," 8th edn. (Köln: DuMont, 1987) in Riklef Kandeler and Ullrich R. Wolfram, "Symbolism of plants".

[52] Riklef Kandeler and Ullrich R. Wolfram, "Symbolism of plants".

[53] Ibid.; Nicholl, *Leonardo*, 210.

[54] Syson and Keith, *Painter at the Court of Milan*, 168. Syson claims that the date of this document is December 28, 1484. However he acknowledges in the footnotes that the end of the date is illegible, and could in fact be 1489.

[55] The devastation caused by the plague during these years was no doubt part of the impetus behind Leonardo's designs for ideal cities, with better systems for drainage and hygienic waste disposal. See Estelle Alma Mare, "Leonardo da Vinci's ideal city designs contextualised and assessed," *South African Journal of Art History* 29: 1 (Jan. 2014): 164-176.

[56] Leonardo in Kemp, *Leonardo on Painting*, 149-151.

[57] Ibid.

[58] Ibid.

[59] Ibid.

[60] Nicholl, *Leonardo*, 199, quotes the contemporary Antonio Billi, who wrote that "[Leonardo] did an altarpiece for Lord Lodovico of Milan, which is said to be the loveliest painting you could possibly see; it was sent by this Lord into Germany, to the Emperor".

[61] Syson and Keith, *Painter at the Court of Milan*, 95.

[62] Emanuel Winternitz, *Leonardo da Vinci as a Musician* (New Haven: Yale University Press, 1982), 6. Leonardo may well have been a friend of Gaffurio.

They had arrived in Milan at about the same time. Gaffurio had taken up the prestigious post of *Maestro di Capella* in January 1484.

[63] Syson and Keith, *Painter at the Court of Milan*, 112; Francesco Malaguzzi-Valeri, *La corte di Ludovico il Moro: La vita privata e l'arte a Milano nella secunda metà del quattrocento* vol. 1 (Milan: Ulrico Hoepli, 1913-23), 503-4.

[64] Ibid.

[65] Edoardo Villata, *Leonardo da Vinci. I documenti e le testimonianze contemporanee* (Milan: Raccolta Vinciana, 1999), in Syson and Keith, *Painter at the Court of Milan*, 111.

[66] It should be noted that it was quite normal for artists to petition patrons for more pay at this time. In this, at least, Leonardo was not breaking new ground.

[67] Syson and Keith, *Painter at the Court of Milan*, 26.

[68] Vasari, trans. Bull, *Lives*, 253.

[69] On the presence of Sforza's men at the court of Maximilian at Innsbruck see Janice Shell, "Ambrogio de Predis" in Giulio Bora et. al., *The Legacy of Leonardo* (Milan: Skira Editore, 1998), 124; Malaguzzi-Valeri, *La corte di Ludovico il Moro*, 3.7-8.

[70] Larry Silver, *Marketing Maximilian: The Visual Ideology of a Holy Roman Emperor* (New Jersey: Princeton University Press, 2008). Maximilian's unusually strategic interest in self-fashioning through image-making suggests that he would certainly have been appreciative of such a gift.

[71] On Ambrogio's presence in Innsbruck see Janice Shell, "Ambrogio de Predis" in Giulio Bora et. al., *The Legacy of Leonardo* (Milan: Skira Editore, 1998), 124; Malaguzzi-Valeri, *La corte di Ludovico il Moro*, 3.7-8.

Chapter Four: A Second Revolution in Paint

[1] "The Hidden Leonardo," National Gallery Website. Accessed April 1, 2017: http://www.nationalgallery.org.uk/paintings/learn-about-art/paintings-in-depth/the-hidden-leonardo?viewPage=1. The National Gallery collaborated with teams from the INOA (Istituto Nazionale di Ottica Applicata) and the OPD (Opificio delle Pietre Dure), who came to London with a high-resolution digital infrared scanner, part of the EU-ARTECH project's mobile laboratory. With this equipment they took a revealing Infraded Reflectogram image of the *Virgin of the Rocks*.

[2] Ashok Roy, "Leonardo da Vinci: Pupil Painter and Master," *National Gallery Technical Bulletin* 32 (2011): 43.

[3] Roy, "Leonardo da Vinci," 32.

[4] "The Hidden Leonardo," National Gallery Website; Roy, "Leonardo da Vinci," 42-3.

[5] Ibid.

[6] Leonardo, *Head of a Youth* (c.1491-3), red chalk and pen and ink on paper, 25.2x17.2 cm, Royal Library, Windsor, RL 12552. Accessed 9July 9, 2017. https://www.royalcollection.org.uk/egallery/object.asp?collector=12756&display=acquired&object=912552&row=186&detail=magnify

[7] Minna Moore Ede, "The Last Supper" in Luke Syson and Larry Keith, *Leonardo Da Vinci: Painter at the Court of Milan* (London: National Gallery, 2011), 268.

[8] Roy, "Leonardo da Vinci," 43.

[9] Roy, "Leonardo da Vinci," 39.

[10] It should be noted that some scholarship has seen the simplification and stylization of plant life in the London version of the *Virgin of the Rocks* as a sign of studio work. See, for example Ann Pizzorusso, "Leonardo's Geology: The Authenticity of the 'Virgin of the Rocks'," *Leonardo* 29: 3 (1996): 197-200. However, the National Gallery has attributed this stylistic shift to a philosophical one on the part of Leonardo.

[11] Roy, "Leonardo da Vinci," 43.

[12] Ibid.

[13] Ibid., 43.

[14] Ibid., 47.

[15] Ibid., 45-46.

[16] Nicholas Eastaugh et.al., *Pigment Compendium: A Dictionary of Historical Pigments* (Oxford: Butterworth-Heinemann, 2004), 33.

[17] Leonardo trans. Martin Kemp, *Leonardo on Painting* (Yale: New Haven, 1989), 69.

[18] Ibid., 88.

[19] Ashok Roy, "Leonardo da Vinci: Pupil Painter and Master," *National Gallery Technical Bulletin* 32 (2011): 32.

[20] See Chapter 8 of this book, *Trouble at Court*, for the political context of Sforza's escape from Milan and Leonardo's return to Florence in 1499.

Chapter Five: Leonardo's Personal Development: Passions of Body and Soul

[1] Fra Stefano Oleggio was the priest at San Francesco Grande who popularized the new Catholic dogma of Mary's Immaculate Conception. Luke Syson and Larry Keith, *Leonardo Da Vinci: Painter at the Court of Milan* (London: National Gallery, 2011), 170.

[2] Leonardo in Martin Kemp, *Leonardo on Painting* (Yale: New Haven, 1989), 144.

[3] Ibid.

[4] Ella Noyes, *The Story of Milan* (London: J.M. Dent & Co, 1908), 254; discussed in Charles Nicholl, *Leonardo da Vinci: The Flights of the Mind* (London: Allen Lane, 2004), 251.

[5] Leonardo, *Studies for casting an equestrian monument* (recto); *Further casting studies, and lines of poetry* (verso) c.1492-3. Recto: Pen and ink with some notes in red chalk. Verso: Pen and ink. Royal Collection, Windsor, RCIN 912349. Accessed July 9, 2017. https://www.royalcollection.org.uk/collection/912349/studies-for-casting-an-equestrian-monument-recto-further-casting-studies-and-lines

[6] Baldassarre Taccone, *Coronatione e sposalizio de la serenisima regina Maria Bianca* (Milan: Pachel, 1493), 99, trans. Nicholl, *Leonardo da Vinci*," 251.

[7] Leonardo, *Codex on the Flight of Birds*, c.1490-1505 (Biblioteca Reale, Torino). Leonardo had designed a Flying machine as early as c.1488-89, *Paris Manuscript*, MS B fol. 74v-75r (Bibliothèque de l'Institut de France). Accessed April 2, 2017. http://universalleonardo.org/work.php?id=514

[8] Leonardo, *Codex Forster*, Fors. 3 49v (Victorian and Albert Museum, London), trans. in Nicholl, *Leonardo*, 531. The ground plan among the rebuses (at the Royal Library, Winsor, RL 12692) is hard to see in reproduction as only part of the metalpoint has been inked in. It is repeated in the same scale in *Codex Atlanticus*, CA 217r/8or-a (Biblioteca Ambrosiana, Milan).

[9] Ella Noyes, *The Story of Milan* (London: J.M. Dent & Co, 1908), 254; discussed in Nicholl, *Leonardo*, 251.

[10] Dante, *Divine Comedy* (completed 1320), Canto XXIV, lines 47-51: "*...Seggendo in piuma/in fama non si vien, né sotto coltre,/sanza la qual chi sua vita consuma/cotal vestigo in/terra di sé lascia/qual fummo in aere ed in acqua la schiuma.*" Leonardo quotes this section of the *Inferno*, the first section of the *Divine Comedy*, in his notebooks at the Royal Library, Windsor, RL fol. 12349v, trans. Nicholl, *Leonardo*, 184.

[11] This is perhaps a picturesque interpretation. Leonardo may have had a comfortable childhood in his grandparents' home, and Verrocchio was one of the wealthiest artists in Florence. Yet the difference between Leonardo's experience as an apprentice and young artist abiding by the stringent guild regulations for pay in Florence, would have been very different from the freedom possible as a court artist in the Duchy of Milan.

[12] Leonardo in Kemp, *On Painting*, 266. It was typical that the master would be responsible for his apprentice's food and clothing. See Janice Shell, *Pittori in bottega: Milano nel Rinasimento* (Torino: Umberto Allemandi, 1995), 64-8.

[13] On his return to Florence, Leonardo is described as getting members of his workshop to make "copies" (*"ritratti"*) of his own works, which he would finish off. See Martin Kemp, "From Scientific Examination to the Renaissance Market: The Case of Leonardo da Vinci's 'Madonna of the Yarnwinder,'" *Journal of Medieval and Renaissance Studies* XXIV (1994): 259-74.

[14] Leonardo's notebook entries from the early 1490s name around a dozen other associates in his pay. Kemp, *On Painting*, 266.

[15] The height of 12 *Braccia* is confirmed by the mathematician and humanist with whom Leonardo collaborated, Lucca Pacioli, in the preface to his book *Divina Proportione*; for other contemporary statistics see Renzo Cianchi, "Figure nuove del mondo Vinciano: Paolo e Vannoccio Biringuccio da Siena," in *Raccolta Vinciana* 20 (Milan: 1964): 277-97.

[16] Leonardo in Kemp, *On Painting*, 266.

[17] Nicholl, *Leonardo*, 141. Archivo di Stato, Operai Palazzo, Stanziamenti, ASF 10, 79v, 80v.

[18] Leonardo's notebooks of c.1493-4, *Paris Manuscript* III, H3 137v, c.1493-4, (Institut de France, Paris), trans. in Nicholl, *Leonardo*, 252.

[19] Leonardo in Kemp, *On Painting*, 266.

[20] Ibid.

[21] Ibid.

[22] Leonardo, "Salaino expenses": *Paris Manuscript* MS L 94r (Institut de France, Paris). Rose coloured stockings: *Codex Arundel*, Ar 229v (British Library, London), in Nicholl, *Leonardo*, 275-6.

[23] Vasari, trans. Bull, *Lives*, 265.

[24] Leonardo, *The head of a youth in profile*, c.1510, red and black chalks on pale red prepared paper, Royal Collection, Windsor, RCIN 912554. Accessed July 9, 2017. https://www.royalcollection.org.uk/collection/912554/the-head-of-a-youth-in-profile

[25] Leonardo, *Codex Atlanticus*, CA 663v/234v-a (Biblioteca Ambrosiana, Milan), trans. in Nicholl, *Leonardo*, 276.

[26] Nicholl, *Leonardo*, 285.

[27] Ibid.

[28] Leonardo, *Codex Forster,* Fors. III 88r (Victoria and Albert Museum, London), in Carlo Vecce, *Leonardo* (Rome: Salerno Editrice, 2006). Payments to Caterina include two of 10 *soldi* each on January 29, 1494. *Paris Manuscript* H. MS 2179, fol. 3, 64v (Institut de France, Paris). Funeral expenses, *Codex Forster,* Fors. II 64v. in *Il Codici Forster*, ed. Augusto Marinoni (Florence, 1992).

[29] Vasari, in Bull, *Lives*, 24.

[30] Leonardo, *A Man Tricked by Gypsies*, pen and ink on paper, c.1493, Royal Collection Trust, RCIN 912495. https://www.royalcollection.org.uk/collection/912495/recto-a-man-tricked-by-gypsies-verso-an-inscription-describing-evil-men

[31] Leonardo's interest in physiognomy has been famously discussed by Ernst Gombrich in *The Heritage of Apelles* (Oxford: Phaidon, 1976), 57-75; and Michael W. Kwakkelstein, *Leonardo as a Physiognomist: Theory and Drawing Practice* (Leiden: Primavera Press, 1994), esp. 55-60. These arguments are developed by Piers D. G. Britton, "The signs of faces: Leonardo on physiognomic science and the 'Four Universal States of Man'," *Renaissance Studies* 16: 2 (Wiley, June 2002): 143-162. Britton writes: Leonardo's "fascination with the morphology of the human visage is richly documented in his surviving drawings, and confirmed in scattered remarks among his writings. Moreover, a few extant notes reveal that Leonardo not only took a keen interest in the face *per se*, but also in the venerable discipline which was devoted to studying and interpreting it, the science of physiognomy." Piers D. G. Britton, "The Signs of faces", 143.

[32] Leonardo, *Studies of male figures*, c.1480-1, pen and ink with metalpoint on paper, 27.7x20.9cm, Musée du Louvre, Paris, 2258. See Zöllner, *Leonardo*, 335; in Syson, Leonardo, 255.

[33] Leonardo in Kemp, *On Painting*, 267.

[34] Leonardo, *Codex Urbinus*, Urb. fol. 110 (Vatican Library); in facsimile form in Amos Philip McMahon, *The Treatise on Painting by Leonardo da Vinci* (New Jersey: Princeton University, 1956), McM 401.

[35] Leonardo, Royal Library, Windsor, RL 12603r and RL 12627; Martin Kemp, *Leonardo da Vinci: The Marvelous Works of Nature and Man* (Oxford: Oxford University Press, 2007), fig. 15, 109. See also Martin Clayton and Ron Philo, *Leonardo da Vinci: The Mechanics of Man* (Los Angeles: J. Paul Getty Museum, 2010), fig. 5, 40. Also catalogued as *The layers of the scalp, and the cerebral*

ventricles Pen and ink, and red chalk, Royal Collection Trust, RCIN 912603. Accessed July 9, 2017.
https://www.royalcollection.org.uk/collection/912603/recto-the-layers-of-the-scalp-and-the-cerebral-ventricles-verso-studies-of-the
[36] Martin Clayton and Ron Philo, *Leonardo da Vinci: Anatomist* (London: Royal Collection Trust, 2011), 11; Kemp, *Marvellous Works,* 108. Kemp notes Leonardo's reliance on Aristotelian ideas.
[37] Leonardo, Royal Library, Windsor, RL 12627r, in Kemp, *Marvellous Works*, 110.
[38] Leonardo, Royal Library, Windsor, RL 19019r in Kemp, *Marvellous Works*, 110. See also Clayton and Philo, *Anatomist*, 41.
[39] Kemp, *Marvellous Works*, 110.
[40] Leonardo, *Codex Trivulziana* 20v. (Castello Sforzesco, Milan, Biblioteca Trivulziana); Kemp, *Marvellous Works*, 111.
[41] Leo Steinberg, *Leonardo's Incessant Last Supper* (New York: Zone Books, 2001). Steinberg discusses the complexity–emotional, iconographical and historiographical–of this masterpiece: Christ's announcement produces intertwined conversations that express emotion through motion.
[42] Ashok Roy, "Leonardo da Vinci: Pupil Painter and Master," *National Gallery Technical Bulletin* 32 (2011): 34.
[43] "The Hidden Leonardo," National Gallery Website. Accessed April 1, 2017: http://www.nationalgallery.org.uk/paintings/learn-about-art/paintings-in-depth/the-hidden-leonardo?viewPage=1.
[44] Clayton and Philo, *Anatomist*, 206, fig. 71. Royal Collection, Windsor, RCIN 919102. Accessed July 9, 2017.
https://www.royalcollection.org.uk/collection/919102/recto-the-foetus-in-the-womb-verso-notes-on-reproduction-with-sketches-of-a-foetus
[45] Leonardo c.1511, Royal Library, Windsor, RL 19102r; Queen's Archive III .8r; Clayton and Philo, *Anatomist,* 206, fig. 71.
[46] Ibid. Leonardo's study is probably based upon dissections of a cow; he erroneously assumes that the heart of the child does not beat until after birth; and he never discovers that humans have a single discoidal placenta.

Chapter Six: Scientific Research: The Magician Alchemist

[1] Kim Veltman discusses this in *Leonardo da Vinci: Studies of the Human Body and Principles of Anatomy*, keynote published in German as "Leonardo da Vinci Untersuchungen zum menschlichen Korper" in *Gepeinigt, begehrt, vergessen. Symbolik und Sozialbezung des Körpers im späten Mittelalter und in der frühen Neuzeit,* ed. Klaus Schreiner (Bad Homburg: Werner Reimers Stiftung, 1992), 287-308. Accessed April 3, 2017.
http://www.sumscorp.com/img/file/1992_Leonardo_da_Vinci,_Studies_of_the_Human_Body_and_Principles_of_Anatomy.pdf
[2] Leonardo, c.1508, Royal Library, Windsor, RL 19021v; in Nicholl, *Leonardo*, 241 and Clayton and Philo, *Anatomist*, Cat. 39, 118-121.

[3] Leonardo, *Codex Leicester*, Royal Library, Windsor, RL 19037v; trans. Clayton and Philo, *Anatomist*, 9.

[4] Clayton and Philo, *Mechanics of Man*, 7 and 9.

[5] Katherine Park, "The Criminal and Saintly Body. Autopsy and Dissection in Renaissance Italy," *Renaissance Quarterly*, 47: 1 (Spring 1994): 10.

[6] Park, "The Criminal and Saintly Body". Park does note that the practice of dissection was more common than previously believed. Yet it was still a difficult undertaking in terms of preservation.

[7] Park, "The Criminal and Saintly Body"; see also Andrea Carlino, *Books of the Body: Anatomical Ritual and Renaissance Learning*, trans. John Tedeschi and Anne C. Tedeschi (Chicago, Illinois: University of Chicago Press, 1999).

[8] See Leonardo's manuscript page with a *Diagram of the bones and nerves of the arm,* Royal Library, Windsor, RL 12613r, in Clayton and Philo, *Mechanics of Man*, 3.

[9] Leonardo, c.1508-10, in Clayton and Philo, *Mechanics of Man*, 29.

[10] Leonardo, Royal Library, Windsor, RL 19070r (detail); in Clayton and Philo, *Mechanics of Man*, 18.

[11] Nicholl, *Leonardo*, 143. Dom Miguel da Silva, the Portuguese bishop of Viseo and friend of Giovanni Rucellai (Zoroastro's later employer) visits and describes Zoroastro's extraordinary workshop.

[12] Clayton and Philo, *Anatomist*, 37.

[13] Leonardo in Clayton and Philo, *Anatomist*, 37; Syson and Keith, *Painter at the Court of Milan*, 146.

[14] Ibid.

[15] Leonardo c.1485-90, Royal Library, Windsor, RL 12613r; in Clayton and Philo, *Anatomist*, Cat. 3, 36. Royal Collection Trust, RCIN 912613. Accessed July 9, 2017. https://www.royalcollection.org.uk/collection/912613/recto-the-bones-and-nerves-of-the-arm-verso-studies-of-the-nervous-system

[16] Leonardo, c.1485-90, Royal Library, Windsor, RL 1262r; in Clayton and Philo, *Anatomist*, Cat. 5, 40.

[17] Leonardo, *Cross-Sections of the Leg*, c.1485-90, Royal Library, Windsor, RL 12627v; in Clayton and Philo, *Anatomist*, Cat. 6, 42. Accessed July 9, 2017. https://www.royalcollection.org.uk/egallery/object.asp?exhibition=&exhibs=FLE MCAT09&pagesize=40&object=912627v&row=7775&detail=magnify

[18] There are 44 folios in signatures probably compiled by Leonardo himself. Royal Collection, Windsor, RCIN 919057, 919058, 919059. Accessed July 9, 2017. https://www.royalcollection.org.uk/collection/919058/recto-the-cranium-sectioned-verso-the-skull-sectioned; https://www.royalcollection.org.uk/collection/919059/recto-the-cranium-verso-notes-on-topics-to-be-investigated; https://www.royalcollection.org.uk/collection/919057/recto-the-skull-sectioned-verso-the-cranium

[19] Leonardo, c.1485-90, Royal Library, Windsor, RL 12613r; Queen's Archive V.21v; K. D. Keele and C. Pedretti, *Leonardo da Vinci. Corpus of the Anatomical Studies in the Collection of her Majesty the Queen at Windsor Castle*, vol. 1 (London/New York, 1979), 1v; trans. in Clayton and Philo, *Anatomist*, 36-7.

[20] Leonardo, *Codex Urbinus* 130r (Vatican Library, Rome); in Kemp, *Leonardo on Painting*, 140.

[21] Leonardo constructed a wooden model, with the help of a carpenter called Bernardo, and received small sums to cover the expenses of making the model. There are seven payments listed between July 1487 and January 1488. See Luca Beltrami, *Documenti e memorie riguardanti la vita e le opere di Leonardo da Vinci* (Milan: Fratelli Treves, 1919), docs. 31-3.

[22] Ibid., docs. 48-50.

[23] Leonardo, *Codex Madrid* I, MS 8937 fol. 30r, fol. 31r and fol. 43r respectively (Madrid, Biblioteca Nacional), reproduced in Frank Zöllner, *Leonardo da Vinci. The Graphic Work* (Cologne: Taschen, 2011), 594.

[24] Ludwig H. Heydenreich, *Leonardo da Vinci: an exhibition of his scientific achievements* (London: Royal Collection Trust, 1949), pl.19.

[25] Leonardo in Kemp, *Leonardo on Painting*, 133.

[26] Ibid.

[27] Ibid.

[28] Using a magnifying glass he must have carefully flayed the skin from the creature whilst still alive, severed the head from the body, slit its stomach down the centre to allow the viscera to spill onto the table, and watched as the frog continued to twitch. Only after this did he cut the spinal cord to stop it moving.

[29] Rudolph Wittkower, "Brunelleschi and 'Proportion in Perspective'," *Journal of the Warburg and Courtauld Institutes*, 16: 3/4 (1953): 288; Martin Kemp, *The Science of Art: Optical Themes in Western Art from Brunelleschi to Seurat* (New Haven: Yale University Press, 1992).

[30] Kemp, *The Science of Art*.

[31] Ibid.

[32] Kim Veltman discusses this in *Leonardo da Vinci: Studies of the Human Body and Principles of Anatomy*, Accessed April 3, 2017. http://www.sumscorp.com/img/file/1992_Leonardo_da_Vinci,_Studies_of_the_Human_Body_and_Principles_of_Anatomy.pdf

[33] Kim H. Veltman and Kenneth David Keele, *Studies on Leonardo da Vinci I: Linear Perspective and the Visual Dimensions of Science and Art* (Munich: Deutsche Kunstverlag, 1986). Veltman acknowledges the cinematographic element of Leonardo's multiple-view diagrams of the arm in Kim H. Veltman, *Leonardo da Vinci: Studies of the Human Body and Principles of Anatomy* (1997), 5. Keynote published in German as "Leonardo da Vinci Untersuchungen zum menschlichen Korper" in Klaus Schreiner ed., *Gepeinigt, begehrt, vergessen. Symbolik und Sozialbezung des Körpers im späten Mittelalter und in der frühen Neuzeit* (Bad Homburg: Werner Reimers Stiftung, 1992), 287-308. Accessed April 3, 2017. http://www.sumscorp.com/img/file/1992_Leonardo_da_Vinci,_Studies_of_the_Human_Body_and_Principles_of_Anatomy.pdf

[34] Ibid.

[35] Alberti writes in his *De pictura*, 1.19 (first published in Italian as *Della pittura* (1435), ed. and trans. Kemp, *On Painting*): "First of all, on the surface which I am going to paint, I draw a rectangle of whatever size I want, which I regard as an open window through which the subject to be painted is seen."

Chapter Seven: A Philosophical Journey

[1] This chapter sets out Leonardo's interest in Neo-Platonic philosophy. Martin Kemp (*Marvellous Works*, 71) notes: "much has been made of [Leonardo's] intellectual affinity with the climate of Aristotelian thought in Northern Italy and his antipathy to the rarefied philosophising of Neo-Platonic Florence, but these polarities are too crudely drawn..." He continues: "Leonardo himself showed a more than passive sympathy with certain aspects of the Platonic philosophy which coloured intellectual life in the Medici circle". This is the vein in which I discuss Leonardo: as a complex and sophisticated thinker; and in who's work we see the traces of both Aristotelian and Platonic theory.

[2] Francesco Melzi's original *Book of Painting* is found as *Codex Vaticanus Urbinas* Latino or *Codex Urbinas* 1270. It is not an autograph by Leonardo, but largely displays texts from now lost manuscripts. Moreover, the loyalty shown by Melzi in the transcription preserves all the characters of the language of Leonardo.

[3] Leonardo, *The Proportions of the Arm*, c.1990, Royal Library, Windsor, RL 19131r.

[4] K. D. Keele and C. Pedretti, *Leonardo da Vinci. Corpus of the Anatomical Studies in the Collection of her Majesty the Queen at Windsor Castle*, vol. 1 (London/New York, 1979), 46. Alberti argued that a man's ideal height was six feet or three *braccia*.

[5] Vitruvius, *Ten Books on Architecture*, trans. Ingrid D. Rowland and Thomas Noble Rowland Howe (Cambridge: Cambridge University Press, 1999), 47. Vitruvius argued that a man's ideal height was four times the length of his forearm.

[6] Leonardo, c.1490, Royal Library, Windsor, RL 19132r, trans. in Kenneth David Keel, and J. Roberts, *Leonardo Da Vinci: Anatomical Drawings from the Royal Library, Windsor Castle* (London: Royal Academy of Arts, 1977), Cat. 43, 144; Syson, *Painter at the Court of Milan*, 150.

[7] This is noted by Syson in *Leonardo, Painter at the Court of Milan*, 150.

[8] Frank Zöllner, *Leonardo da Vinci: Complete Paintings and Drawings* (London: Taschen, 2003), 384. Zöllner discusses the tension between empirical observation and mathematical calculation at work in these drawings.

[9] Leonardo, *Studies of human proportions*, c.1490. Pen and ink on paper, 14.6x21.8cm, Royal Collection, Windsor, RL 19130r. Accessed July 9, 2017. https://www.royalcollection.org.uk/egallery/object.asp?category=294&pagesize=20&object=919131r&row=605

[10] See, for example, Leonardo's proportions of the leg and foot, Royal Library, Windsor, RL 19136-9v; Queen's Archive VI.11v; K. D. Keele and C. Pedretti, *Leonardo da Vinci. Corpus of the Anatomical Studies in the Collection of her Majesty the Queen at Windsor Castle*, 3 vols. (London/New York, 1978-1980), 31v; in Martin Clayton and Ron Philo, *Leonardo da Vinci: Anatomist* (London: Royal Collection Trust, 2011), 17.

[11] Leonardo quotes from Vitruvius: "Vitruvius, the architect says in his work on architecture that the measurements of man are distributed by Nature as follows: that 4 fingers make one palm, and 4 palms make one foot; 6 palms make a cubit; 4 cubits make a man's height ... from the elbow to the tip of the hand will be a fifth

part of a man; from the elbow to the armpit will be the eighth part of a man." Beneath the drawing is given the scale. Leonardo, Royal Library, Winsor, RL 19132r in Syson, *Painter at the Court of Milan*, 150-51.

[12] Andrea Gamberini ed., *Late Medieval and Early Modern Milan: The Distinctive Features of an Italian State* (Milan: Brill, 2015).

[13] Julia Cartwright, *Beatrice d'Este, Duchess of Milan 1475-1497: A Study of the Renaissance* (London: J. M. Dent & Sons, 1920), 75. Accessed May 4, 2017. http://www.gutenberg.org/files/25622/25622-h/25622-h.htm#FNanchor_70_70

[14] Polissena d'Este, letter dated February 12, 1491, in Cartwright, *Beatrice d'Este, Duchess*, 77-8. "...I cannot express how happy [the duchess Beatrice d' Este] is to see herself every day more affectionately caressed and petted by her husband, who seems to find his sole delight in giving her every possible pleasure and amusement. It is indeed a rare joy to see them together and to realise what cordial love and good-will he bears her". Polissena was Beatrice's cousin who remained with the young duchess in Milan after the marriage.

[15] Francesco Malaguzzi-Valeri, *Pittori lombardi del Quattrocento* (Milan: L. F. Cogliati, 1902), 61. Malaguzzi-Valeri discusses the Classically-inspired artistic acquisitions in Milan at this time.

[16] Richard Schofield, "Giovanni da Tolentino Goes to Rome: A Description of the Antiquities of Rome in 1490," *Journal of the Warburg and Courtauld Institutes* 43 (1980): 246-256.

[17] Francesco Malaguzzi-Valeri, *Pittori lombardi del Quattrocento* (Milan: L. F. Cogliati, 1902), 61.

[18] S. Lang, "Leonardo's Architectural Designs and the Sforza Mausoleum," *Journal of the Warburg and Courtauld Institutes* 31 (1968): 218-233.

[19] On the influence of Roman architecture on Bramante, including the Pantheon, and his development of the High Renaissance style, see Christophe Luitpold Frommel, "Bramante and the Origins of the 'High Renaissance'" in Jill Burke, *Rethinking the High Renaissance. The Culture of the Visual Arts in Early Sixteenth-Century Rome* (Farnham: Ashgate, 2012).

[20] Leonardo, *Madrid Codex* II, Ma II 157v, 151v (Biblioteca Nacional, Madrid). These two dated pages of Leonardo's *Madrid Codex* give the approximate chronology of his work on the monument. Leonardo began on May 17, 1491 when he wrote: "Here a record shall be kept of everything related to the bronze horse now under construction". On another page dated December 20, 1493 he records his decision to cast it on its side rather than standing. Contemporary court poet Taccone describes the immense horse as commemorative of Sforza's father in 1493. Baldassarre Taccone, *Coronatione e sposalizio de la serenisima regina Maria Bianca* (Milan: Pachel, 1493), 99; Nicholl, *Leonardo da Vinci*, 251. It is likely, therefore, that the planning stages for the horse had commenced some time earlier in the late1480s.

[21] Kemp, *Marvellous Works*, 193. On relating his own work to the Roman tradition of bronze horses Leonardo was also taking up the challenge, which had been faced by his Renaissance predecessors, Donatello and Verrocchio. On the scale of the horse see Renzo Cianchi, "Figure nuove del mondo Vinciano: Paolo e Vannoccio Biringuccio da Siena," in *Raccolta Vinciana* 20 (Milan: 1964): 277-97.

[22] Pliny the Elder ("Naturalis Historia" 35.36.79–97) discusses the famous Greek artist, Apelles. In comparing Leonardo to Apelles, Bellincioni reinforced the notion that Classical culture was literally being "reborn" in Milan under the humanist leadership of Sforza.

[23] Syson and Keith, *Painter at the Court of Milan*, 30.

[24] Maya Corry, "The Alluring Beauty of a Leonardesque Ideal: Masculinity and Spirituality in Renaissance Milan," *Gender & History* 25: 3 (November 2013): 565-589. Corry argues convincingly for the Neo-Platonic environment in Milan within which intellectual context Leonardo's depictions of the ideally beautiful male figure must be understood.

[25] Leonardo, *Codex Trivulzio* 2r (Castello Sforzesco, Milan, Biblioteca Trivulziana).

[26] Ibid.

[27] Ibid.

[28] Ibid. The longer 28-canto version, "Morgante Maggiore," was published in Florence in 1482 and Leonardo quotes from it more than once.

[29] Leonardo, transcribed in *Paris Manuscript*, MS A (Institut de France, Paris); *Codex Atlanticus*, CA 559r/210r-a (Biblioteca Ambrosiana, Milan); notes on the verso reappear on A52r; discussed in Nicholl, *Leonardo*, 215. In the Madrid inventory of 1504 Leonardo mentions 116 volumes.

[30] Leonardo transcribed in *Paris Manuscript*, MS A (Institut de France, Paris); *Codex Atlanticus*, CA 559r/210r-a (Biblioteca Ambrosiana, Milan); notes on the verso reappear on A52r. Ficino's text has been translated in Marsilio Ficino, *Platonic Theology* ed., James Hankins and William R. Bowen (Cambridge Mass.: Harvard University Press, 2002).

[31] Bellincioni, trans. Edoardo Villata, *Leonardo da Vinci. I documenti e le testimonianze contemporanee*, intro. P.C. Marani (Milan: Raccolta Vinciana, 1999); Syson and Keith, *Painter at the Court of Milan*, 111.

[32] British Museum, inventory no. 1877,0113.364.

[33] Syson and Keith, *Painter at the Court of Milan*, 217. See also Jill Pederson, "Henrico Boscano's 'Isola beata': New evidence for the Academia Leonardi Vinci in Renaissance Milan," *Renaissance Studies* 22 (2008): 450-75.

[34] Ibid.

[35] The letters between Ficino and Cavalcanti can also be found in *Della Divine Lettere del Gran Marsilio Ficino*, trans. M. Felice, 2 vols (Venice: Gabriel Giolito de' Ferrari, 1563), English trans. Rictor Norton. Accessed June 17, 2017. http://rictornorton.co.uk/ficino.htm

[36] Ibid.

[37] That Pacioli and Leonardo knew each other well is illustrated by the fact that they left Milan together in 1499 and shared accommodation in Florence for a short while. See also G. M. Biggiogero, "Luca Pacioli e la sua 'Divina proportione,'" *Rendiconti dell'Istituto lombardo di scienze e lettere* 94 (1960): 3-30.

[38] Ibid.

[39] Leonardo may have been a friend of Gaffurio's. They had arrived in Milan at about the same time. Gaffurio had taken up the prestigious post of *Maestro di Capella* in January 1484 and Leonardo probably painted his portrait in 1490. Emanuel Winternitz in *Leonardo da Vinci as a Musician* (New Haven: Yale

University Press, 1982), 6, believes that they likely knew one another and even claims that they "lent each other books." This may be due to the following: Leonardo refers to Plutarch's *Lives* in a marginal note; Gaffurio owned a copy of the 1491 edition, which he purchased in Milan in 1494. On this copy (see Kate Trayman Steinitz, "Two Books from the Environment of Leonardo da Vinci in the Elmer Belt Library of Vinciana: Gaffurio and Plutarch," *Libri* 2 (1951-52): 1-14) figs. 1 and 2 show Gaffurio's inscriptions on the colophon and title page. Emanuel Winternitz, in *New Grove* 10:671, believes that Leonardo refers to Gaffurio's *De harmonia musicorum instrumentorum* in a passage in his notes on anatomy discussing pitch in relation to length and width of a pipe or tube, written c.1508-10. Leonardo remarks: "And I do not go into this at greater length because it is fully treated in the book about harmonical instruments"; see Edward MacCurdy, *The Notebooks of Leonardo da Vinci, Arranged, Rendered into English and Introduced*, I (London: Jonathan Cape, 1956), 171. See also Bonnie J. Blackburn, "Leonardo and Gaffurio on Harmony and the Pulse of Music," in Barbara Haggh ed., *Essays on Music and Culture in Honor of Herbert Kellman* (Paris: Minerve, 2001), 128-49.

[40] Donald Zeyl, "Plato's Timaeus", *The Stanford Encyclopedia of Philosophy* (Spring 2014 Edition). Accessed April 5, 2017. https://plato.stanford.edu/archives/spr2014/entries/plato-timaeus. See also Robin Waterfield trans., *Timaeus and Critias* (Oxford: Oxford University Press, 2008).

[41] Plato, "Timaeus" 55c, in Waterfield, *Timaeus*; Zeyl, "Plato's Timaeus".

[42] Donald Zeyl, "Plato's Timaeus".

[43] Plato, "Timaeus", in Waterfield, *Timaeus*; Zeyl, "Plato's Timaeus".

[44] For Pythagorean cosmology and the World Soul see Carl A. Huffman, "The Pythagorean Conception of the Soul from Pythagoras to Philolaus," in *Body and Soul in Ancient Philosophy*, D. Frede and B. Reis eds. (Berlin: Walter de Gruyter, 2009), 21-44.

[45] Protagoras, "Truth" (also known as "Refutations"), Plato, *Theaetetus* 151e, Sextus, *Against the Mathematicians* VII.60 (=DK 80B1), in C.C.W. Taylor and Mi-Kyoung Lee, Edward N. Zalta ed., "The Sophists", *The Stanford Encyclopedia of Philosophy* (Winter 2016 Edition). Accessed April 3, 2015. https://plato.stanford.edu/entries/sophists/#Pro

[46] Henry Davis, *The Republic, The Statesman of Plato* (London: M. W. Dunne, 1901; Nabu Press reprint, 2010), 252. Plato's *Republic* VII.XII reads: "As the eyes, said I, seem formed for studying astronomy, so do the ears seem formed for harmonious motions: and these seem to be twin sciences to one another, as also the Pythagoreans say."

[47] Pliny the Elder, *Natural History*, books I-II, (II.xviii.xx), 77AD, translated by Harris Rackham (Boston: Harvard University Press, 1938) 277-8: "...occasionally Pythagoras draws on the theory of music, and designates the distance between the Earth and the Moon as a whole tone, that between the Moon and Mercury as a semitone, ... the seven tones thus producing the so-called diapason, *i.e.* a universal harmony."

[48] For Pythagoras' *Harmony of the Spheres* see Ian Mueller, "Greek arithmetic, geometry and harmonics: Thales to Plato," in C. C. W. Taylor ed., *Routledge*

History of Philosophy Vol. I: From the Beginning to Plato (London: Routledge, 1997), 271-322.

[49] Franchinus Gaffurius, "Practica Musicae" in Clement A. Miller, *Musicological Studies and Documents* 20 (Neuhausen-Stuttgart: American Institute of Musicology, 1968). For Gaffurio's basis in Pythagorean harmonic theory see Clement A. Miller, "Gaffurius's 'Practica Musicae': Origin and Contents," *Musica Disciplina* 22 (1968): 105-128.

[50] Luca Pacioli, *De divina proportione* 1498, 28v. (Venice: Paganinus de Paganinus, 1509). The manuscripts of 1498 are in Milan, Biblioteca Ambrosiana, Milan, MS A 170 sup. and Geneva, Bib. Publique et Universitaire, MS Langues Etrangeres 210; an illustration from the Ambrosian Codex can be found in Alessandro Vezzosi, *Leonardo Da Vinci: Renaissance Man* (London: Thames and Hudson, 1997), 81. The Venetian publication (1509) can be read online: https://issuu.com/s.c.williams-library/docs/de_divina_proportione. Accessed April 7, 2017. See also Nicholl, *Leonardo*, 304-5.

[51] Ibid.

[52] Leonardo, *Codex Atlanticus*, CA 334/120r-d (Biblioteca Ambrosiana, Milan), trans. Nicholl, *Leonardo*, 305.

[53] Thomas Brachert, "A Musical Canon of Proportion in Leonardo da Vinci's 'Last Supper'," *The Art Bulletin* 53 (1971-Issue 4).

[54] Ibid. Royal Library, Windsor. No. 12542.

[55] Leonardo, MS A8b, and various other notes in Brachert, "A Musical Canon," 464.

[56] Ibid. The two tapestries on each side fill out one twelfth of the rear wall, the following section embraces one tapestry (plus interstice), whilst the nearest tapestry (plus interstice and outer border) takes up the last two-twelfths on either side.

[57] Brachert, "A Musical Canon," 465.

[58] Plato, "Republic," Book 10. In Plato's *Parmenades* he also discusses "the One" as ultimate reality.

[59] Plato, "Republic," Book 10.

[60] Plato, *Republic,* 532, referenced in Syson and Keith, *Painter at the Court of Milan*, 32.

[61] Ibid.

[62] Ibid.

[63] Marsilio Ficino also saw that Plato must be re-read for a Christian audience. There was a tendency, he wrote in the work's dedicatory preface, addressed to Lorenzo de' Medici, to separate philosophy from religion. Using Plato, and trying "to paint a portrait of Plato as close as possible to the Christian truth," seemed to be the way out of this impasse. Marsilio Ficino, *Theologia Platonica,* ed. and trans. Michael Allen and James Hankins, *Platonic Theology* (Cambridge Mass.: Harvard University Press, 2001), vol.1, proem, sec. 3, 10-11.

[64] Leonardo transcribed in *Paris Manuscript*, MS A (Institut de France, Paris); *Codex Atlanticus*, CA 559r/210r-a (Biblioteca Ambrosiana, Milan); notes on the verso reappear on A52r. Ficino's text has been translated in Marsilio Ficino,

Platonic Theology ed., James Hankins and Michael Allen (Cambridge Mass.: Harvard University Press, 2002).

[65] Marsilio Ficino, *Platonic Theology* ed., James Hankins and William R. Bowen (Boston: Harvard University Press, 2002), Bk. 9-11, ix. Ficino writes that the Soul was immortal and therefore "independent of the body"... "The more the mind is separated from the body the better its condition."

[66] Ficino, *Platonic Theology*, Books 9-11, Ch. 2.

[67] Marsilio Ficino's *De Amore* was cast in the form of a literary dialogue and set in the villa of Lorenzo de' Medici with Ficino's friends, including his lover and patron as the interlocutors. Each gives a Neo-Platonic reading of the several speeches in Plato's *Symposium*. It was this work that popularized the concept of "Platonic love" as a poetical conceit in Florence and Milan in the Renaissance.

[68] Marsilio Ficino, *De Amore*, II.2. trans. in Sears Reynolds Jayne, *Commentary on Plato's "Symposium" on Love* (Connecticut: Spring Publications, 1994), 46.

[69] Ficino, *Platonic Theology* in Michael J.B. Allen and James Hankins (ed. and tr.), *Platonic Theology* (Cambridge, Mass.: Harvard University Press, 2004), vol. 4, 222-23. See also Christopher S. Celenza, Edward N. Zalta ed., "Marsilio Ficino," *The Stanford Encyclopedia of Philosophy* (Summer 2015 Edition). Accessed April 6, 2017. https://plato.stanford.edu/archives/sum2015/entries/ficino.

[70] Ficino, *De Amore,* in Allen and Hankins, *Platonic Theology*, vol. 4, 222-23.

[71] Ibid.

[72] There is a vast literature on this topic. See David A. Brown et. al., *Virtue and Beauty. Leonardo's "Ginevra de' Benci" and Renaissance Portraits of Women*, Exh. Cat. (Washington DC: National Gallery of Art, Washington, 2001), 21-23; Syson and Keith, *Painter at the Court of Milan*, 103-5.

[73] See Bellincioni's poem on the subject in Villata, *Leonardo da Vinci*, 76-7, no. 72C, trans. in Syson and Keith, *Painter at the Court of Milan*, 111.

[74] See Brown et. al., *Virtue and Beauty*, 21-23; Syson and Keith, *Painter at the Court of Milan*, 103-5.

[75] Leonardo, *Codex Urbinus*, Urb. fols. 14v-15r (Vatican Library, Rome), trans. in Kemp, *Leonardo on Painting*, 26.

[76] Ibid.

[77] Ibid.

[78] Ibid., 23.

[79] Bellincioni, in Villata, *Leonardo da Vinci*, 76-7, no. 72C, trans. in Syson and Keith, *Painter at the Court of Milan*, 111.

[80] Leonardo, c.1490-2, *Codex Urbinus*, Urb. fol. 36r-v. (Vatican Library, Rome); in facsimile form in Amos Philip McMahon, *The Treatise on Painting by Leonardo da Vinci* (New Jersey: Princeton University, 1956), McM 280; trans. Syson and Keith, *Painter at the Court of Milan*, 40.

Chapter Eight: Trouble at Court

[1] Cecilia Mary Ady, *A History of Milan Under the Sforza* (London: G.P. Putnam's Sons, 1907), 152-3. Accessed April 8, 2017.

https://archive.org/stream/historyofmilanun005616mbp#page/n175/mode/2up

[2] Leonardo, *Paris Manuscript,* MS H 1, fol. 40r (Institut de France, Paris). On the political background of these emblems see Edmondo Solmi, "La politica di Ludovico il Moro nei simboli di Liornardo da Vinci," in *Scritti varii di erudizione e di critica in nore di Rodolfo Reiner* (Torino: Bocca, 1912), 491-509. Accessed April 24, 2017. http://www.franuvolo.it/sito/doc/Leonardo-in/082.pdf. See also Ladislaus Reti, "'Non si volta chi a stella è fisso': Le imprese di Lionardo da Vinci," *Bibliothèque d'humanisme et renaissance* 21 (1959): 7-54.

[3] Ibid.

[4] The sketched head of a young black boy (*Paris Manuscript,* MS H 103v. (Institut de France, Paris)) is probably an allusion to the Moor; there are descriptions (Carlo Pedretti, *Commentary on the Literary Works of Leonardo da Vinci compiled by Jean Paul Richter* (Oxford: Phaidon, 1977) 2.214) of an allegorical painting at the *Castello Sforzesco* showing a black servant (Sforza) brushing the dress of a lady (Italy). There is an allegorical composition: *Il Moro with the spectacles, and Envy depicted together with False Report, and Justice black for Il Moro.* The Moor holds spectacles, a symbol of truth, out towards Envy, who holds a banner with a bird pierced with an arrow. The caption (*Paris Manuscript,* MS H 288v.) is separate from the drawing. Musee Bonnat, Bayonne, 656; A. E. Popham, *The Drawings of Leonardo da Vinci* (London: Jonathan Cape, 1946), no. 109b.

[5] Cecilia Mary Ady, *A History of Milan Under the Sforza* (London: G.P. Putnam's Sons, 1907), 144. Accessed April 8, 2017. https://archive.org/stream/historyofmilanun005616mbp#page/n175/mode/2up

[6] Bernardino Corio, *L'historia di Milano* (Milan, 1503; Venice: Per Giovan Maria Bonelli, 1554). Accessed April 9, 2017. https://archive.org/details/lhistoriadimilan00cori. Corio writes of the desperate letters between Isabelle and her father, King of Naples: "If you do not help us … I would rather die by my own hands than bear this tyrannous yoke and suffer in a strange country under the eyes of a rival." trans. in Ady, *A History of Milan Under the Sforza,* 145.

[7] Ady, *A History of Milan Under the Sforza,* 152-3.

[8] Ibid.

[9] Ibid.,151.

[10] A letter from Sforza dated March 1494 illustrates his hopes regarding the French: that he would find in them an ally "docile enough to serve his designs and powerful enough to ensure their success." Roma, Archivio di Stato, Patense Estere, Delaborde, 262 in Ady, *A History of Milan Under the Sforza,* 147.

[11] The treaty between the Florentines and the French can be found in Giuseppe Canestrini and Abel Desjardins, *Négociations diplomatiques de la France avec la Toscane: documents* (Paris: Impr. nationale, 1859-1886); in Pasquale Villari, trans. Lynda Villari, *The Life and Times of Niccolo Machiavelli* (London: T. Fischer Unwin, 1892), 202. Accessed April 9, 2017. https://archive.org/stream/lifeandtimesnic00villgoog#page/n246/mode/2up

[12] Paul Strathern, *The Medici: Godfathers of the Renaissance* (London: Vintage, 2007), 213.

[13] The Dominicans (literally Domini-cani) were known as the hounds of the Lord well before Savonarola's autocracy.

[14] Strathern, *The Medici*, 217.

[15] Nicholl, *Leonardo*, 291.

[16] See National Gallery of Ireland, Dublin website. Accessed April 8, 2017. https://www.royalcollection.org.uk/collection/themes/exhibitions/leonardo-da-vinci/national-gallery-of-ireland-dublin/studies-for-casting-an-equestrian-monument-recto-further-casting-studies-and-lines-of-poetry-verso.

[17] Nicholl, *Leonardo*, 291. See also Carlo Vecce, *Leonardo* (Rome: Salerno Editrice, 2006), 149-51; Marino Sanudo, *La spedizione di Carlo VIII* (Venice: M. Visentini, 1873), 118-19.

[18] Leonardo, *Codex Atlanticus*, CA 914r/335v-a (Biblioteca Ambrosiana, Milan); trans. Nicholl, *Leonardo*, 291.

[19] Julia Cartwright, *Beatrice d'Este, Duchess of Milan 1475-1497: A Study of the Renaissance* (London: J. M. Dent & Sons, 1920), 306-7. Accessed May 4, 2017. http://www.gutenberg.org/files/25622/25622-h/25622-h.htm#FNanchor_70_70

[20] Cartwright, *Beatrice d'Este*, 316.

[21] Ibid.

[22] This is implied by Sforza's reduction in payment to Leonardo. See Leonardo in Beltrami, *Documenti e memorie*, doc. 70; Carlo Pedretti, *Commentary on the Literary Works of Leonardo da Vinci compiled by Jean Paul Richter* (Oxford: Phaidon, 1977), 2.296; trans. Nicholl, *Leonardo*, 300.

[23] Leonardo in Beltrami, *Documenti e memorie*, doc. 70; Pedretti, *Commentary*, 2.296; trans. Nicholl, *Leonardo*, 300.

[24] Leonardo, *Codex Atlanticus*, CA 866r/315v-a (Biblioteca Ambrosiana, Milan); John Paul Richter ed., *The Literary Works of Leonardo da Vinci*, 2 vols., 3rd edn. (London: Sampson Low, Marston, Searle & Rivington, 1883), 1344. Accessed online April 1, 2017. http://warburg.sas.ac.uk/pdf/cnm22b2242052v1.pdf; trans. Nicholl, *Leonardo*, 300.

[25] Ibid.

[26] Villari, *The Life and Times of Niccolo Machiavelli*, 203.

[27] Leonardo, *Codex Atlanticus*, CA 773r/284r (Biblioteca Ambrosiana, Milan); Richter ed., *The Literary Works*, 1468; CA 570/214r-b, c.1506-8; Pedretti, *Commentary*, 2.353; trans. Nicholl, *Leonardo*, 319.

[28] Leonardo, *Paris manuscript*, MA I 6ir (Institut de France, Paris); trans. Nicholl, *Leonardo*, 320.

[29] Villari, *The Life and Times of Niccolo Machiavelli*, 212.

[30] Villari, *The Life and Times of Niccolo Machiavelli*, 212.

[31] Corio, *L'historia di Milano*, 49v; trans. Nicholl, *Leonardo*, 321.

[32] Nicholl, *Leonardo*, 321.

[33] Villari, *The Life and Times of Niccolo Machiavelli*, 212.

[34] Leonardo, *Codex Atlanticus*, CA 289r/104r-b; I 28v, 34r (Biblioteca Ambrosiana, Milan); trans. Nicholl, *Leonardo*, 320.

[35] Leonardo, *Codex Atlanticus*, CA 669/247a (Biblioteca Ambrosiana, Milan); Richter ed., *The Literary Works*, 1379; Gerolamo Calvi, *Leonardo da Vinci e il*

Conte di Ligny ed altri appunti su personaggi Vinciani, in Raccolta Vinciana 3 (1907), S. 99-110; trans. Nicholl, *Leonardo*, 321.
[36] Villari, *The Life and Times of Niccolo Machiavelli*, 213.
[37] Ibid.
[38] Leonardo, trans. Nicholl, *Leonardo*, 322.
[39] Luca Beltrami, *Documenti e memorie riguardanti la vita e le opere di Leonardo da Vinci* (Milan: Fratelli Treves, 1919), doc.101. The cash was deposited in Florence on January 7 and 15, 1500.
[40] Ibid.
[41] Syson and Keith, *Painter at the Court of Milan*, 172.
[42] *Supplica* of 1503: Beltrami, *Documenti e memorie*, doc. 120. *Arbitrato* of 1506: ibid., doc. 170. Cf. docs. 121-2, 167-9; for further paperwork see in Nicholl, *Leonardo*, 404.

Chapter Nine: International Fame

[1] Charles Nicholl, *Leonardo da Vinci: The Flights of the Mind* (London: Allen Lane, 2004), 325-6.
[2] Rose Marie San Juan, "The Court Lady's Dilemma: Isabella d'Este and Art Collecting in the Renaissance," *Oxford Art Journal* 14: 1 (1991): 67-78.
[3] Nicholl, *Leonardo*, 336-7.
[4] On April 24, 1506 Leonardo drew 50 *florins* from his bank account at Santa Maria Nuova. Luca Beltrami, *Documenti e memorie riguardanti la vita e le opere di Leonardo da Vinci* (Milan: Fratelli Treves, 1919), doc. 101.
[5] Vasari in Nicholl, *Leonardo*, 332.
[6] Noel L. Brann, *The Debate Over the Origin of Genius During the Italian Renaissance* (Leiden, Boston, Cologne: Brill, 2002), 2. According to Brann, during the Italian Renaissance the concept of "genius" reached a cultural acme in the history of western thought and was concerned, on the one hand, with the notion that the human mind had transcended the limits of finite material nature (linked to Neo-Platonic thought), and on the other the concept that it was circumscribed by the finite boundaries of nature.
[7] Ugolino Verino, 1501-2; trans. David Franklin, *Painting in Renaissance Florence, 1500-1550* (Yale: Yale University Press, 2001), 22.
[8] Luca Beltrami, *Leonardo da Vinci e Cesare Borgia:(1502).* (Milan: Allegretti, 1916); Edward MacCurdy, "Leonardo and War." *Raccolta Vinciana* X (1919): 117-126.
[9] Villari, *The Life and Times of Niccolo Machiavelli*, 1.291-3. The full text is in Niccolo Machiavelli, *Legazioni e commissarie*, ed. Sergio Bertelli (Milan: Feltrinelli, 1964), 1.267-8. Cf. See also Vickie Sullivan, "Patricide and the plot of 'The Prince': Cesare Borgia and Machiavelli's Italy," *Journal of Medieval and Renaissance Studies*, 21 (1993): 83-102 in Nicholl, *Leonardo*, 344.
[10] Beltrami, *Leonardo da Vinci e Cesare Borgia*; MacCurdy, "Leonardo and War," 117-126.
[11] Vasari in Bull, *Lives*, 266.

[12] Claire J. Farago, "Leonardo's 'Battle of Anghiari': A Study in the Exchange between Theory and Practice," *The Art Bulletin* 76 (1994 - Issue 2), Published online: 16 May 2014. Accessed April 15, 2017.
http://www.tandfonline.com/doi/abs/10.1080/00043079.1994.10786588

[13] Rona Goffen, *Renaissance Rivals: Michelangelo, Leonardo, Raphael, Titian* (New Haven and London: Yale University Press, 2002), 150; see also Farago, "Leonardo's 'Battle of Anghiari.'"

[14] Leonardo, Budapest, Szépmüséveszeti, Muzeum, Inv. 1175r; see also Carmen Bambach et. al., *Leonardo Da Vinci: Master Draftsman* (New York: Metropolitan Museum of Art, 2003), 453.

[15] Leonardo, *A male nude, and a partial study of the left leg,* c.1504-6, red chalk (partly wetted) on red prepared paper, Royal Library, Windsor, RL 12593r; K. D. Keele and C. Pedretti, *Leonardo da Vinci. Corpus of the Anatomical Studies in the Collection of her Majesty the Queen at Windsor Castle,* 3 vols. (London/New York, 1978-1980), 85r; in Clayton and Philo, *Anatomist,* 74. RCIN 912593. Accessed July 9, 2017. https://www.royalcollection.org.uk/collection/912593/a-male-nude-and-a-partial-study-of-the-left-leg

[16] Leonardo, Royal Library, Windsor, RL 12593r; Keele and Pedretti, *Leonardo da Vinci,* 85r; in Clayton and Philo, *Anatomist,* 74.

[17] Leonardo, *The muscles of the shoulder, torso and leg,* Royal Library, Windsor, RL 12640r; Queen's Archive VI. 13r; Keele and Pedretti, *Leonardo da Vinci,* 82r; in Clayton and Philo, *Anatomist,* 78. RCIN 912640r. Accessed July 9, 2017. https://www.royalcollection.org.uk/collection/912640/the-muscles-of-the-shoulder-torso-and-leg

[18] Leonardo, Royal Library, Windsor, RL 12640r; Queen's Archive VI. 13r; Keele and Pedretti, *Leonardo da Vinci,* 82r; in Clayton and Philo, *Anatomist,* 78.

[19] Sarah Blake McHam discusses Renaissance figurative sculpture as metaphoric of a Florentine body politic. I suggest the same should be done for Leonardo's nudes in relation to the *Battle of Anghiari.* See Sarah Blake McHam, "Donatello's Bronze 'David' and 'Judith' as Metaphors of Medici Rule in Florence," *The Art Bulletin* 83: 1 (2001).

[20] Leonardo was not trained in fresco technique, and experimented with oil paint for the *Last Supper.* This is the reason that such a small portion of the original work remains on the wall. The mural started to deteriorate rapidly after it was completed. See Mauro Matteini and Arcangelo Moles, "A Preliminary Investigation of the Unusual Technique of Leonardo's Mural 'The Last Supper,'" *Journal Studies in Conservation* 24 (1979-Issue 3). Published online February 11, 2014. Accessed April 15, 2017.
http://www.tandfonline.com/doi/abs/10.1179/sic.1979.014

[21] Nicholl, *Leonardo,* 392.

[22] Najemy, *A History of Florence,* 390-400.

[23] *Supplica* of 1503: Beltrami, *Documenti e memorie,* doc. 120. *Arbitrato* of 1506: ibid., doc. 170. Cf. docs. 121-2, 167-9; in Nicholl, *Leonardo,* 404.

[24] In a document notarised on May 30, Leonardo promised to return to Florence within three months or be fined 150 *florins.* Beltrami, *Documenti e memorie,* doc. 176.

[25] Charles Nicholl, *Leonardo da Vinci: The Flights of the Mind* (London: Allen Lane, 2004), 403 and 416.

[26] *Supplica* of 1503 in Beltrami, *Documenti e memorie*, doc. 120. *Arbitrato* of 1506, ibid., doc. 170. Cf. docs. 121-2, 167-9; see Nicholl, *Leonardo*, 404.

[27] Ibid.

[28] D'Amboise to Gonfaloniere Soderini, Dec. 16, 1506, in Beltrami *Documenti e memorie*, doc. 180; in Nicholl, *Leonardo*, 405.

[29] Leonardo's notes and sketches for this pleasure villa can be found in the following notebooks: *Codex Atlanticus*, CA 732bv/271v-a, 629b/231r-b, v-a. (Biblioteca Ambrosiana, Milan); Pedretti, *Commentary*, 2.28-31; Raccolta Vinciana 18 (1960), 65-96.

[30] Ibid.

[31] Paolo Giovio "Life of Leonardo da Vinci" (c.1527), in Ross King, *Leonardo and the Last Supper* (London: Bloomsbury, 2012), 260. Giovio said that Louis XII "coveted it so much that he enquired anxiously from those standing around him whether it could be detached from the wall and transported forthwith to France."

[32] Villata, *Leonardo da Vinci*, nos. 233-5. Two subsequent letters between d'Amboise and the *Signoria* (October-December 1506), and the three further to Louis XII's intervention (January 1507), ibid., nos. 236-7, 240-43.

[33] Ibid.

[34] Ibid.

[35] Grazioso Sironi, *Nuovi documenti riguardanti la "Vergine delle rocce" di Leonardo da Vinci* (Firenze: Giunti Barbèra, 1981), 21-3; Beltrami, *Documenti e memorie,* doc. 192.

[36] Ibid.

[37] Ibid.

[38] Kenneth D. Keele, *Leonardo Da Vinci's Elements of the Science of Man* (New York & London: Academic Press, 1983), 40. A draft letter in the hand of Melzi (*Codex Atlanticus*, CA 939v/342v-a (Biblioteca Ambrosiana, Milan)) refers to the dispute as "the matter pending between myself and my brother Ser Giuliano, the head of the other brothers."

[39] Piero di Braccio di Martelli was a mathematician and linguist and a friend of Bernardo Rucellai and a member of his Platonic Salon. See Alessandro Cecchi, "New Light on Leonardo's Florentine Patrons," in Carmen Bambach, *Leonardo da Vinci: Master Draughtsman* (New York: Metropolitan Museum of Art, 2003), 133. The house was on Via Larga, later swallowed up by the church and convent of San Giovannino in the 1550s. Nicholl, Leonardo, 414.

[40] Leonardo left most of his possessions and all his notebooks to Melzi when he died. See Paul Strathern, *The Artist, the Philosopher and the Warrior. Leonardo, Machiavelli and Borgia: A Fateful Collusion* (London: Vintage, 2010), 392; Keele, *Leonardo Da Vinci's Elements of the Science of Man, 2.*

[41] Leonardo, *Codex Leicester* 34r; cf. A 54v-56r; trans. Nicholl, *Leonardo*, 417.

[42] Leonardo, Royal Library, Windsor, RL 19027r, v.

[43] Leonardo, Royal Library, Windsor, RL 19027r, c. in Nicholl, *Leonardo*, 419.

[44] Leonardo, *Codex Arundel* 1r; trans. Nicholl, *Leonardo*, 416.

[45] Edoardo Villata, *Leonardo da Vinci. I documenti e le testimonianze contemporanee,* ed. E. Villata, presented by P.C. Marani (Milan: Raccolta Vinciana, 1999), nos. 247, 249; trans. Nicholl, *Leonardo,* 413. The King's letter is countersigned by Florimond Robertet, commissioner of the *Madonna of the Yarnwinder.*

[46] Jill Dunkerton, "Leonardo in Verrocchio's Workshop: Re-examining the Technical Evidence" in "Leonardo da Vinci: Pupil, Painter and Master," *National Gallery Technical Bulletin* 32 (2011): 36. The top layer of ultramarine covers the frame, suggesting the painting was already framed and in position at this time.

[47] Vivian Jacobs and Wilhelmina Jacobs, "The Color Blue: Its Use as Metaphor and Symbol," *American Speech* 33: 1 (Feb., 1958): 29-46.

[48] Ashok Roy, ed., "Leonardo da Vinci; Pupil, Painter and Master," *National Gallery Technical Bulletin* 32 (2011), 45, fig. 25, shows the azurite overlain by ultramarine.

[49] Dunkerton, "Leonardo in Verrocchio's Workshop," 36.

[50] Ibid., 48.

[51] Ibid.

[52] Ibid.

[53] Ibid., 47. Incised lines that seem to lie beneath the surface suggest that the cross was an original feature of the design.

[54] Leonardo was not unusual in this respect. As it would have been for any artist at this time, a contract consisted of specific stipulations that an artist had to meet. See Michael Baxandall, *Painting and Experience in Fifteenth-Century Italy* (Oxford: Oxford University Press, 1972), for contract details from this period.

[55] The Confraternity may not have been able to distinguish Leonardo's hand in reality. Yet, whether or not this is the case, from the repeated requests for Leonardo's return to Milan, it seems clear that the artist's presence was valuable to them.

[56] Nicholl, *Leonardo,* 422; Sironi, *Nuovi documenti,* 23-6.

[57] Angela Ottino della Chiesa, *Opera complete Leonardo da Vinci Pittore,* (Milan: Rizzoli, 1967), 94.

Post Script

[1] Charles Nicholl, *Leonardo da Vinci: The Flights of the Mind* (London: Allen Lane, 2004), 424.

[2] Ibid.

[3] Ibid. The Swiss version was exhibited in the Palazzo Reale, Milan in 2000. See Flavio Caroli, *Il Cinquecento Lombardo: Da Leonardo a Caravaggio* Exh. Cat. (Milan: Palazzo Reale, 2000), cat. II.2.

[4] Angela Ottino della Chiesa, *Opera complete Leonardo da Vinci Pittore,* (Milan: Rizzoli, 1967), 94.

[5] Ibid.

[6] Ibid; Nicholl, *Leonardo,* 424; Brendan Cassidy, *The Life & Letters of Gavin Hamilton (1723-1798). Artist & Art Dealer in Eighteenth-Century Rome* (London and Turnhout: Brepols, 2012).

[7] Thereza Wells, "Selling Leonardo's 'Virgin of the Rocks,'" *Burlington Magazine* 153: 1305 (2011): 803.

[8] Ottino della Chiesa, *Opera complete*, 94.

[9] M. Davies, *National Gallery Catalogues. The Earlier Italian Schools*, 2nd edn. (London: National Gallery, 1961), 270; Rachel Billinge, Luke Syson and Marika Spring, "Altered Angels: Two Panels from the Immaculate Conception Altarpiece once in San Francesco Grande, Milan", *National Gallery Technical Bulletin* 32 (Yale University Press, 2011): 57.

[10] Séverine Laborie, *Louvre website*. Accessed June 10, 2017. http://www.louvre.fr/en/oeuvre-notices/virgin-rocks

[11] On Ambrogio's presence in Innsbruck see Shell, "Ambrogio de Predis" in Giulio Bora et. al., *The Legacy of Leonardo* (Milan: Skira Editore, 1998), 124; Malaguzzi-Valeri, *La corte di Ludovico il Moro*, 3.7-8.

[12] Séverine Laborie, *Louvre website*. Accessed June 10, 2017. http://www.louvre.fr/en/oeuvre-notices/virgin-rocks

[13] Nicholas Penny quoted in *Guardian online*, July 27, 2011. Accessed April 1, 2016. http://www.theguardian.com/artanddesign/2011/jul/27/leonardo-da-vinci-paintings-national-gallery-louvre

[14] Charles Darwent, *Independent online*, November 14, 2011. Accessed April 1, 2016. http://www.independent.co.uk/arts-entertainment/art/reviews/leonardo-da-vinci-painter-at-the-court-of-milan-national-gallery-london-6261265.html Charles Darwent

[15] Laura Cumming, *Guardian online*, November 13, 2011. Accessed April 1, 2016. http://www.theguardian.com/artanddesign/2011/nov/13/leonardo-da-vinci-national-gallery-review

[16] Richard Dorment, *Telegraph online*. Accessed April 1, 2016. http://www.telegraph.co.uk/culture/art/leonardo-da-vinci/8870754/Leonardo-da-Vinci-Painter-at-the-Court-of-Milan-National-Gallery-in-London-review.html

[17] Vasari, trans. Bull, *Lives*, 266.

[18] The National Gallery Annual Report and Accounts for the year ended March 31, 2012, published online. Accessed April 1, 2016. https://www.gov.uk/government/uploads/system/uploads/attachment_data/file/229067/0490.pdf

[19] Ibid. The exhibition entitled *Devotion by Design: Italian Altarpieces before 1500*, which ran between July 6, 2011–October 2, 2011, was the second most popular show that year with only 47,793 visitors.

[20] Ambrogio's presence in Innsbruck at around the time the first painting disappeared suggests that it may have been taken to Maximilian I. See Shell, "Ambrogio de Predis," 124; Malaguzzi-Valeri, *La corte di Ludovico il Moro*, 3.7-8.

[21] Leonardo c.1510-11, Royal Library, Windsor, RL 19016r; *Paris Manuscript* MS A. 17r (Institut de France, Paris); Keele and Pedretti, *Leonardo da Vinci*, 150r; trans. in Clayton and Philo, *Anatomist*, 196.

[22] Ludwig Choulant, Fielding Hudson Garrison, Edward Clark Streeter, *History and Bibliography of Anatomic Illustration: In Its Relation to Anatomic Science and the Graphic Arts* (Chicago: Chicago University Press, 1852), 99.

[23] Leonardo, *Paris Manuscript* MS E, 2176 (Institut de France, Paris): "I left Milan for Rome on 24 September 1513, in the company of Giovan, Francesco de Melzi, Salai, Lorenzo and Il Fanfoia." trans. Nicholl, *Leonardo*, 458.

[24] Christine Shaw, *Julius II: The Warrior Pope* (London: John Wiley & Sons, 1997), 140.

[25] Giorgio Vasari (*Lives*, trans. George Bull, 292) first identified some of the figures in Raphael's *School of Athens* as having the facial features of contemporaries. Since then many Art Historians have followed suit, including: Ernst H. Gombrich, "Raphael's 'Stanza Segnatura' and the Nature of its Symbolism," in *Symbolic Images: Studies in the Art of the Renaissance* (London: Phaidon, 1975); Daniel Orth Bell, "New Identifications in Raphael's 'School of Athens'," *The Art Bulletin* 77: 4 (1995): 638-646. Others dispute the fact that Leonardo's face was inserted upon Plato's body. See William E. Wallace, "Leonardo as Plato", *Source: Notes in the History of Art* 30: 1 (Fall 2010): 8-11.

[26] Luca Beltrami, *Documenti e memorie riguardanti la vita e le opere di Leonardo da Vinci* (Milan: Fratelli Treves, 1919), doc. 218, trans. Nicholl, *Leonardo*, 463. On December 1, 1513, one of the Pope's architects, Giuliano Leno, listed various building-works to be carried out in the Vatican precincts, among them "things to be done at Belvedere in the rooms of Messer Lionardo da Vinci."

[27] Leonardo, Royal Library, Windsor, RL 12377-86 in Frank Zöllner, *Leonardo da Vinci: Complete Paintings and Drawings* (London: Taschen, 2003), nos. 451-60. These are a unified series of "deluge" studies.

[28] Antonio de Beatis trans. in Kenneth D. Keele, *Leonardo Da Vinci's Elements of the Science of Man* (New York & London: Academic Press, 1983), 40; Gustavo Frizzoni, "Leonardo da Vinci rammentato da un viaggiatore contemporaneo," *Nuova Antologia* vol. 144, 5th edn. (Roma, 1909), 631-637; Alessia Coralli and Antonio Perciaccante, "Leonardo's Recurrent Stroke?" *The Lancet Neurology* 15: 7 (2016): 667.

[29] Luca Landucci, *A Florentine diary from 1450 to 1516 by Luca Landucci continued by an anonymous writer till 1542 with notes by Iodoco del Badia*, trans. Alice de Rosen Jervis (London: J.M. Dent & Sons; New York: E.P. Dutton & Co., 1927), 205. Landucci recounts the arrival of the papal circus in Florence on November 30, 1515, as "a marvellous thing".

[30] Benvenuto Cellini, *Discorso dell'architettura*, in *Opera Omnia*, ed. Bruno Maier (Milan: Novara, 1968), 858-60.

[31] An authorisation of two years'-worth of payment exists in the Archive Nationale in *Paris Manuscript*, MS KK 289 (Institut de France, Paris). In the same document Leonardo is formally named "the King's Painter". Janice Shell and G. Sironi, "Salai and the inventory of his estate," *Raccolta Vinciana 24* (1992): no. 38; Frank Zöllner, *Leonardo da Vinci 1452-1519* (London: Taschen, 2000), 94.

[32] Cellini, *Discorso dell'architettura*, 858-60.

[33] Leonardo, *Paris Manuscript*, MS KK 289 (Institut de France, Paris); Janice Shell and G. Sironi, "Salai and the inventory of his estate," no. 38.

[34] Antonio Beatis, *The Travel Journal*, ed. John Hale (London: Hakluyt Society, 1979), 131-4; the original manuscript may be found in the Biblioteca Nazionale, Naples, X.F.28. Antonio de Beatis, the secretary of Cardinal Luigi of Aragon,

describes his master's visit to Leonardo at his French estate, collaborating evidence of the artist's pension and comfortable setting; see also Zöllner, *Leonardo da Vinci,* 81-92.

GLOSSARY OF KEY TERMS

aerial perspective: the technique of representing distant objects as fainter and more blue in colour, for example the mountains in the background of Leonardo's *Virgin of the Rocks*. Leonardo discovered that colour was seen as less saturated in the distance.

all' antica: in the style of antique or Classical art.

Apelles: an Ancient Greek artist made famous in the writing of Pliny the Elder.

"block book": a book of patterns to be traced verbatim by artists in the Middle Ages.

bottega: artist's studio.

camerini: small rooms or apartments.

cartone: "cartoon" in English. This was a full size "mock up" drawing on paper that could be transferred to panel or canvas using a technique similar to tracing.

castello: castle.

chiaroscuro: a painterly effect of dramatically contrasted light and shadow, resulting in a three-dimensional effect. This was only truly possible with the advent of oil paint, which allowed for deeper and richer tones.

colore: literally meaning "colour," in its fuller sense this was a term used by the Tuscan author and artist Giorgio Vasari (*Lives*, 1550) to define a particular approach to painting. He saw the *colore* approach as typically Venetian, with a focus on colour at the expense of what he saw as the Tuscan artists' serious and intellectual approach to design, or *disegno*. Vasari's discussion of *colore* versus *disegno* was part of a calculated propaganda campaign to establish Tuscan artists as the greatest of the Italian Renaissance.

Compagnia di San Luca: the equivalent of the artist's guild or union in Florence.

condottiere: military leader. A *condottiere* was hired, along with his army, to fight wars on behalf of other noblemen or rulers.

confraternity: generally a Christian voluntary association of laymen, or brotherhood, created for the purpose of promoting special works of Christian charity or piety.

contrapposto: a pose in which one leg remains straight, whilst the other is bent. This causes a twisting of the torso, and a sense of movement or potential energy in the body that in turn creates a sense of naturalism. This pose was first developed by the Ancient Greeks, famously in Polykleitos' *Doryphoros*, and was revived during the Italian Renaissance.

Corte Vecchio: "old court" or "old palace".

de facto **ruler**: a ruler in fact, but not by right.

disegno: literally meaning "design" in English. (See *colore.*)

Duomo: cathedral.

equestrian monument: a life size statue of a military ruler on horseback. This form of sculpture was first seen in Classical times and was revived in the Italian Renaissance.

fabbrica: literally meaning "factory", this term alludes to a large scale artist's workshop.

Franciscan Order: a male religious Order, or group of friars, who adhere to the teachings of St Francis of Assisi. The movement originated within the Catholic Church.

garzone: literally meaning "boy", this term was applied to young apprentices in an artist's workshop. A *garzone* would be given menial tasks such as running errands.

glaze: a thin, transparent layer of oil paint.

guild: similar to a workers' union, Florentine guilds consisted of men working within the same trade. Guilds would control the quality and price of products, as well as monitoring the training of young craftsmen. In Florence there were 7 major guilds and 14 minor guilds at the time Leonardo was alive.

humanism (or Renaissance humanism): the study of Classical Antiquity that started in Italy, triggered by the rediscovery of Classical texts, architecture and art works in the 15^{th} and 16^{th} century. Renaissance humanism placed man and human intellect at the heart of its ethos, and embraced the Classical philosopher Protagoras' dictum that man was "the measure of all things."

iconography: An iconography is a particular range or system of symbols or types of image used by an artist or artists to convey particular meanings. For example in Christian religious painting there are recognized

iconographies, with certain objects or figures having specific symbolic meanings, such as the lamb which represents Christ, or the dove which represents the Holy Spirit.

Immaculate Conception: a Catholic doctrine according to which the Virgin Mary was conceived through a miracle rather than through sexual intercourse. This allowed her to be created pure, without Original Sin.

Immacolata: "the immaculate," refers to Mary as immaculately conceived. (See **Immaculate Conception**.)

imprimatura: the first wash of paint that was layered over the underdrawing to fix it in place and prevent smudging. The underdrawing would be seen through this *imprimatura* and used for the basis of a painting.

Infrared Reflectogram: a form of photography that allows the drawing beneath the paint surface to become visible. Thin paint layers, opaque to visible light, are partially transparent to radiation in the 700 nm to 2,000 nm range. White gesso, and to a lesser extent other light-coloured grounds, reflect infrared rays, but where there is a carbon-based underdrawing, reflectance is reduced.

macrocosm: a large-scale representation of something much smaller. For example, during the Renaissance the universe was seen as a macrocosm of the human body.

maquette: a small-scale model, often made in plaster or clay and arranged on a metal armature. This would be used as a three-dimensional study for a larger sculpture, or as a model from which to sketch.

microcosm: a small-scale representation of something much larger. For example, during the Renaissance the human body was seen as a microcosm of the universe.

mimesis: the Greek word for "copy".

Neo-Platonism: a school of philosophy that might be considered a sub-category of humanism, seeking to revive the teaching of the Greek philosopher, Plato. During the Renaissance the Neo-Platonic philosopher, Marsilio Ficino, translated Plato's work from Greek into Latin, adding his own commentaries in order to make Plato relevant to a Christian audience.

Original Sin (also called Ancestral Sin): the Catholic doctrine that all humans are born with sin. This stems from the "fall" of mankind, when Adam and Eve were expelled from the Garden of Eden for committing the Original Sin, namely the sin of disobedience in eating the forbidden fruit from the tree of knowledge of good and evil.

Palazzo Vecchio: "old palace".

Pazzi Conspiracy: An assassination attempt on the Medici brothers made during mass at the Cathedral of Florence on 26th April 1478 by the rival banking family, the Pazzi. Giuliano de' Medici was killed by Francesco Pazzi, but Lorenzo was able to defend himself and escaped only slightly wounded.

polyhedron: a four dimensional geometric solid with surfaces that consist of multiple equilateral triangles.

Renaissance: the "rebirth" of Classical art and literature that occurred roughly between 1400-1600 in Italy.

sfumato: "smoky" modelling. This was an invention of Leonardo da Vinci's, in which the contours of his figures appeared "smoky" or smudged, creating the impression of a living, breathing form.

Signoria: the republican government of Florence. This included one chancellor or *Gonfaloniere*, six members elected from within the major guilds and two members elected from the minor guilds (a total of nine members).

spolvero: the process used to transfer designs from a *cartone* to panel, similar to tracing. A needle-like tool was used to prick holes around the outlines of the drawing, which was then laid face down upon the panel. Chalk powder was then pushed through the holes by dabbing the paper with a small sack or powder puff. Once the *cartone* was removed, the dots of powder left on the panel were joined up to create the underdrawing for a painting.

studiolo: a small study, most typically associated with court palaces, but may also refer to an artist's studio.

tetractys: a triangular figure consisting of ten points arranged in four rows: one, two, three, and four points in each row. As a mystical symbol it was very important to the secret worship of Pythagoreanism.

tonal modelling: the use of a single colour range (usually black to white) or "shading" to create the illusion of three-dimensional form.

Transubstantiation: the Catholic doctrine that states that the bread and wine tasted during Holy Communion or Mass transforms into the body and blood of Christ in the priest's hands. This is counter to the notion of Consubstantiation, assumed by Protestants, where the bread and wine simply *represent* the body and blood of Christ.

underdrawing: a drawing made on the panel or canvas used as a basis or template over which to paint.

undermodelling: Leonardo built up his underdrawing with tonal modelling to create a sense of three-dimensionality in black and white.

BIBLIOGRAPHY

Leonardo's writings (manuscripts):

Codex Atlanticus, Milan, Biblioteca Ambrosiana: *Leonardo da Vinci, Il codice atlantico della Biblioteca Ambrosiana a Milano*, ed. A. Marinoni, 24 vols. (Florence 1974-1980).

Codex Leicester, Collection Bill Gates, Seattle: *The Codex Hammer* [i.e. the Codex Leicester], ed. C. Pedretti (Florence, 1987).

Codices Madrid I and II, Madrid, Biblioteca Nacional: *The Manuscripts of Leonardo da Vinci at the Biblioteca Nacional of Madrid*, ed. L. Reti, 5 vols. (New York, 1974).

Codex Arundel, London, British Museum: *I manoscritti e I disegni di Leonardo da Vinci, il Codice Arundel* 263, 4 vols. (Rome, 1923-30).

Codex Forster, London, Victoria and Albert Museum: *Leonardo da Vinci, Il Codice Forster del Victoria and Albert Museum di Londra*, ed. A. Marinoni, 3 vols. (Florence, 1992).

Keele, C. D. and C. Pedretti, *Leonardo da Vinci. Corpus of the Anatomical Studies in the Collection of her Majesty the Queen at Windsor Castle*, 3 vols. (London/New York, 1978-1980).

Manuscripts A–I, Paris, Institut de France: *Leonardo da Vinci, I manoscritti del Institut de France*, ed. A. Marinoni, 12 vols. (Florence, 1986-1990).

Pedretti C., (Hg.), *The Drawings and Miscellaneous Papers of Leonardo da Vinci in the Collection of her Majesty the Queen at Windsor Castle*, vol. 1: *Landscape, Plants and Water Studies* (London 1982), vol. 2: *Horses and Other Animals* (London, 1987), vol. 3: *Figure Studies*, and vol. 5: *Miscellaneous Papers*.

Royal Library, Windsor Castle: *The Drawings of Leonardo in the Collection of her Majesty the Queen at Windsor Castle*, ed. K. Clark and C. Pedretti, 1968-69 (first published 1935).

Primary Sources

Leonardo

Calvi, Gerolamo, *I manoscritti di Leonardo* (Bologna: Zanichelli, 1925).

Cottrell, Phillip, Michael John Gorman, Michael Ryan et al., *Leonardo da Vinci: The Codex Leicester,* Exh. Cat. Chester Beatty Library (London: Scala Publishers Ltd., 2007).

Kemp, Martin, *Leonardo On Painting* (New Haven: Yale University Press, 1989).

Keele, Kenneth David and Jane Roberts, *Leonardo Da Vinci: Anatomical Drawings from the Royal Library, Windsor Castle* (New York: The Metropolitan Museum of Art, 1983).

MacCurdy, Edward, *The Notebooks of Leonardo da Vinci, Arranged, Rendered into English and Introduced*, 2 vols. (2nd ed. London: Jonathan Cape, 1956).

McMahon, Amos Philip, *The Treatise on Painting by Leonardo da Vinci* (New Jersey: Princeton University, 1956).

Pedretti, Carlo, *Leonardo da Vinci: Fragments at Windsor Castle from the Codex Atlanticus* (London: Phaidon, 1957).

—. *Commentary on the Literary Works of Leonardo da Vinci compiled by Jean Paul Richter* (Oxford: Phaidon, 1977).

Richter, Irma A., *"Paragone", Comparison of the Arts by Leonardo Da Vinci* (New York: Oxford University Press, 1949).

Richter, John Paul, ed., *The Literary Works of Leonardo da Vinci*, 2 vols., 3rd edn. (London: Sampson Low, Marston, Searle & Rivington, 1883). Accessed online April 1, 2017. http://warburg.sas.ac.uk/pdf/cnm22b2242052v1.pdf

Other primary sources (not Leonardo)

Alberti, Leon Battista, *Della Pittura*, 1435, ed. and trans. Martin Kemp as *On Painting* (London: Penguin, 1991).

Beatis, Antonio, *The Travel Journal*, ed. John Hale (London: Hakluyt Society, 1979).

Bellincioni, Bernardo, trans. Edoardo Villata, *Leonardo da Vinci. I documenti e le testimonianze contemporanee*, ed. E. Villata, presented by P.C. Marani (Milan: Raccolta Vinciana, 1999).

Beltrami, Luca, *Documenti e memorie riguardanti la vita e le opere di Leonardo da Vinci* (Milan: Fratelli Treves, 1919).

Bruni, Leonardo, *Panegyric to the City of Florence,* 1403-4. Accessed online April 28, 2015.
http://www.york.ac.uk/teaching/history/pjpg/bruni.pdf

—. "Historiarum Florentini populi libri XII", ed. and trans. James Hankins, *History of the Florentine People* (Boston: Harvard University Press, 2007).

Canestrini, Giuseppe and Abel Desjardins, *Négociations diplomatiques de la France avec la Toscane: documents* (Paris: Impr. nationale, 1859-1886).

Cellini, Benvenuto, *Prose e Poesie di Benvenuto Cellini* (Firenze: Gugliemo Piatti, 1829).

Cenini, Cennino, "Il Libro dell'Arte o Trattato della Pittura" (1433) trans. Mary P. Merrifield, *Treatise on Painting* (London: Robson, Levey and Franklyn, 1844). Accessed April 1, 2017.
https://archive.org/stream/atreatiseonpain00merrgoog#page/n3/mode/2 up

Corio, Bernardino, *L'historia di Milano* (Milan, 1503; Venice: Per Giovan Maria Bonelli, 1554).

Ficino, Marsilio, "Letter to Paul of Middelburg," 1492, in *The Letters of Marsilio Ficino* Vol. 2, Liber III (London: Shepheard-Walwyn, 1991).

—. *De amore*, 1484, Bodleian Library, Oxford, Can. Class. Lat. 156. trans. in Sears Reynolds Jayne, *Commentary on Plato's "Symposium" on Love* (Connecticut: Spring Publications, 1994) and Michael J.B. Allen and James Hankins (ed. and tr.), *Platonic Theology* (Cambridge, Mass.: Harvard University Press, 2004), vol. 4.

—. *Platonic Theology,* ed. and trans. Michael J.B Allen and James Hankins, 6 vols. (Cambridge, Mass.: Harvard University Press. 2001-06).

—. *Della Divine Lettere del Gran Marsilio Ficino*, trans. M. Felice, 2 vols (Venice: Gabriel Giolito de' Ferrari, 1563), English trans. Rictor Norton. Accessed June 17, 2017. http://rictornorton.co.uk/ficino.htm

Gaffurius, Franchinus, "Practica Musicae" in Clement A. Miller, *Musicological Studies and Documents* 20 (Neuhausen-Stuttgart: American Institute of Musicology, 1968).

Landucci, Luca, *A Florentine diary from 1450 to 1516 by Luca Landucci continued by an anonymous writer till 1542 with notes by Iodoco del Badia*, trans. Alice de Rosen Jervis (London: J.M. Dent & Sons.; New York: E.P. Dutton & Co., 1927).

Machiavelli, Niccolò, *Legazioni e commissarie*, ed. Sergio Bertelli (Milan: Feltrinelli, 1964).

Malaguzzi-Valeri, Francesco, "Artisti Lombardi a Roma nel Rinascimento: Nuovo documenti su Cristoforo Solari, Bramante e Caradosso, " *Repertorium fur Künstwissenschaft,* XXV (1992): 57-64.

Marani, Pietro C., "Leonardo a Venezia e nel Veneto: Documenti e testimonianze," in *Leonardo & Venezia,* Exh. Cat., ed. Giovanna Nepi Scire and Pietro C. Marani (Milan: Bompiani, 1992).

Medici, Lorenzo de', "Ambra", stanza 18, trans. Jon Thiem, *Lorenzo de' Medici: Selected Poems and Prose* (Pennsylvania: Pennsylvania State University, 1991).

Pacioli, Luca, *Summa de arithmetica, geometria, proportioni et proportionalita* (Venice, 1494), ed. and trans. Jeremy Cripps (Seattle: Pacioli Society, 1994). Accessed April 20, 2017.
http://jeremycripps.com/docs/Summa.pdf

—. *De divina proportione,* 1498 (Venice: Paganinus de Paganinus, 1509). The MMS of 1498 are in Milan, Biblioteca Ambrosiana, MS A 170 sup. and Geneva, Bib. Publique et Universitaire, MS Langues Etrangeres 210; the Venetian publication (1509) can be read online. Accessed April 1, 2017.
https://issuu.com/s.c.williams-library/docs/de_divina_proportione

Plato, *Parmenides,* trans. with commentary by Samuel Scolnicov as *Plato's Parmenides* (Berkley, Los Angeles, London: University of California Press, 2003).

—. "The Republic," ed. Henry Davis, *The Republic, The Statesman of Plato* (London: Nabu Press, 2010).

—. *Timaeus and Critias,* trans. Robin Waterfield (Oxford: Oxford University Press, 2008).

Pliny the Elder, "Naturalis Historia," trans. in *Pliny the Elder, The Natural History,* ed. John Bostock and trans. Harris Rackham (Boston: Harvard University Press, 1938). Accessed April 20, 2017.
http://www.perseus.tufts.edu/hopper/text?doc=Perseus%3Atext%3A19 99.02.0137%3Abook%3D35%3Achapter%3D36

Protagoras, "Truth" (also known as "Refutations"), Plato, *"Theaetetus"* 151e, Sextus *"Against the Mathematicians"* VII.60 (=DK 80B1), in C.C.W. Taylor and Mi-Kyoung Lee and Edward N. Zalta ed., "The Sophists," *The Stanford Encyclopedia of Philosophy* (Winter 2016 Edition). Accessed April 5, 2015.
https://plato.stanford.edu/entries/sophists/#Pro

Scotus, Duns, "Ordinato," III d.3 q.1., in Carlo O.F.M. Balic, "The Medieval Controversy over the Immaculate Conception up to the Death of Scotus," in O'Connor, E.C.S.C., *The Dogma of the*

Immaculate Conception: History and Significance (South Bend: University of Notre Dame Press, 1958).

Sironi, Grazioso, *Nuovi documenti riguardanti la "Vergine delle rocce" di Leonardo da Vinci* (Firenze: Giunti Barbèra, 1981).

Taccone, Baldassarre, *Coronatione e sposalizio de la serenisima regina Maria Bianca* (Milan: Pachel, 1493).

Vasari, Giorgio, *Le Vite de più eccellenti Pittori Scultori ed Architettori*, vol. III, 1568, ed. G. Milanesi (Florence, 1906); trans. George Bull, *Georgio Vasari, The Lives of the Artists* (London: Harmondsworth, 1965); and trans. Gaston. du C. de Vere, *Lives of the Most Eminent Painters, Sculptors and Architects* (London: Everyman, 1996).

Verino, Ugolino, 1501-2, trans. David Franklin in *Painting in Renaissance Florence, 1500-1550* (New Haven: Yale University Press, 2001).

Villata, Edoardo, *Leonardo da Vinci. I documenti e le testimonianze contemporanee*, ed. E. Villata, presented by P.C. Marani (Milan: Raccolta Vinciana, 1999).

Vitruvius, *Ten Books on Architecture*, trans. Ingrid D. Rowland and Thomas Noble Rowland Howe (Cambridge: Cambridge University Press, 1999).

Secondary Sources

Acidini, Luchinat C. ed., *Maestri e botteghe. Pittura a Firenze alla fine del Quattrocento*, Exh. Cat. (Florence: Palazzo Strozzi, 1992).

Ady, Cecilia Mary, *A History of Milan Under the Sforza* (London: G.P. Putnam's Sons, 1907). Accessed April 1, 2017. https://archive.org/stream/historyofmilanun005616mbp#page/n175/mode/2up

Aiken, Jane Andrews, "The Perspective Construction of Masaccio's 'Trinity' Fresco and Medieval Astronomical Graphics," *Artibus et Historiae* 16:31 (1995): 171-187.

Ames-Lewis, Francis, *Drawing in Early Renaissance Italy*, 2nd ed. (New Haven: Yale University Press, 2000).

Balic, Carlo O.F.M., "The Medieval Controversy over the Immaculate Conception up to the Death of Scotus," in O'Connor, E.C.S.C., *The Dogma of the Immaculate Conception: History and Significance* (South Bend: University of Notre Dame Press, 1958).

Bambach, Carmen. C., *Drawing and Painting in the Italian Renaissance Workshop: Theory and Practice, 1300–1600* (New York: Cambridge University Press, 1999).

Bambach, Carmen. C., with Rachel Stern and Alison Manges, *Leonardo Da Vinci: Master Draftsman* (New York: Metropolitan Museum of Art, 2003).

Baxandall, Michael, *Painting and Experience in Fifteenth-Century Italy* (Oxford: Oxford University Press, 1972).

Behling, Lottlisa, "Die Pflanze in der mittelalterlichen Tafelmalerei," 2nd edn. (Köln, Graz: Böhlau, 1967) in Riklef Kandeler and Ullrich R. Wolfram, "Symbolism of plants: examples from European-Mediterranean culture presented with biology and history of art, MAY: Columbine," *Journal of Experimental Botany*, 60: 6 (2009): 1535-1536.

Bell, Daniel Orth, "New Identifications in Raphael's 'School of Athens'," *The Art Bulletin* 77: 4 (1995): 638-646.

Beltrami, Luca, *Leonardo da Vinci e Cesare Borgia: (1502)*. (Milan: Allegretti, 1916).

Biggiogero, G. M., "Luca Pacioli e la sua 'Divina proportione,'" *Rendiconti dell'Istituto lombardo di scienze e lettere* 94 (1960): 3-30.

Billinge, Rachel, Luke Syson and Marika Spring, "Altered Angels: Two Panels from the Immaculate Conception Altarpiece once in San Francesco Grande, Milan," *National Gallery Technical Bulletin* 32 (Yale University Press, 2011): 57-77.

Blackburn, Bonnie J., "Leonardo and Gaffurio on Harmony and the Pulse of Music," in Barbara Haggh ed., *Essays on Music and Culture in Honor of Herbert Kellman* (Paris: Minerve, 2001).

Brachert, Thomas, "A Musical Canon of Proportion in Leonardo da Vinci's 'Last Supper'," *The Art Bulletin* 53 (1971-Issue 4).

Brann, Noel L., *The Debate Over the Origin of Genius During the Italian Renaissance* (Leiden, Boston, Cologne: Brill, 2002).

Britton, Piers D. G., "The signs of faces: Leonardo on physiognomic science and the 'Four Universal States of Man'," *Renaissance Studies* 16: 2 (Wiley, June 2002): 143-162.

Brooks, Sarah, "Icons and Iconoclasm in Byzantium," *Heilbrunn Timeline of Art History* (New York: The Metropolitan Museum of Art, 2009). Accessed May 21, 2017.
http://www.metmuseum.org/toah/hd/icon/hd_icon.htm

Brown, David A., "Leonardo and the idealised portrait in Milan," *Arte Lombardo* 67 (1983/4): 102-16.

—. "Leonardo apprendista," *Lettura Vinciana 39* (Florence: Giunti, 2000).

Brown, David A. et. al., *Virtue and Beauty. Leonardo's "Ginevra de' Benci" and Renaissance Portraits of Women*, Exh. Cat. (Washington DC: National Gallery of Art, Washington, 2001).

Brown, Donald E., *Hierarchy, history, and human nature: The social origins of historical consciousness* (Tucson: University of Arizona Press, 1988).

Brown, Mark, "Leonardo da Vinci works to be shared by National Gallery and the Louvre," *The Guardian*, July 27, 2011. Accessed April 1, 2016. http://www.theguardian.com/artanddesign/2011/jul/27/leonardo-da-vinci-paintings-national-gallery-louvre

Calvi, Gerolamo, *Leonardo da Vinci e il Conte di Ligny ed altri appunti su personaggi Vinciani*, in Raccolta Vinciana 3 (1907), S. 99-110.

Cameron, James, in Eddie Wrenn, "Avatar: How James Cameron's 3D film could change the face of cinema forever," *Daily Mail,* August 26, 2009. Accessed November 13, 2015. http://www.dailymail.co.uk/tvshowbiz/article-1208038/Avatar-How-James-Camerons-3D-film-change-face-cinema-forever.html#ixzz3PIqFJHw7

Carlino, Andrea, *Books of the Body: Anatomical Ritual and Renaissance Learning*, trans. John Tedeschi and Anne C. Tedeschi (Chicago, Illinois: University of Chicago Press, 1999).

Caroli, Flavio, *Il Cinquecento Lombardo: Da Leonardo a Caravaggio* (Milan: Palazzo Reale, 2000).

Cartwright, Julia, *Beatrice d'Este, Duchess of Milan 1475-1497: A Study of the Renaissance* (London: J. M. Dent & Sons, 1920). Accessed May 4, 2017. http://www.gutenberg.org/files/25622/25622-h/25622-h.htm# FNanchor_70_70

Cassidy, B., *The Life & Letters of Gavin Hamilton (1723-1798). Artist & Art Dealer in Eighteenth-Century Rome* (Turnhout: Brepols, 2012).

Celenza, Christopher S., "Marsilio Ficino," *The Stanford Encyclopaedia of Philosophy* (Summer 2015 Edition), Edward N. Zalta ed. Accessed April 20, 2017. https://plato.stanford.edu/archives/sum2015/entries/ficino/

Choulant, Ludwig, Fielding Hudson Garrison, Edward Clark Streeter, *History and Bibliography of Anatomic Illustration: In Its Relation to Anatomic Science and the Graphic Arts* (Chicago: Chicago University Press, 1852).

Cianchi, Renzo, "Figure nuove del mondo Vinciano: Paolo e Vannoccio Biringuccio da Siena" (Milan: Raccolta Vinciana 20, 1964).

Cianchi, Marco, *Leonardo's machines* (Florence: Becocci, 1988).

Clark, Kenneth, *Leonardo da Vinci: An account of his development as an artist* (London: Pelican, 1963).

Clark, Kenneth, *Leonardo da Vinci*, intro. Martin Kemp (London: Penguin 1989).

Clayton, Martin and Ron Philo, *Leonardo da Vinci: The Mechanics of Man* (Los Angeles: J. Paul Getty Museum, 2010).

Clayton, Martin and Ron Philo, *Leonardo da Vinci: Anatomist* (London: Royal Collection Trust, 2011).

Conner, C., *A People's History of Science: Miners, Midwives, and Low Mechanicks* (New York: Nation Books, 2005).

Coolidge, John, "Further Observations on Masaccio's 'Trinity'," *The Art Bulletin* 48: 3/4 (Sep.-Dec., 1966): 382-384.

Coralli, Alessia and Antonio Perciaccante, "Leonardo's Recurrent Stroke?" *The Lancet Neurology* 15: 7 (2016): 667.

Corry, Maya, "The Alluring Beauty of a Leonardesque Ideal: Masculinity and Spirituality in Renaissance Milan," *Gender & History* 25: 3 (November 2013): 565–589.

Cottrell, Phillip, Michael John Gorman, Michael Ryan et al., *Leonardo da Vinci: The Codex Leicester,* Exh. Cat. Chester Beatty Library (London: Scala Publishers Ltd., 2007).

Cumming, Laura, "Leonardo da Vinci: Painter at the Court of Milan–review," *The Guardian*, November 13, 2011. Accessed April 1, 2016. http://www.theguardian.com/artanddesign/2011/nov/13/leonardo-da-vinci-national-gallery-review

Darwent, Charles, "Leonardo da Vinci, Painter at the Court of Milan, National Gallery, London," *Independent*, November 14, 2011. Accessed April 20, 2017. http://www.independent.co.uk/arts-entertainment/art/reviews/leonardo-da-vinci-painter-at-the-court-of-milan-national-gallery-london-6261265.html

Davies, Martin, *National Gallery Catalogues. The Earlier Italian Schools*, 2nd edn. (rev.) (London: National Gallery, 1961).

—. "Making sense of Pliny in the Quattrocento," *Renaissance Studies* 9 (1995): 240-257.

de Roover, Raymond Adrien, *The rise and decline of the Medici Bank: 1397-1494* (New York City, Toronto: W. W. Norton & Company, 1966).

Dorment, Richard, "Leonardo da Vinci: Painter at the Court of Milan, National Gallery in London: review," *The Telegraph*, November 7, 2011. Accessed April 20, 2017. http://www.telegraph.co.uk/culture/art/leonardo-da-vinci/8870754/Leonardo-da-Vinci-Painter-at-the-Court-of-Milan-National-Gallery-in-London-review.html

Dunkerton, Jill, *Giotto to Dürer: Early Renaissance Painting in the National Gallery* (London: National Gallery Press, 1991).

—. "Leonardo in Verrocchio's Workshop: Re-examining the Technical Evidence," in "Leonardo da Vinci: Pupil, Painter and Master," *National Gallery Technical Bulletin* 32 (2011): 4-31. Accessed June 13, 2017. https://www.nationalgallery.org.uk/upload/pdf/dunkerton2011.pdf

Eastaugh, Nicholas, Valentine Walsh, Tracey Chaplin, Ruth Siddall, *Pigment Compendium: A Dictionary of Historical Pigments* (Oxford: Butterworth-Heinemann, 2004).

Eastlake, Charles Lock, *Materials for a History of Oil Painting*, Volume 1 (London: Longman, 1847). Accessed May 8, 2017. https://archive.org/details/materialsforahi03eastgoog

Elam, Caroline, "Lorenzo de' Medici's Sculpture Garden," *Mitteilungen des Kunsthistorischen Institutes in Florenz* 36: 1/2 (1992): 41-84.

Embolden, William A., *Leonardo da Vinci on Plants and Gardens*, (Portland: Timber Press, 1987).

Emison, Patricia, "Leonardo's landscape in the 'Virgin of the Rocks'," *Zeitschrift für Kunstgeschichte* 56: 1 (1993): 116-118.

Fahey, Stanley Joseph, *From medieval corporatism to civic humanism: Merchant and guild culture in fourteenth- and fifteenth-century Florence*, PhD (State University of New York at Binghamton, 2011). Accessed May 12, 2017. 3491075.http://search.proquest.com/openview/d16aa8ff34df550cc5b89 3915603a9fa/1?pq-origsite=gscholar&cbl=18750&diss=y

Fallows, David, *Josquin* (Turnhout: Brepols, 2009).

Farago, Claire J., "Leonardo's 'Battle of Anghiari': A Study in the Exchange between Theory and Practice," *The Art Bulletin* 76 (1994 - Issue 2). Accessed April 15, 2017. http://www.tandfonline.com/doi/abs/10.1080/00043079.1994.10786588

Franklin, David, *Painting in Renaissance Florence, 1500-1550* (New Haven: Yale University Press, 2001).

Frizzoni, Gustavo, "Leonardo da Vinci rammentato da un viaggiatore contemporaneo," *Nuova Antologia* vol. 144, 5th edn. (Roma, 1909), 631-637.

Frommel, Christophe Luitpold, "Bramante and the Origins of the 'High Renaissance'" in Jill Burke, *Rethinking the High Renaissance. The Culture of the Visual Arts in Early Sixteenth-Century Rome* (Farnham: Ashgate, 2012).

Gamberini, Andrea ed., *Late Medieval and Early Modern Milan: The Distinctive Features of an Italian State* (Milan: Brill, 2015).

Gavitt, Philip, *Charity and Children in Renaissance Florence: The Ospedale Degli Innocenti 1410-1536* (Ann Arbor: University of Michigan Press, 1990).

Giannetto, Nella, *Bernardo Bembo, umanista e politico Veneziano* (Florence: Leo S. Olschki, 1985).

Goffen, Rona, *Renaissance Rivals: Michelangelo, Leonardo, Raphael, Titian* (New Haven and London: Yale University Press, 2002).

Gombrich, Ernst H., "Raphael's 'Stanza Segnatura' and the Nature of its Symbolism," in *Symbolic Images: Studies in the Art of the Renaissance* (London: Phaidon, 1975).

—. *Art and Illusion* (London: Phaidon, 1960).

—. *The Heritage of Apelles* (Oxford: Phaidon, 1976).

Hankins, James, "Cosimo de' Medici and the 'Platonic Academy'," *Journal of the Warburg and Courtauld Institutes,* 53 (1990): 144-162.

Hartt, Frederick, *A History of Italian Renaissance Art: Painting, Sculpture, Architecture* (London: Thames and Hudson, 1970).

Harvey, Susan A., *Scenting Salvation. Ancient Christianity and the Olfactory Imagination* (California: University of California Press, 2006).

Heydenreich, Ludwig H., *Leonardo da Vinci: an exhibition of his scientific achievements* (London: Royal Collection Trust, 1949).

Huffman, Carl A., "The Pythagorean Conception of the Soul from Pythagoras to Philolaus," in D. Frede and B. Reis ed., *Body and Soul in Ancient Philosophy* (Berlin: Walter de Gruyter, 2009).

Huntsman, Penny, *Thinking About Art: A Thematic Guide to Art History* (London: Wiley, 2015).

Jacobs, Vivian and Wilhelmina, "The Color Blue: Its Use as Metaphor and Symbol," *American Speech* 33: 1 (Feb., 1958): 29-46.

Jelly, Frederick M.O.P., "The Roman Catholic Dogma of Mary's Immaculate Conception," in H. George Anderson, J. Francis Stafford, Joseph A. Burgess ed., *The One Mediator, The Saints, and Mary: Lutherans and Catholics in Dialogue VIII* (Minneapolis: Augsburg Fortress, 1992).

Jones, Susan, "Painting in Oil in the Low Countries and Its Spread to Southern Europe," *Heilbrunn Timeline of Art History* (Metropolitan Museum of Art, 2012). Accessed May 8, 2017.
http://www.metmuseum.org/toah/hd/optg/hd_optg.htm

Jutte, Robert, *A History of the Senses: From Antiquity to Cyberspace,* (London: Wiley, 2004).

Kandel, Eric R., *The Age of Insight. The quest to understand the unconscious in art, mind and brain* (New York: Random House, 2012).

Kandeler, Riklef, and Ullrich R. Wolfram, "Symbolism of plants: examples from European-Mediterranean culture presented with biology and history of art, MAY: Columbine," *Journal of Experimental Botany,* 60: 6 (2009): 1535-1536. Accessed April 1, 2017. http://jxb.oxfordjournals.org/content/60/6/1535.full

Keele, Kenneth David and J. Roberts, *Leonardo Da Vinci: Anatomical Drawings from the Royal Library, Windsor Castle* (London: Royal Academy of Arts, 1977).

Keele, Kenneth David, *Leonardo Da Vinci's Elements of the Science of Man* (New York & London: Academic Press, 1983).

Kemp, Martin, *Leonardo On Painting* (Yale: New Haven, 1989).

—. *The Science of Art: Optical Themes in Western Art from Brunelleschi to Seurat* (New Haven: Yale University Press, 1992).

—. "From Scientific Examination to the Renaissance Market: The Case of Leonardo da Vinci's 'Madonna of the Yarnwinder'," *Journal of Medieval and Renaissance Studies* XXIV (1994): 259-74.

—. *Leonardo da Vinci: The Marvelous Works of Nature and Man* (Oxford: Oxford University Press, 2007).

—. *Mona Lisa: The People and the Painting* (Oxford: Oxford University Press, 2017).

King, Ross, *Brunelleschi's Dome: The story of the great cathedral in Florence* (New York: Random House, 2010).

—. *Leonardo and the Last Supper* (London: Bloomsbury, 2012).

Kwakkelstein, Michael W., *Leonardo as a Physiognomist: Theory and Drawing Practice* (Leiden: Primavera Press, 1994).

Lang, S., "Leonardo's Architectural Designs and the Sforza Mausoleum," *Journal of the Warburg and Courtauld Institutes* 31 (1968): 218-233.

Löber K. Agaleia, *Erscheinung und Bedeutung der Akelei in der mittelalterlichen Kunst* (Köln, Wien: Böhlau, 1988).

Malaguzzi-Valeri, Francesco, *Pittori lombardi del Quattrocento* (Milan: L. F. Cogliati, 1902).

—. *La corte di Ludovico il Moro: La vita privata e l'arte a Milano nella secunda metà del quattrocento*, 4 vols (Milan: Ulrico Hoelpi, 1913–23). Accessed April 19, 2017. https://archive.org/details/lacortedilodovic01mala

Mare, Estelle Alma, "Leonardo da Vinci's ideal city designs contextualised and assessed," *South African Journal of Art History* 29: 1 (Jan. 2014): 164-176.

Martindale, Andrew, *The Rise of the Artist in the Middle Ages and Early Renaissance* (New York: McGraw-Hill, 1972).

Matteini, Mauro and Arcangelo Moles, "A Preliminary Investigation of the Unusual Technique of Leonardo's Mural 'The Last Supper,'" *Journal Studies in Conservation* 24 (1979-Issue 3). Accessed April 15, 2017. http://www.tandfonline.com/doi/abs/10.1179/sic.1979.014

McCue, James F., "The Doctrine of Transubstantiation from Berengar through Trent: The Point at Issue," *The Harvard Theological Review* 61: 3 (July 1968): 385-430.

McHam, Sarah Blake, "Donatello's Bronze 'David' and 'Judith' as Metaphors of Medici Rule in Florence," *The Art Bulletin* 83: 1 (March 2001): 32-47.

McManus, Stuart M., "Byzantines in the Florentine polis: Ideology, Statecraft and ritual during the Council of Florence," *The Journal of the Oxford University History Society*, 6 (Michaelmas 2008/Hilary 2009).

Meagher, Jennifer, "Italian Painting of the Later Middle Ages," *Heilbrunn Timeline of Art History* (Metropolitan Museum of Art, 2010). Accessed May 8, 2017. http://www.metmuseum.org/toah/hd/iptg/hd_iptg.htm

Miller, Clement A., "Gaffurius's 'Practica Musicae': Origin and Contents," *Musica Disciplina* 22 (1968): 105-128.

Monfasani, John, "A Description of the Sistine Chapel under Pope Sixtus IV," *Artibus et Historiae,* 4: 7 (1983): 9-18.

Moore Ede, Minna, "The Last Supper" in Luke Syson and Larry Keith, *Leonardo Da Vinci: Painter at the Court of Milan* (London: National Gallery, 2011).

Mueller, Ian, "Greek arithmetic, geometry and harmonics: Thales to Plato," in C. C. W. Taylor ed., *Routledge History of Philosophy Vol. I: From the Beginning to Plato* (London: Routledge, 1997), 271-322.

Najemy, John M., *A History of Florence 1200-1575* (London: Wiley-Blackwell, 2008).

Nicholl, Charles, *Leonardo da Vinci: The Flights of the Mind* (London: Allen Lane, 2004).

Noyes, Ella, *The Story of Milan* (London: J.M. Dent & Co, 1908).

O'Connor, E.C.S.C., *The Dogma of the Immaculate Conception: History and Significance* (South Bend: University of Notre Dame Press, 1958).

Ottino della Chiesa, Angela, *Opera complete Leonardo da Vinci Pittore* (Milan: Rizzoli, 1967).

Panofsky, Erwin, *Studies in Iconology* (Oxford: Oxford University Press, 1939).

Park, Katherine, "The Criminal and Saintly Body. Autopsy and Dissection in Renaissance Italy," *Renaissance Quarterly* 47: 1 (1994): 1-33.

Pawlik, Johannes, *Theorie der Farbe*, 8th edn. *(Köln:* DuMont, 1987).

Pederson, Jill, "Henrico Boscano's 'Isola beata': New evidence for the Academia Leonardi Vinci in Renaissance Milan," *Renaissance Studies* 22 (2008): 450-75.

—. *The Academia Leonardi Vinci: Visualizing dialectic in Renaissance Milan, 1480–1499*, Ph.D., The Johns Hopkins University, 2008, 428; 3288613.

Pizzorusso, Ann, "Leonardo's Geology: The Authenticity of the 'Virgin of the Rocks'," *Leonardo* 29: 3 (1996): 197-200.

Popham, A. E., *The Drawings of Leonardo da Vinci* (London: Jonathan Cape, 1946).

Quiviger, François, *The Sensory World of Italian Renaissance Art* (London: Reaktion Books, 2010).

Reti, Ladislaus, "'Non si volta chi a stella è fisso': Le imprese di Lionardo da Vinci," *Bibliothèque d'humanisme et renaissance* 21 (1959): 7-54.

Robb, Nesca A., *Neoplatonism of the Italian Renaissance* (London: Allen and Unwin, 1935).

Roy, Ashok, "Leonardo da Vinci; Pupil, painter and master," *National Gallery Technical Bulletin* 32 (2011).

San Juan, Rose Marie, "The Court Lady's Dilemma: Isabella d'Este and Art Collecting in the Renaissance," *Oxford Art Journal* 14: 1 (1991): 67-78.

Sanudo, Marino, *La spedizione di Carlo VIII* (Venice: M. Visentini, 1873).

Scaff, Susan von Rohr, "The Virgin Annunciate in Italian Art of the Late Middle Ages and Renaissance," *College Literature* 29: 3 (Summer, 2002): 109-123.

Schillebeeck, Edward O.P., *Mary, Mother of Redemption* (New York: Sheed & Ward, 1964).

Schofield, Richard, "Giovanni da Tolentino Goes to Rome: A Description of the Antiquities of Rome in 1490," *Journal of the Warburg and Courtauld Institutes* 43 (1980): 246-256.

Shaw, Christine, *Julius II: The Warrior Pope* (London: John Wiley & Sons, 1997).

Shell, Janice and G. Sironi, "Salai and Leonardo's Legacy," *Burlington Magazine* 133 (1991): 95-108.

Shell, Janice and G. Sironi, "Salai and the inventory of his estate," *Raccolta Vinciana 24* (1992): 109-53.

Shell, Janice, *Pittori in bottega: Milano nel Rinasimento* (Torino: Umberto Allemandi, 1995).

—. "Ambrogio de Predis" in David Alan Brown ed. *The Legacy of Leonardo* (Milan: Skira Editore, 1998).

Silver, Larry, *Marketing Maximilian: The Visual Ideology of a Holy Roman Emperor* (New Jersey: Princeton University Press, 2008).

Solmi, Edmondo, "La politica di Ludovico il Moro nei simboli di Lionardo da Vinci," in *Scritti varii di erudizione e di critica in nore di Rodolfo Reiner* (Torino: Bocca, 1912), 491-509. Accessed April 24, 2017. http://www.franuvolo.it/sito/doc/Leonardo-in/082.pdf.

Strathern, Paul, *The Medici: Godfathers of the Renaissance* (London: Vintage, 2007).

—. *The Artist, the Philosopher and the Warrior. Leonardo, Machiavelli and Borgia: A Fateful Collusion* (London: Vintage, 2010).

Steinberg, Leo, *Leonardo's Incessant Last Supper* (New York: Zone Books, 2001).

Sullivan, Vickie B. and John T. Scott, "Patricide and the Plot of 'The Prince': Cesare Borgia and Machiavelli's Italy," *Journal of Medieval and Renaissance Studies* 21 (1993): 83-102.

Syson, Luke, and Larry Keith, *Leonardo Da Vinci: Painter at the Court of Milan* (London: National Gallery, 2011).

The National Gallery Annual Report and Accounts for the year ended 31 March 2012. Accessed April 20, 2017. https://www.gov.uk/government/uploads/system/uploads/attachment_data/file/229067/0490.pdf

Thomas, Anabel, *The Painter's Practice in Renaissance Tuscany* (Cambridge: Cambridge University Press, 1995).

Trayman Steinitz, Kate, "Two Books from the Environment of Leonardo da Vinci in the Elmer Belt Library of Vinciana: Gaffurio and Plutarch," *Libri* 2 (1951-52): 1-14.

Uribe Hanabergh, Verónica, "The belvedere torso's influence as an accidental fragment in art, from the renaissance to the xixth century," *Ensayos: Historia y Teoría del Arte,* 23 (2012): 74-99.

Vecce, Carlo, *Leonardo* (Rome: Salerno Editrice, 2006).

Veltman, Kim. H., and Kenneth David Keele, *Studies on Leonardo da Vinci I: Linear Perspective and the Visual Dimensions of Science and Art* (Munich: Deutsche Kunstverlag, 1986).

—. *Leonardo da Vinci: Studies of the Human Body and Principles of Anatomy* (1997), keynote published in German as "Leonardo da Vinci Untersuchungen zum menschlichen Korper" in Klaus Schreiner ed., *Gepeinigt, begehrt, vergessen. Symbolik und Sozialbezung des Körpers im späten Mittelalter und in der frühen Neuzeit* (Bad Homburg: Werner Reimers Stiftung, 1992), 287-308. Accessed April 3, 2017.

http://www.sumscorp.com/img/file/1992_Leonardo_da_Vinci,_Studies _of_the_Human_Body_and_Principles_of_Anatomy.pdf

Vezzosi, Alessandro, *Leonardo da Vinci: Renaissance Man*, trans. Alexandra Bonfante-Warren (London: Thames and Hudson, 1997).

Vico, Enea, "The Academy of Baccio Bandinelli" (17.50.16-35) in *Heilbrunn Timeline of Art History* (New York: The Metropolitan Museum of Art, 2000). Accessed April 20, 2017. http://www.metmuseum.org/toah/works-of-art/17.50.16-35.

Villari, Pasquale, trans. Lynda Villari, *The Life and Times of Niccolò Machiavelli* (London: T. Fischer Unwin, 1892). Accessed April 9, 2017. https://archive.org/stream/lifeandtimesnic00villgoog#page/n246/mode/ 2up

Wells, Thereza, "Selling Leonardo's 'Virgin of the Rocks'," *Burlington Magazine* 153: 1305 (2011): 803.

White, Michael, *Leonardo da Vinci: The First Scientist* (London: Abacus, 2000).

Winternitz, Emanuel, *Leonardo da Vinci as a Musician* (New Haven: Yale University Press, 1982).

Wittkower, Rudolph, "Brunelleschi and 'Proportion in Perspective'," *Journal of the Warburg and Courtauld Institutes*, 16: 3/4 (1953): 275-291.

Woolgar, C.M., *The Senses in Late Medieval England* (New Haven: Yale University Press, 2006).

Zeyl, Donald, "Plato's Timaeus," *The Stanford Encyclopedia of Philosophy* (Spring 2014 Edition). Accessed April 5, 2017. https://plato.stanford.edu/archives/spr2014/entries/plato-timaeus

Zöllner, Frank, *Leonardo da Vinci 1452-1519* (London: Taschen, 2000).

—. *Leonardo da Vinci: Complete Paintings and Drawings* (Cologne: Taschen, 2011).

—. *Leonardo da Vinci. The Graphic Work* (Cologne: Taschen, 2011).

INDEX

PRAISE FOR
"LEONARDO AND *THE VIRGIN OF THE ROCKS*"

"Leonardo's oeuvre is well documented, yet this book is unique in its focus on his two versions of *The Virgin of the Rocks*. Katy Blatt's thematic approach allows for new links to be made between these paintings and their intellectual resonance. Unusually vivid and arresting in its interpretation of the artist and his times, this is a valuable, eminently readable contribution to the paintings within their wider cultural contexts."
—Professor Jean Michel Massing, Professor of Art History, King's College, Cambridge.

"This lively introduction to Leonardo and his two *Virgin of the Rocks* paintings synthesizes existing scholarship in a fresh and accessible way. Through close attention to materials and technique, Blatt really make the process of creation come alive in a way that will resonate very strongly with both students of Art History and the interested layperson."
—Dr. Diana Presciutti, Lecturer in Italian Renaissance Art and Visual Culture, Essex University.